Painting and System

Translated by Sima N. Godfrey

Painting and System

Marcelin Pleynet

The University of Chicago Press
Chicago and London

First published in Paris under the title *Système de la Peinture,* © Editions du Seuil, 1977.

The University of Chicago Press, Chicago 60637
The University of Chicago Press, Ltd., London

© 1984 by The University of Chicago
All rights reserved. Published 1984
Printed in the United States of America

93 92 91 90 89 88 87 86 85 84 54321

Library of Congress Cataloging in Publication Data

Pleynet, Marcelin, 1933–
 Painting and system.

 Translation of: Système de la peinture.
 Includes index.
 1. Painting, Modern—20th century. 2. Painting—Psychology. I. Title.
ND195.P54213 1984 759.06 84-209
ISBN 0-226-67093-7

The poetry of a painting must be made by the
spectator . . . It must come unbeknownst to the artist.
Poetry is the very result of painting itself; for it lives in
the soul of the spectator and genius consists in
awakening it.

CHARLES BAUDELAIRE

The objective of the text of art criticism . . . is for me
to place myself bluntly before something that implies
another discourse, a discourse that will not be in the
text; and to place the reader before something that
implies another discourse, that is to say, why not his
own?

MARCELIN PLEYNET

Contents

Tout cela assez touristique, comme l'ensemble de mon séjour new yorkais où je ne rencontre que le "business" du monde de l'art et de l'Université.

Marcelin Pleynet, *L'Amour*

Translator's Introduction

To the American reader, accustomed to the academic protocol that underwrites the style of "serious" art history, the critical essays of Marcelin Pleynet may appear as an oddly Gallic excursion into the field of modern art. To be sure, Pleynet himself seems to cut a curious figure in the world of professional art historians—something of the stylish French tourist intruding on the "business" of art and scholarship. Such a caricature, though hasty, is not entirely without truth, for in the self-conscious writings of Marcelin Pleynet there is a calculated effect of *flânerie* that has been designed to disturb the institutional complacency of the French specialist as much as the American.[1] The apparently loose structure of these essays on art, with their radically plural discourses and digressive styles, was conceived in the willful climate of antiacademicism that governed the intellectual moment of their production in the Paris of the late sixties. More particularly, these essays bear the unmistakable trace of the specific context of their publication, exemplifying as they do the counterdominant intellectual trends of the dominant avant-garde journal of its day, *Tel Quel.*

From 1962 to 1982, the year of its final issue,[2] Marcelin Pleynet served as the managing editor of this influential periodical, which introduced Continental and American audiences alike to the work of—among others—Philippe Sollers, Julia Kristeva, Tzvetan Todorov, Roland Barthes, Gérard Genette, Michel Foucault, and Jacques Derrida. Essays by these critics appeared between the covers of *Tel Quel* as well as in the collection of books that it generated at the

Editions du Seuil, and while some of the authors eventually moved to other publishing houses (or founded journals of their own) their work remained the implicit background to the intellectual adventure that *Tel Quel* charted in the active world of French critical theory. As such, the collection of articles published in 1968, *Tel Quel: Théorie d'ensemble,* represents a major landmark in the collective articulation of this highly controversial and multidisciplinary group of authors. And it is against the backdrop of the variable interests and convictions of *Tel Quel* that Pleynet's own versatile career as author can best be read.[3]

The variety of discourses that punctuate Pleynet's writing parallels the various interdisciplinary emphases that have at different times informed the literary tastes and theoretical premises of *Tel Quel.* During the twenty years of his editorial direction, *Tel Quel* espoused such diverse causes as the New Novel in literature, psychoanalysis in the social sciences, Maoism in politics, poststructuralism in criticism, and deconstruction in philosophy. Like the journal, however, whose stated ambitions were from the start "poetic, in the broadest sense of the word—that is, encompassing all the literary genres" (*Tel Quel,* no. 1 [spring 1960]: 3), Pleynet's own theoretical enterprise originates in *poetry;* the personal journals as well as the critical corpus that spans the fields of literature, painting, and music remain ultimately subordinate to his investigations of poetic language. Since 1962 he has published five volumes of poetry, some of which first appeared in the pages of *Tel Quel* along with his articles on art and literature. In 1977, the year Seuil reprinted the present selection of art criticism in its popular paperback series "Points" (the essays in *Système de la peinture* originally appeared in 1971 as part of *L'Enseignement de la peinture,* Tel Quel series), Pleynet also published a large critical anthology of his writings, under the title *Art et Littérature.* Following the success of that book, Pleynet was interviewed by Alain Borer, Alain Coulange, and Gérard-Georges Lemaire, and their conversation was published in the spring issue of *Tel Quel* (no. 75, 1978). In that article ("Poésie oui") Pleynet elaborates his critical methodology in terms of the poetic preoccupations that form the constant point of reference for his intellectual *bricolage.* "My approach tends to test . . . whatever is presented as normativity and to examine it against poetic language—a language whose end is not the finiteness

of normative discourse, scientific or otherwise, but an infinity of discourses and languages" (p. 77). "The discourse on painting has allowed me to analyze certain of the resistances that I may have come up against in the kind of writing I do" (p. 80). "The precise reference for my texts on painting is poetry" (p. 83).

At the same time that he emphasizes the poetic context of his own preoccupations in the analysis of painting, Pleynet stresses the importance of situating the problematics of art (and more specifically modern art) within the appropriate historical and ideological context that conditions their formal articulation. In this, the deliberately nonspecialized focus of Pleynet's critical discourse (poetic, historical, ideological, psychoanalytical, etc.) restates the fundamental antiacademicism of the *Tel Quel* project, whose theoretical platform declared the modern breakdown of autonomous fields of culture (as readily defined by the University) and the related hierarchies of expertise that they sanctioned.

The art criticism represented in this volume, like most of Pleynet's criticism, addresses cultural productions of the past century. For Pleynet, as for his colleagues, the distinctive creative energies of our era emerge from a radical *rupture* with tradition that took place in the nineteenth century: an epistemological break that is dramatized in the work of those authors who constitute *Tel Quel's* modernist canon—Lautréamont, Mallarmé, Marx, Freud, and, more recently, Joyce. To be sure, these names appear frequently in Pleynet's writings as indices of the profound transformation that has reshaped the structures of modern culture and knowledge. To this nineteenth-century academy of antiacademic innovators, Pleynet adds the name of Cézanne, an artist whose deconstruction of representational space comes to occupy an analogous position in the history of Western painting to Mallarmé's and Lautréamont's writings in the "revolution of poetic language" (cf. Pleynet's *Lautréamont* [Paris: Seuil, 1967] and Kristeva's *La Révolution du langage poétique* [Paris: Seuil, 1974]). It is thus significant that in the four essays presented here Cézanne should remain the constant point of artistic reference, despite the fact that three of the essays do not specifically address French art or artists at all.

Cézanne, however, like Lautréamont and Mallarmé, does belong to the specific culture and idiolect of Marcelin Pleynet; and, as a critic, Pleynet would be the first to acknowledge the subjective

nature of his (poetic) investment in painting with all the idiosyn-
cratic allusions and associations he brings to it. Indeed, he defends
his aleatory approach methodologically by discrediting the sup-
posed "rigor" of any totalizing method that might consider itself
absolute.

> I do not think that a general method exists, a system that would
> allow you to examine anything and everything; there is a cer-
> tain relation to the object (a relation that changes with the
> object) that produces the analytic and critical discourse; for
> each "effect of the real" there is an "effect of discourse" and it
> is never the same . . . It is like dream analysis. Freud has very
> rightly pointed out that a dream in itself has no meaning. It is
> the biographical, historical, everyday context and the discourse
> about the dream that give it meaning. I think that painting can
> be considered like a dream. ("Poésie oui," p. 75)

Like the tourist visiting the business world of art and scholarship,
Pleynet "drops in" on various cultural institutions that stand on the
periphery of the unrestricted poetic space that is his true "field" of
inquiry. Most often it is to Freud and psychoanalysis that he pays his
call.

> Freud's discourse is based on scientific foundations and as such
> it occupies (or tends to occupy) an objective function in the
> organization of society. I would hope that what *I* do can be
> clearly distinguished from that. The place of the psychoanalytic
> institution . . . is not suited for a writer. Of course I can always
> pass by and drop in, as they say . . . Think of what happened not
> too long ago at the Radio Building; they organized group visits
> and opened some rooms for show. For other rooms they said,
> "No, that's closed." You might say that I do not accept being
> told, "No, that's closed." I can't even accept saying it to myself.
> My point of reference for what I do and for what I write is
> poetic language—that is, a language that is in no ways nor-
> mative. And it is on that basis that I pay my call to
> psychoanalysis. ("Poésie oui," pp. 76–77)

It is ironic that as in the case of Freud—the maverick become
institution—the artists Pleynet deals with, radical innovators of the
modern, have come to constitute in the imagination of the twen-
tieth century an institution of their own, the "avant-garde." As such
they prefigure the experience of *Tel Quel* itself, which in defying an

academic order of power and knowledge came to constitute a counteracademic order of its own that enjoyed a certain measure of power and prestige in the sixties and seventies through its intellectual solidarity and influential publications. Yet, like Pleynet himself, the individual artists of whom he writes remain haunted by phantoms of the academy with which they struggle. It is that dialectical relation of the individual avant-garde artist with the conventions of an immediate past that most often engages Pleynet in his speculative account of painting and system.

> One must understand that an artist, and especially an avant-garde artist who is involved in a process that is not academic, wishes nonetheless to defend himself and to demonstrate the positive aspects of his work; he is always somewhat drawn to justify himself in terms of the academy. When Rothko says, "I refer to paintings by Michelangelo," he is really saying, "Of course what I do appears completely eccentric and aberrant, but I assure you, I know my academy!" That artists borrow from history is absolutely certain, but that their borrowings are as justified in quite the same way as they would like us to think is in my opinion completely false. In other words, their relation to culture is empirical and for very particular reasons . . . The creative rhythm of an artist can absolutely not be rationalized; it has its own determinations. And it is in the order of rhythm that these borrowings are made, most often in a great hurry and at great speed. ("Poésie oui," p. 82)

Pleynet's concern with academic pasts (pictorial as well as poetic) is a particularly French preoccupation, as is his concern with avant-garde ruptures and attempted ruptures from inherited systematizations. Similarly, the journalistic-poetic strategy he has adopted to deal with these issues is modeled on a French tradition of the poet as art critic that gained particular prominence in the same nineteenth century to which he constantly returns.

Charles Baudelaire, arguably the greatest French poet of the nineteenth century and the shadow who presides over much of Pleynet's own poetry—a recent collection of Pleynet's poems, *Rime* (Paris: Seuil, 1981), begins with a reflection on Baudelaire's prose poems and explicitly echoes the *Fleurs du Mal* in a number of titles and images—remains the strongest voice of French art criticism in that century as well, despite the unorthodox style of his presenta-

tion. The most famous essays on art, the "Salon of 1859" and "The Painter of Modern Life," contain hardly a single thorough description of a painting—an "oversight" for which Baudelaire has been faulted by more academic critics and historians of art. What they do contain, however, are seminal insights into the problematic relation of the modern artist to the cumulative lessons of an inherited past and the previously unexpressed realities of a modern world that makes demands on the artist's imagination that no academy can adequately meet. Baudelaire's writings on art, like the writings of Pleynet, who follows in his critical as well as poetic wake, are governed by a principle stated at the beginning of his career: "The poetry of a painting must be made by the spectator" (1846). Already in the mid-nineteenth century Baudelaire had dramatically overturned the premises of (academic) writing on art by displacing the focus of criticism from the object (the painting) and its expressive (intentional) content onto the impressive effects it might produce on the spectator. Art for Baudelaire thus enters into a dialogue with the spectator that becomes a text of criticism and, at its best, poetry. One recalls his observations in the famous second chapter of the "Salon of 1846," "What Good is Criticism?": "I sincerely believe that criticism is best when it is amusing and poetic; not cold and algebraic like the criticism which, under the pretext of explaining everything, expresses neither hate nor love and is willfully stripped of any kind of temperament. As a beautiful painting gives us nature reflected by an artist, so criticism should be the painting reflected by an intelligent and sensitive mind." Similarly, in "The Universal Exhibition of 1855" Baudelaire admits that in his criticism he will often appreciate a painting "only through the sum of ideas and dreams it brings to my mind." We are back in the familiar (unfamiliar) world of painting and dreams that Pleynet describes. A careful reading of Baudelaire's critical essays suggests that his self-styled impressionism is less a factor of technical ignorance (of painting) or editorial haste than a strategic choice corresponding to aesthetic convictions that were explicitly stated throughout his career. By extension, the "neoimpressionistic" style of Pleynet's writings implicitly reaffirms the same aesthetic convictions that have directed an alternate genre of "poetic" art criticism in France for well over a century.

By situating Pleynet's art criticism within the immediate context

of French intellectual trends of the late 1960s and against the more distant, but equally influential intertext of Baudelaire's poetry and art-criticism of the 1850s, one quickly sees that the unconventionality of Pleynet's performance is determined by a specific set of conventions that, although not academic, still bear the authority of a now "classical" model. And it is in recalling Baudelaire's identification of the modern artist/critic with the dandyish *flâneur* that Pleynet's "tourism" takes on new unexpected status. That modern (or postmodern) readers continue to be surprised by this discourse ultimately proves the validity of the overriding premise that informs Pleynet's critical argument: despite all appearances, the twentieth century continues to struggle belatedly with the ambivalent legacy of its immediate past. While the modernist aesthetic may have succeeded in overcoming the traditionalisms of the nineteenth century, postmodernism still answers to that century's revolutionary novelty.

A final note regarding this translation. Pleynet's style, I have suggested, is conditioned more by his poetic instinct that by the linear logic of conventional academic prose. I have tried to maintain the rhythms of his sentences, which are often long and repetitive. Pleynet has emphasized his deliberate use of repetition as part of the poetic structure of his thought. Similarly, some of the logical transitions are replaced by word associations (the most notable, and outrageous, being his play on Matisse's name at the end of the first essay, a play whose aberrant nature he happily admits; cf. "Poésie oui," p. 80). I have added the original French in parentheses wherever necessary for the comprehension of an ambiguous phrase or play on words. I have also tried to maintain the apparently spontaneous rhythm of the author's digressive reflections, despite the complicated syntax they often entail. While Pleynet's stylistic excesses seem occasionally self-indulgent fifteen years after the fact, they reveal an extraordinary enthusiasm and commitment that should not be misrepresented.

The preparation of this manuscript was facilitated by a grant from the University of North Carolina at Chapel Hill. Special thanks are due to Richard Shiff, whose expert advice saw me through several difficult passages.

<div align="right">Sima Godfrey</div>

As for the study of painting, some prefer complexity while others prefer simplicity. Complexity is bad and simplicity is bad. Some prefer facility while others prefer difficulty. Difficulty is bad and facility is bad. Some think it noble to have a method while others think it noble not to have a method. To have no method is bad. To remain totally enclosed within a method is even worse. First of all one must [observe] a strict rule, and then penetrate all its transformations intelligently. The goal of possessing a method is ultimately no method. It is like the way Kou Tch'ang-k'ang drips his colors.

The *Chou Wen* says: Painting is made up of limits, it is like the paths that border fields.

KIE TSEU YUAN HOUA TCHOUAN

Painting and System?

The essays collected in this volume demonstrate the approaches of some of the artists and avant-garde movements that powerfully marked the first half of this century. Each of them tried to create a system—a system, however, that could not be used for any but the corpus that initiated it and set it into play. Through the discourse that they provoke, works by Cézanne, Matisse, and Mondrian establish the aesthetic, formal, and ideological structuring of a system that in each case works, it turns out, only in its particularity.

The essays that follow are based on an initial acknowledgment of the social, ideological, political, and economic transformations that were operative during the second half of the nineteenth century and responsible for the issues that would haunt the first half of the twentieth. As such, these essays are oriented toward the introduction of a new reading of the ideological foundations and determinations of this complex historical process.

The works and artists that are the object of this critical investigation indicate less a specific choice on my part (of the sort a certain kind of society has felt obliged to recognize and cultivate) than some of the more important and inescapable dramatizations of representation that characterize the contemporary imagination. Needless to say, in writing this I recognize that I am by that very gesture implicated in this movement, although that implication does not necessarily represent a choice. And that is precisely what characterizes these texts for me: the analytic implication of a discourse in a process that raises—through the often heterogeneous informa-

tion investing modernity—those productive contradictions that seem to initiate what must be called a new culture.

At some point in the future, the manner by which Cézanne, following the impressionists, radicalized the situation and the role of the work of art in modern society will have to be addressed. The end of the nineteenth century, it seems, witnessed the termination of a certain type of relation between artist and institution. Nor is it at all by chance that this break was accompanied by a reconsideration of traditional modes of representation. The work of Cézanne, I would maintain, epitomizes the very characteristics of modernity: that is, a bringing into focus of the system that constitutes the position of the subject in the process of interpreting and analyzing his/her relation to an entire social structure. If we look at the vast array of modern art works, we can find no single example, from the end of the nineteenth century down to our own day, that does not reveal the stubborn presence and immediacy of this issue, viewed from every angle and argument—that is, the question of the subject's relation to laws and institutions, in which every individuality challenges the truth of the system that constitutes it. At some point, most artists are tempted to clarify the radically new kind of relation they engage in with social reality, but these individual attempts to reduce the contradictions that are at work in their lives and art— whether they be the rationalizations of Matisse or the theosophical declarations of Mondrian—can never be fully resolved.

Certain artists and certain groups or schools have made it their purpose, nevertheless, to generalize and somehow socialize modern art; in these cases, the consequences of the move toward analytic interpretation (which characterizes the position of the modern artist) are deliberately ignored. The transformations within the order of the representational systems that affect the analytic withdrawal are aestheticized, and what comes to fill and institutionalize the place of interpretive vacancy most often belongs to the order of philosophical discourse. It is in this light that the theories of Gropius and Kandinsky are considered in "The Bauhaus and Its Teaching," as are Malevich's propositions in "The Russian Avant-Garde."

The essays in this volume—on Matisse, Mondrian, the Bauhaus, and the Russian constructivists—focus on the functionally corrosive issue of the subject's place in the order of representation.

This issue, though probably initiated by Cézanne, has, with its sub-
sequent elaboration by artists like Matisse, clearly programmed all
of our modernity. By illustrating the double movement of initiative
and withdrawal, these essays try to indicate the analytic gesture
that engages the modern artist on a course that will define a system
(see "Matisse's System," which serves as a programmatic introduc-
tion to this volume). At the same time, they demonstrate the vari-
ous resistances that come from an ignorance of the particularities of
this system (or the desire to exploit it toward ends that are not its
own), resistances that oppose the opening of these works onto the
new attitudes to culture and thought that relate to the representa-
tional function they propose.

The question remains as to how these various systems may be
conjoined under the generic heading of painting. Does my collec-
tive title, *Painting and System,* suggest that the systems constitut-
ing the specificity of given corpuses of painting might allow us to
consider a general system of painting? Such a general system of

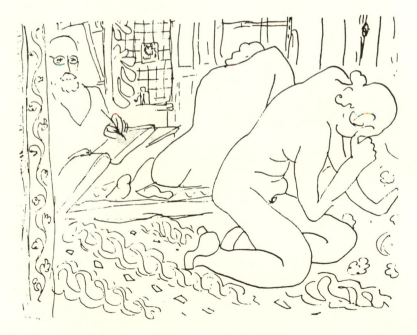

Nude in the Mirror with Self-Portrait of the Artist (1937)

painting is possible only to the extent that painting, like every other human activity, has its symptoms and its history; but it would seem to me that what characterizes our modernity in a symptomatic way is above all the fundamentally asystematic distortion that has taken place between *subject* and *history.* And so? So, we are still left with the question of knowing what painting teaches. To learn what painting teaches from the discourse it demands and generates— that is what these essays attempted to grapple with some seven years ago, and that is what I have continued to elaborate in my work ever since. To remain within the confines of the essays presented here, I would say that it is because painting teaches us so much more than its own history that it both is and is not resolved into a system. As a result, its destiny is to open forth onto new forms of culture and thought.

MARCELIN PLEYNET (1977)

Thus, to a certain extent, the function of
representation engages the very life of the
person who assumes it.

GEORGES BATAILLE

1 Matisse's System

(Introduction to a Program)

1. The Didactic Course

The Immediate Impressionist Past

Without setting oneself the naive goal of establishing the birth-date of modern painting, one may—indeed, one must—acknowl-edge just how much the initial thrust of modern art owes to impressionism. To make this point is, of course, to say everything and to say very little. The history of this period, still so close to us, is so loaded, so implicated in numerous economic, scientific, politi-cal, and ideological transformations[1] that its complexity seems to have determined infinitely more than developments in the early part of this century alone. The closeness no doubt blinds us, and this blindness produces a historicist investment that blinds us all the more by constituting in diachronic sequence that which, as his-tory, can only be examined in its synchrony. Why then the produc-tion of so many histories? From Delacroix, Ingres, Courbet, from impressionism to postimpressionism and right up to our own day, we have seen them multiply: histories of cubism, of fauvism, of ana-lytic cubism, synthetic cubism, futurism, expressionism, and sur-realism, not to mention the recent histories of op art, pop art, etc. One can hardly keep track of them; nor can critical evaluations of this proliferation be blamed for initially rejecting all historical ap-proaches to these various movements—thenceforth reduced to mere "convulsions." This "reaction," this ahistorical attitude is no less blinded than the other, and it confirms the latter's refusal to

consider the multiple aspects of a given phenomenon in their complex unity. We are left, then, with the option of reading the historicist investment in its convulsive reverse side, and reading anarchy on the metaphysical horizon of this investment. In this way, we may perhaps succeed in reconstituting historically the specific nature of the discipline that concerns us here.

To mark the initial thrust that impressionism gave to modern painting is to say everything and to say very little, to the extent that we are ourselves immediately involved in the headlong rush of modernism; we also follow a kind of schematization that tends to reduce the organic unity of a complex whole to a manner. Many are the questions that need to be asked. First of all there is the question of knowing what we mean by impressionism. Should we understand it simply as a "manner" of painting (a technique) or as the effect of cultural and ideological transformation? The two of course go hand in hand, but do we really respect the nature of the ideological transformation when we reduce it to a technique? The impressionists, Manet among them, thoroughly sanctioned the blurring that such a reduction presupposes. In the preface to his exhibition of 1867, Manet wrote: "An effect of sincerity was produced that seemed to give the works a character that made them look like protestations, whereas in fact the painter was thinking only of rendering his 'impression'" (and the role of the word *impression* is evident in such a discourse). It is certainly interesting to note how many modern art movements found themselves originally baptized in ridicule with the very name that today permits us to distinguish them: impressionism, cubism, and so forth. While this fact in itself does not demand lengthy elaboration, it would be a mistake not to take into account the ideological reversal that is implied. All this by way of signaling the use that I am obliged to make of terms like "impressionism" and—beyond the theoretical misappropriation that these terms have undergone—what I mean to point out in using them.

If we keep to the historicist order that we find, for instance, in John Rewald's two volumes on impressionism,[2] we are immediately drawn to the irreducible autonomy of different painters' practices, from Manet to Monet, from Degas to Renoir, not to mention the altogether eccentric presence of Cézanne. Although the Salon des Refusés of 1863 contained works by Manet, Pissarro, Jongkind,

Guillaumin, Cézanne, etc., it was only in 1873 that the idea of a group exhibition took form; even then, the group introduced itself as the "Anonymous Cooperative Society of Painters, Sculptors, Engravers, etc." The exhibition opened on 15 April, 1874, and the group probably owes its name to the article published by Louis Leroy in the *Charivari,* entitled "Exposition des impressionistes" (the word *impression* had earlier been used primarily by Théophile Gautier and Redon to define the work of Daubigny). The history in question continued its course with all its vicissitudes until 1886 and eventually became, at the origin of modern painting, the history of a "school" whose development would last thirty years (assuming once again, that we are dealing with a history). One should not, however, forget, in fact, that if Cézanne is eccentric, Manet remains marginal to this history, as does Degas. In the wake of these artists, postimpressionism as such appears under that rubric only to reinforce the historicist myth of a history of impressionism, censoring, in the very locus in which it defines itself, the objective productivity of a pictorial discipline.

Postimpressionism, claiming for itself the ever "eccentric" Cézanne, would in record time leave several flourishing groups in its wake, in distinct contrast to impressionism, which had so much trouble constituting itself as a group. From 1885 on, the pointillists would gather around Signac, the school of Pont Aven around Gauguin, the Nabis group around Bonnard and Maurice Denis, and so forth. And from that time on, the specific history of painting was systematically reproduced and reduced (schools, sporadic movements, minigroups). Cubism, fauvism, dadaism, surrealism, expressionism, orphism, Blaue Reiter, de Stijl, neoplasticism, suprematism, etc., appear as so many entities fighting for center stage and claiming an autonomy that they could not imagine to be relative. A revolutionary "ordering" of modern painting thus emerges; each one of these fragmentary platforms ("parties") presents itself as a totality, as a historical unit that excludes or tends to exclude any global approach to the pictorial problematic in its operational complexity. It is a most persuasive example of historicist blurring: the very possibility of historical evolution is paralyzed and annihilated.

That situation compels us to consider pictorial manifestations today, whatever they may be, only in relation to the totality of manifestations in the history of modern painting. That is, we are forced

to confront every pictorial manifestation with its non-thought, the act of "rupture" that it performs, without ever entertaining the theoretical return to the signifying complexity that is its origin. This performance, we have seen, appears at once vast and yet very precisely circumscribed, unique and yet given to the most violent contradictions in its productive reality. For a great many, indeed for most, modern painters (the term "modern" here stretching from the postimpressionists to our own day), this historical return—to a pictorial field considered in its productive totality—jars with the "coherence" of their practice. My decision to stop here to examine more specifically the work of Matisse is therefore determined primarily by the fact that a critical return to the complexity of the pictorial field does not seem to contradict the painter's practice; moreover this practice not only lends itself but calls for such an investigation.

Matisse—Attorney, Painter

Born in the second half of the nineteenth century (1869), Matisse occupies a special historical position. A contemporary of Signac (born in 1863), Toulouse-Lautrec (1864), and Bonnard (1867), he belongs to a generation that is, practically speaking, closer to Seurat (1859) than to Picasso (1881) or Braque (1882); the early Matisse is located somewhere on the outer edge of the chronological evolution within which modern art defines and encloses itself. As a twentieth-century painter, not only was Matisse born too early for his century, as it were, but he also began to paint rather late in his career. When in 1891 at the age of twenty-two he enrolled in the Académie Julian (where Bouguereau was teaching), all he know about painting was what he had been able to learn on his own, painting chromographs with a box of paints his mother had given him a year earlier. Thinking, no doubt, of the precocious career of the young Picasso (who at nineteen was already working on what would later be called his "blue period"), certain critics, among them Alfred Barr, have felt compelled to express regret at the years Matisse spent in academic study. What is certain, however, is that if one can date the influence of Lautrec and Steinlen on Picasso at eighteen, Matisse, from the age of twenty-two to twenty-four, during his brief stay at the Académie Julian (where Bouguereau reproached him for understanding nothing of perspective)

and then later in the studio of Gustave Moreau, was initiated to painting by means of more or less academic instruction—notably in copying Chardin, Fragonard, Ribera, D. de Heem, Philippe de Champaigne, Annibale Carraci, Poussin, and others.

The painter's first years have been the object of much controversy, some of which we should pay particular attention to, considering the late start of Matisse's career and the maturity and seriousness of his study. We should also point out that the kind of problems posed by the debates surrounding the career of an artist like Matisse are not necessarily solved by contemporary eyewitness accounts or by documents. Late in his life, Matisse was known to give altogether contradictory answers to certain questions: the painter, having forgotten what he was turning away from, often presented as logically true that which seemed to him to be the most likely interpretation. Nor are the lengthy monographs devoted to Matisse during his lifetime—written by people close to him and by critics who scrupulously sought to verify their facts with the artist himself—any the less contradictory.

Such are the problems surrounding the question of Matisse's initial decision to become a painter. All the biographers present as determining factors both the appendectomy that confined Matisse to his bed for a good part of 1890 and especially—and I shall return to this—the box of paints given to him the same year by Madame Matisse. Where the information becomes vague and interpretations diverge is with respect to the young man's interest in the plastic arts in the years preceding the operation. According to Gaston Diehl,[3] Matisse appears to have been completely indifferent to artistic questions before 1890. During the year he spent in Paris (1887–88) while preparing for his law degree, he did not even visit the Louvre once, if Diehl is correct, a detail which Raymond Escholier[4] passes over in silence and which is challenged by the more recent edition of Alfred Barr's book:[5] "Then in 1887 his father sent him to Paris to study law at the University, in the curriculum which led to the diploma of attorney or *avoué*. Matisse was not much interested in his subject and remembers spending a good deal of time at the Louvre." Here we have two contradictory statements that can hardly be verified.

Alfred Barr's book was reprinted in 1966, and the critic's affirmation (which I trust he checked with the painter) is nevertheless

contradicted by the inaugural speech that Matisse himself wrote for the opening of the Cateau-Cambrésis museum. "Did I not come to Paris for one year of law school, without the faintest desire of visiting any of the great museums, not even the annual Salon of painting, at a time when I filled my free time with ordinary distractions?"

What we do know, however—and on this point all the accounts agree—is that at all times Matisse was very careful to respect the principles he had been taught. This is how Matisse spoke in 1952, at the inauguration of the Cateau museum, of his decision to become a painter: "It was with the constant sense of my decision, despite my certainty that I was on the true path where I could feel myself in my own climate and not facing a closed horizon as in my former life, that I grew frightened, conscious of the fact that I could not turn back. I threw myself headlong into my work, therefore, driven by the principle that I had been hearing all my life in the words 'Hurry up!' Like my parents, I hurried to get to work, pushed on by something I cannot exactly describe, by a force that I perceive today as alien to my life as a normal man."[6] Matisse's respect for these principles explains many of the issues that concern us, and I shall make repeated reference to them. Matisse's father owned a grain and drug business in Bohain-en-Vermandois (a town of only 6,900 inhabitants even today); the principle ("Hurry up!") that Matisse recalled two years before his death evokes in effect the values of the turn-of-the-century *petite bourgeoisie,* aspiring to a stable place for its sons in the lower ranks of the legal profession. We are thus led to consider Matisse's activity from a somewhat more precise point of view, or at least to challenge those interpretations that somehow tend to situate his career in the romantic halo that envelops "artists" of the *belle époque.* It is more likely that, while studying to be an attorney, Matisse did not think of becoming a painter—would he otherwise have spoken of closed horizons?—and he may not have even thought of it when, in 1889, he enrolled in Professor Croisé's early morning class in elementary drawing at the Quentin de la Tour school. At the Cateau museum inauguration, Matisse further recalled that he passed his law examination with brilliant success; this would lead us to suppose that he took his studies in law—from which nothing could apparently distract him—at least as seriously as he would later take his profession as painter. It appears likely then that it took the operation and his inactive convalescence as

well as his mother's gift[7] to persuade Matisse to devote himself to that "force" which at the end of his life he would continue to regard as "alien to his life as a normal man."

The Academy and Modernity

Another important problem raised by the early years of Matisse's career and his study of painting concerns his discovery of impressionist art, especially the work of Cézanne.

In 1892, Matisse began working in Gustave Moreau's studio, and his training there was a determining factor in his career. Many are the tributes Matisse paid to Moreau; particularly striking are the remarks in which he relates memories of Moreau's teaching: "Certain painters of my generation regularly visited the Old Masters at the Louvre, where Gustave Moreau had taken them, before they had any knowledge of the impressionists." Matisse would often return to this aspect of Moreau's teaching: "It is remarkable that Cézanne, like Gustave Moreau, should have spoken of the Old Masters of the Louvre."[8] "In so doing, he [Moreau] spared us from the dominant tendency at the Ecole, where people looked only to the Salon. It was almost a revolutionary attitude on his part to teach us the way of the museum at a time when official art, dedicated to the worst sort of pastiches, and contemporary art, attracted by the doctrine of *plein-air,* seemed to conspire to pull us away."[9] "In any case, he [Moreau] was capable of enthusiasm and even rapture. One day he would affirm his admiration for Raphael; another day, for Veronese. He would arrive one morning and announce that there was no greater master than Chardin. Moreau knew how to pick out and show us the greatest painters, while Bouguereau, for his part, invited us to admire Giulio Romano." In order to understand the importance for a young painter of this return to the study of painting as the understanding of its many historical evaluations, we must refer—as Matisse does in recalling his studies—to the very last years of Salon art. Otherwise it is difficult for us to imagine how artists living in Paris could ignore all of modern art in 1892—the year of the major Seurat retrospective at the Salon des Indépendants, a year when various galleries were also showing exhibitions of Manet, Pissarro, Monet, Van Gogh, etc. "Certain painters of my generation regularly visited the Old Masters at the Louvre . . . before they had any knowledge of the impressionists."

Matisse's discovery of impressionist art is generally dated around 1897, the year of the exhibition of the Caillebotte bequest at the Luxembourg museum. Pierre Schneider maintains the probability of this date in the catalogue to the Centenary Exhibition,[10] even though certain remarks by Matisse and several paintings of 1896 indicate that the artist had at least seen, if not understood, some of Cézanne's works before the exhibition of the Caillebotte bequest. If only with respect to the teaching of Moreau, an artist very much involved in the artistic life of his time, Matisse's remarks permit us to assume that the names of at least some contemporary painters had penetrated the studio. In a note to Raymond Escholier, Matisse draws attention to this passing observation by Moreau: "I've just seen a Lautrec poster of an acrobat on a newspaper kiosk. It has a certain rude vigor." Given that Moreau was drawn to cite Lautrec on at least one occasion, it is more than likely that he cited other impressionists and postimpressionists as well. Indeed, in an interview with Alfred Barr, Matisse denied the following statement, which he had allowed Jacques Guenne to publish in a 1925 interview: "Did you visit the impressionist exhibitions?—No, I only became familiar with their work at the opening of the Caillebotte collection."[11] Returning to this same question, Matisse replied to Alfred Barr that he had seen the impressionists at Durand-Ruel's and Vollard's before 1897. Furthermore, according to Alexander Romm, Matisse seems to have been particularly impressed by two Cézanne paintings that were brought to Moreau's studio (Alfred Barr suggests they were brought there by Linaret).[12]

Which of Matisse's two statements should we take seriously? The answer to Alfred Barr's question clearly suggests that Matisse saw the Cézanne show at Vollard's in 1895. Beyond the contradictory affirmations and denials, however, the real question is to know what the artist did with what he saw; whether what he saw determined what he made; and whether what he made did not determine to some extent what he was capable of seeing. For our own purposes, we must not forget that on leaving Bohain-en-Vermandois, indeed on finishing the elementary drawing course at Saint-Quentin, Matisse was hardly prepared to understand modern painting. Nor should we forget that Matisse, like so many others, was not born an avant-garde artist. First we have to take into consideration the lessons he drew from classical painting, and only then can we

focus upon the artist's discovery of the problems of his own time.
Rapid as the development of his work may have been, neither the
Matisse family tradition—"Hurry up!"—nor his own natural intel-
ligence could speed up his artistic evolution or transform his paint-
ing overnight. Matisse may very well have seen modern paintings
before 1897 without their having effected the qualitative transfor-
mation of his work that would come a few years later.

Raymond Escholier notes that, with the *Ray* (1894) and *Pyramid
of Peaches,* "Matisse was already experimenting with planes."[13] A
painting like *The Blue Carafe,* also called *Still Life with a Lemon,* [14]
marks a treatment of space that goes far beyond the historical and
formal structures it makes use of (the glass, bottle, and half-peeled
lemon, etc., which suggest the tradition of Dutch painting). The
plane of the table, sharply inclined as in a technique dear to
Cézanne, seems to thrust the objects that rest on it beyond the
surface of the picture. This plane, which occupies two-thirds of the
painting, represents a table only to the extent that the objects it
supports suggest one; the plane is presented simply as a white sur-
face, one of whose edges proceeds from the right angle at the bot-
tom of the picture toward the center. The rest of the painting,
which is dark reddish-brown, is painted in thick impasto with large
strokes [*taches*] of yellowish-brown. What should stand for the
background is not painted as a "realist" background but as an inde-
terminate surface (without ground). In this painting, signed and
dated, Matisse has worked out a division of the canvas into planes,
using right and other angles (the edge of the table, the angle of the
wall, the decorative lines on the wall) as a pretext—a pretext al-
ready systematized by Cézanne. This same technique is articulated
more precisely in *Interior with a Top Hat* (1896)[15] and *Still Life
with a Black Knife,* paintings which, though still quite far from
Cézanne's *Still Life with a Plaster Figure,* [16] nevertheless mark the
stages of Matisse's preoccupation with the possible derealization of
planes and their irrational intrication.

The year 1896, with the series of seascapes,[17] must be consid-
ered decisive in Matisse's evolution outside of the academic frame-
work. The date is doubly significant since it is (without apparent
conflict) the year both of Matisse's official entry into the academic
structure (the Salon) and the year when his work seems to break
away most from the categories of academic instruction that he had

received. In the spring of 1896, shortly after Matisse's father had made the trip from Bohain to Paris to ask Gustave Moreau if his son really had any talent, and had left reassured of that fact, Matisse exhibited four paintings at the Salon of the Société des Beaux-Arts. Two of these paintings were sold, and Matisse was named an associate member of that organization by Puvis de Chavannes. Matisse thus found himself committed to the career of an orthodox painter under the auspices of Carolus Duran and Jacques-Émile Blanche. That same year, however, while traveling in the company of the artist Émile Wéry (an artist who had some familiarity with impressionist technique), Matisse met John P. Russell, an admirer and collector of impressionist art and a close friend of Monet.[18] Assuming that this anecdote is accurate, we note yet again that Matisse approached modernity from an altogether marginal angle, as it were. To be sure, he returned from this trip with a series of paintings that denote a certain confusion. The many complex problems that were engaging Matisse's attention at the time are clearly suggested by the series *Cliffs, Seascapes,* and *Grottos* at Belle Isle, 1896. Problems first of composition: the seascape, with its curves, can offer him no pretext for the formal use of straight lines and angles that he had demonstrated in his interiors and still lifes. In his attempt to schematize his composition, he almost always arrives at circular effects (he paints not the sea but coves); edges and angles (corners) thus create a set of difficulties that remain less resolved and more visible in these paintings than in any of his subsequent works. Second, there is the famous issue of perspective. Bouguereau had told Matisse, "You are sorely in need of learning perspective." In this series the flattening out of planes that interested Matisse literally brings to the surface—by the very awkwardness of the composition—a problem that had only been hinted at until that time; the horizon is presented not far in the distance but high on the painting. Just as the table top in the *Blue Carafe* (1895) is sharply inclined, so too the seascape, drawn upward, seems to stand erect and to collapse on the plane of the canvas in such a way that one almost expects the gray of the sea to overflow any moment onto the thin strip of earth that separates it from the edge of the painting and to come spilling onto the floor. Matisse described this series in a very negative way: "A gray and deafened sea, the phantoms of some rocks drowned in the rain, a shapeless foreground of colored

lichen."[19] He did not, however, destroy the series. On the contrary, it both prepared for his departure from the Beaux-Arts and announced such paintings as the famous *Dinner Table* (*La Desserte*) of 1897[20] that would scandalize the Salon.[21]

Started at the beginning of the winter, that is, *before* the exhibition of the Caillebotte bequest (the exhibition at the Luxembourg museum was more or less contemporaneous with the opening of the Salon), this painting marks not only the definite transformation of Matisse's palette but his decisive entry into a modern problematic. And the members of the Salon made no mistake about it; although the composition respected academic canon (in defense of the painting, Moreau would tell George Desvallières that the carafes were painted with such conviction that you could hang your hat on their glass stoppers), the jury nonetheless accepted the work only after much deliberation. With this painting, one can be certain that Matisse had seen impressionist paintings even though, as with his earlier works, the question is not so much *what* he had seen of modern painting as what he had seen *in* it. The formal shifts that might have passed for awkwardness in the seascapes of 1896 are here replaced by the positioning of a point of view; the transformation (a more superficial one) of stroke and palette indicate Matisse's familiarity at that time with modern painting, with the impressionists especially, rather than Cézanne. In retrospect, Matisse would himself define far better than anyone the limits and promises of this painting. In response to a question by Margaret Scolari (in Paris, June 1931) he recalled: "The public discovered that I had microbes at the bottom of my carafes."[22]

Georges Duthuit is correct in insisting that Matisse did not have a revolutionary "temperament." He became a painter with the same serious conviction with which his parents had become grain and drug merchants: "Like my parents I hurried to get to work." Accordingly, it is likely that the jury and the public's opposition to his painting was not without consequence for his work (given that reactionary stupidity always seems to lead inevitably to the radicalization and acceleration of that which it might have restrained). Although Matisse was not a revolutionary, the "seriousness" of his work would suggest that his productive energy was in no way discouraged by this incident. To pursue Matisse's own image, we might say that the stupidity of the "salonnards" precipitated the rise

of the "microbes" from the bottom of the carafe to the stopper and right up to the paint brush. The obligations, aspirations, and craft of the artist changed radically from that moment on. He was suddenly in a position to see and to understand what he had seen; and it was at this very moment that the Caillebotte bequest was exhibited at the Luxembourg museum.[23]

Modernity's Creative Contradictions

This moment in Matisse's career is a particularly important one for understanding what would continue to distinguish this artist from his contemporaries. If his nomination as a member of the Salon of the Société des Beaux-Arts initiated Matisse into an academic career, the "event" of *The Dinner Table,* a mere six years after his enrollment in the Académie Julian, forced him to disengage himself from the academy without, however, abandoning his study. The remarkable acceleration that then took place in his work was that of a student discovering all the significance of a new field of inquiry. This was not the impatient modernist rush that would produce the idiosyncratic mannerisms of the avant-garde, but a quasi-systematic assimilation of everything that impressionism had made possible. Matisse became as attached to the modernist school as he had been to the academic school, and with the same rigor. After this moment, he probably attended all the shows in Paris at Durand-Ruel's and at Vollard's. At the end of that same year, he visited Rodin's studio in the company of Manguin, and met Pissarro there. From this date on, Matisse's interest in modern painting can be clearly traced. On Pissarro's advice, Matisse went to London on his honeymoon in order to see paintings by Turner. It was Pissarro, too, who encouraged Matisse to study Cézanne; Alfred Barr quotes the following remark by Pissarro as reported by Matisse: "Pissarro: Cézanne is not an impressionist because all his life he has been painting the same picture." (Matisse here explained that Pissarro was referring to the "bathers" picture which Cézanne repeated so obsessively, and he added: "A Cézanne is a moment of the artist while a Sisley is a moment of nature.")[24]

The precise distinction that Matisse reveals between a Cézanne and an impressionist undoubtedly was, and would remain, a determining factor in his attitude toward his own work as a painter. This

distinction, which he never explicated, constantly reappears in Matisse's remarks as a reminder of the importance he continued to attach to the work of Cézanne. The notions that this sentence brings into play are, to say the least, ambiguous (although the "moment of the artist" and "moment of nature" accurately represent what Matisse sought to elucidate in all his texts and remarks). "A Sisley is a moment of nature" clearly refers to impressionist painting and theory, and we know what Matisse thought of the "plein-air" artists. The sentence can only be read in terms of the opposition that Matisse stresses elsewhere between "plein-air" art and the art of the museums, with which he was familiar thanks to the guidance of Gustave Moreau (to whom he continued to remain grateful). On the other hand, was it not Cézanne (who painted a moment of the artist) who said that his ambition was "to make something that would be like the art of the museums?" The distinction that Matisse draws is indeed already heavily biased by a Cézannean perspective. Until the very end of his life, Matisse would reaffirm that a painting is a moment of the artist, thereby insisting on its not being a *copy* of nature (the ambiguity of this statement derives from the use of a naturalist definition of nature). He would also contrast what the artist learns while painting a picture (the knowledge derived from practice) with the painting as specular work, as a window-mirror "open" onto the world.

By choosing 1906–7 as the beginning of the great permutation in the artist's practice—in addition to the exhibition of *The Dinner Table* at the Salon of 1897 and the exhibition of the Caillebotte bequest—we draw attention to the systematic study of impressionist painting as well as the work of other artists that allowed for this decisive transformation in Matisse. In *La Phalange* (1907), Apollinaire reports the following remark by Matisse: "I have never avoided the influence of others . . . I would have to consider this an act of cowardice or lack of sincerity toward myself. I believe that the personality of the artist develops and asserts itself through the struggles that it has to undergo . . . If the fight is fatal and the personality [of the artist] succumbs, it means that this was bound to be its fate."[25] At the time we are referring to, Matisse had certainly discovered the impressionists and modern painting already, but he had also discovered, we might say, the manner in which he was attracted to this kind of painting and the way in which he had come

to understand it. In other words, it was the time when he not only understood the technique but understood how and why he understood it. As Raymond Escholier puts it: "It is the period when Matisse is in the habit of declaring in an always somewhat solemn voice: *Cézanne is the master of us all.*"[26]

Both this transformation and the artist's awareness of it need to be defined. We have seen how from the start Matisse found himself becoming a painter and evolving within that discipline almost inadvertently, in terms of various accidents, primarily of a biographical nature; his exposure to and recognition of impressionism is similarly predicated on chance. While his empirical experience was to some extent that of any artist, it is nonetheless certain that one of these "accidents," determined by both biographical and psychological elements, would to a degree precipitate in Matisse a decisive return on the conscious level to an unconscious level of practice (the "incident" of the Salon of 1897, no doubt). If, on the recommendation of Pissarro, he devotes his honeymoon to Turner's painting, it is because "it seemed to me that Turner must be the passage between tradition and impressionism. In fact, I found the use of color for construction in Turner's watercolors closely related to Claude Monet's paintings."[27] Here Matisse squarely insists upon the rational character that would mark his work from that time on. The idea that must be stressed in this statement is that of a "passage between tradition and impressionism;" it recalls Pissarro's statement of the same year, "Cézanne is not an impressionist," and prepares us for Matisse's later affirmation, "Cézanne is the master of us all." This was the turning point in Matisse's understanding of his own artistic evolution.

In thinking through this "passage," Matisse would pause to examine in sequence or, on occasion, simultaneously Turner, Monet, Manet, Van Gogh, Rodin, Gauguin, and Cézanne. At the time he was working on the radicalization of "construction through color" that he found in Turner, Monet, and Gauguin and that he practiced more or less successfully during the year 1898. A painting like *Sunset in Corsica* (1898),[28] is significant for the way the artist, in his very practice, tackles the problematic of his passage. Everything in this painting is determined by Matisse's project of constructing, through color as well as by the subject matter he chooses, a sunset—that is to say, the constructive (constitutive) effects of light

and color. Despite some awkwardnesses, this is a very important painting; it permits us to understand how and why Matisse would occasionally abstract elements from the tradition of painting he had been taught toward an experimental and progressive end. The limitations of this painting are, to my mind, closely linked to a misunderstanding (due to a lack of awareness) in Matisse's practice in 1898. Having not yet identified the different moments of the *passage* between tradition and modernity (for lack of familiarity with Cézanne), he was in effect drawn to a brushed "plein-air" radicalism that forced him to pass mechanically from one technique (a traditional one) to another (impressionist). In the following years it was the mastery of the practice of painting in its totality, organized around the passage of modernity, that would allow Matisse—at the very moment when he managed to abstract the tradition of painting—to structure the dialectical forces which, in the 1898 painting, he had only sought to understand. The specific expertise of Matisse's practice lies in this dialectical achievement.

While we must be careful not to speak of anticipatory work, at this moment in the artist's production we can already identify very clearly just how this system, which was in the process of finding itself and finding its articulation, was tied to the artist's biography. (In one way or another, the absence of a soundly developed theory or, if one prefers, the necessary empiricism of the artist's critical reflections would always imply this biographical return, but in a more general and on the whole secondary way.) For the year 1898, and until the first years of the twentieth century, we must look at Matisse's painting alongside his biography in order to define the paths and understand the order of this complex and intelligent practice. Thus we note that at the very moment in his painting when (with the aid of Turner) he was charting the passage from tradition to impressionism, he bought a painting by Cézanne which he had discovered during one of his visits to Ambroise Vollard, the art dealer. Gaston Diehl, recalling a personal conversation with Matisse, tells us that Matisse thought back to this Cézanne while painting on the banks of the Garonne River: "The very scene of soldiers sporting in the river reminded him more particularly of another Cézanne, a small painting of *Three Bathers* in which the hierarchical structure of everything was so well composed, and the trees and the hands counted as much as the sky. He had discovered

it at Vollard's during one of their discussions; it was turned toward
the wall and had probably been standing there since the second big
exhibition of Cézanne's work. For the first time he noticed in that
work "the strength, the harmony of the arabesque blended with the
color and the firmness of the form."[29] Matisse kept this Cézanne
painting until 1936, when he gave it to the Musée de la Ville de
Paris. It was then that he wrote to Raymond Escholier: "For the
thirty-seven years that I have owned it I have come to know this
canvas fairly well, so I would hope; it has given me moral support in
the critical moments of my career as an artist; I have drawn my faith
and perseverence from it."[30] Georges Duthuit notes that "Céz-
anne's work, before intervening as an element of rupture, would
have the value of a stimulating contradiction and still more,"[31]
which is a good way of defining the precise moment when Matisse
"thinks back" to the painting he had seen at Vollard's. The interven-
tion of Cézanne (in 1898–99) stands as a stimulating contradiction
at the very heart of impressionism, and it is only in the years to
follow that Cézanne's work would establish on the one hand the
hierarchy of the "passage" from tradition to impressionism and, on
the other, the productive negation (the rupture) so fiercely sought
after by impressionists, preimpressionists, and postimpressionists
alike.

The "Cézannean antagonism" that Matisse thus discovered with-
in the texture of impressionism transformed his practice almost im-
mediately. He abandoned the limited field of "passage" from one
tradition to another and rediscovered a historical dimension in a
productive, critical form. Just as Cézanne had sought to remain at-
tached to the history of painting, to produce something that would
be "like the art of the museum," and, inspired by Poussin, wished to
create works that were like "living Poussin," Matisse found in
Cézanne the way to dialectize the productive effects of modernity
with the history that had produced it. Cézanne, as George Duthuit
points out, would first of all allow Matisse to take his distance from
impressionism, to reassess construction through color outside of a
"plein-air" framework and, finally, to use that construction not for
the reproduction of a naturalist phenomenon but as a "moment" of
consciousness. This is the direction in which Cézanne was leading
him.

Matisse darkened his palette for a short while around 1900 and

turned to still darker and more mixed colors (the combined use of dark blues, greens and purples—of browns, burgundies, reds, and oranges). This is most striking in the *Male Model* or *Bevilacqua* (Pierre Matisse collection), *Nude with Pink Shoes* (G. Daelemans collection), *Still Life with Chocolate Pot* (Alex Maguy collection) and *Interior with Harmonium* (Cimiez museum). In the first two of these pieces it is clear, as Matisse himself remarked, [32] that he was influenced by Cézanne, who was himself marked by Courbet; similarly in the *Interior with Harmonium* the use of a point of view to determine the composition has as its echo the formal articulations of Manet.

One could continue endlessly tracking down the work of synthesis that Matisse undertook during these years. To this work he added the reading of Signac's "From Eugène Delacroix to Neo-impressionism," an essay that appeared in 1898 in the *Revue blanche.* The pointillist experiment occupies in Matisse's work a particularly significant place well worth situating. Only Signac, delighted at finding in Matisse a disciple of such mastery, could have misinterpreted it. The artist's system was already well established, and Matisse embraced pointillism or neo-impressionism in just the same way he had taken on impressionism, with the difference that he now had at his disposal the experience and the work that would allow him to glean, from the new techniques he was attempting, more information with less delay. This pointillist phase confirms Matisse's will to dominate all the techniques of "modernity"; the theoretical implications and scientific pretensions of pointillism, however, distinguished this practice from all others. It is remarkable that Matisse, who frequently returned to Cézanne's warning, "Beware of influential masters," never hesitated to confront them himself, and this without the least ill effect. The encounter with pointillism is of interest precisely because in presenting Matisse with a theory that was not really a theory (a kind of positivistic and scientistic theory), and one for which he did not really possess the philosophical means to engage in thoroughly, pointillism led him to reflect upon and justify his work from an entirely subjective point of view: the artist's emotion, expressivity, and so on. This might be considered the most lasting effect of Matisse's confrontation with neo-impressionism. His resistance to the pointillist discipline is carefully elaborated in an interview with Gaston Diehl in May 1943:

"For me, this didn't work at all. Once I had established my dominant tone, I couldn't help reacting to it as violently as I did. I was in the middle of making a small landscape with dabs of paint, and I just couldn't produce the harmony of light I was looking for through the prescribed rules; I constantly had to start everything over . . . Cross, who witnessed my futile efforts, observed that I ended up producing contrasts as powerful as the dominant tone in my paintings, and he told me that I wouldn't be able to stay with neo-impressionism much longer. Indeed, several months later, while working in front of an exhilirating landscape, all I could think of was making my colors sing, with no regard at all for the positive and negative rules. I started composing from that point on with my drawing in such a way as to enter directly into the arabesque with color."[33]

One cannot help but hear the Cézannean echo in these remarks. Similarly, in the bathers of *Luxe, calme et volupté* (1904–5) as in those of the *Joy of Life* (*La Joie de vivre*) (1905–6), the reference to Cézanne is repeated and reaffirmed. Matisse stopped short of the pseudotheory of the neo-impressionists, it seems, because of the scientistic reduction that it imposed. What characterized, on the other hand, Cézanne's influence on Matisse, and the importance that Matisse accorded to Cézanne, was, for Matisse as for Cézanne, the refusal of any kind of "modernist" reduction. "A young painter, knowing full well that he cannot invent everything, must above all *organize his brain by reconciling the different points of view* of the beautiful works of art that impress him *at the same time as he interrogates nature.* Once he has acquired the *awareness* to understand the means of expression at his disposal, the painter must ask himself the question 'What do I want?' and then proceed in his search from the simple to the composite in order to discover the answer."[34] Gustave Moreau's often repeated remark about Matisse, "You will simplify painting," is misleading; to accept it at face value is to content oneself with only the most superficial effects of Matisse's work. Matisse did not simplify painting, far from it. He carried it to its most extreme point of elaboration and complexity. It was the simplification of "plein-air" that helped Matisse understand the importance of the art of the museum. For him as for Cézanne, the avant-garde could not be reasoned either against or outside of history. It was the limits of scientistic simplification that made him abandon neo-impressionism just as it would be the nar-

row rationalistic limits of cubism that Matisse's paintings would implicitly comment on and criticize around 1915.

The many variations that Matisse undertook in his didactic course through impressionism could serve to demonstrate, if necessary, both the irreducibility of these variations to any single school and the complex diversity of the problems raised by pictorial practice at the end of the nineteenth century. Any attempt to consider and understand this diversity in its entirety, to think through the complex whole in each of its parts, would demand the formal elaboration of a system. We have just seen how Matisse set about to search for and define this system during the first ten years of his career; moving from that basic system, we may now establish the theoretical scenario of Matisse's work, its limitations and its success.

2. PAINTING AND "THEORY"

With and Against Theories

The writings, the more or less published (quoted) letters of Matisse, and his reported remarks are numerous to be sure, but they vary all too often in quality. As we have just seen, Matisse's experience with neo-impressionism put him on guard against scientistic reductions, against what he called theory: "I feel the need to keep my distance from all theoretical ideas."[35] The different theories that presented themselves did not respond to what he had learned in his craft as a painter, and consequently it was Matisse's faithfulness to his practice that alienated him from these theories. It remains that such a context (empirical theory and subjective practice) was not capable of reducing the contradictions that constituted it. And it is these same contradictions and misunderstandings that we should examine more closely. As Matisse attached himself to the various schools and movements that founded modern painting, not only would he assume the contradictions and misunderstandings that constituted this painting in modernity, but he would furthermore devote all of his energy and the force of his work to them. They alone would account henceforth for his evolution and his regressions.

Theoretical rationalism could not account for Matisse's practice,

and so Matisse, with the conceptual means he had at his disposal, turned to the idea of irrationality—that is, to his "artistic temperament." It was with this notion that the productive aspect of his practice would most often be confused—a confusion that raises a series of problems that we shall return to shortly.

It is thus neither as a direct consequence nor by accident that Matisse became a "fauve" when he abandoned neo-impressionism (*Luxe, Calme et Volupté* is dated 1904, while the *Woman with the Hat* dates from 1905). The personal program that his practice as a student and young painter systematically traced implies the irreducibility of painting to any of its various aspects; this is equally true of the rationality that everywhere informed the arts at the end of the nineteenth and beginning of the twentieth century. To protect himself from diverse positivistic tendencies, Matisse had as his only defense the "quality" of his painting, and the old, traditional, and quasi-religious notions of the great unanswerable questions on art. Curiously, it is easy to see how this necessary return to a reactionary ideology might satisfy Matisse the "subject," son of a petit-bourgeois grain dealer, diligent in his work and driven to social success by his father's "Hurry up!"

All this took place in the course of the first years of the twentieth century, and not during the *belle époque* of the master craftsmen of religious art; against the backdrop of the Industrial Revolution and its transformations, the various ideological, rationalistic, and positivistic upsurges were, and still are, representative of progressive forces. We have a fine example of this with cubism, whose development would have repercussions very different from the work of Matisse. It is worth recalling that these two pictorial systems were not only contemporary but in many respects linked; Braque, for instance, from 1907 (the year of the *Landscapes at La Ciotat*) to 1908 (the *Large Nude*) made the move from fauvism to cubism, and his *Nude* of 1908 contains certain allusions to Matisse's *Standing Model* of 1907 (Carlos Martin collection). The importance that was initially accorded to the cubists as opposed to Matisse clearly illustrates the "rational" character of the (then dominant) ideology of progress, at a time when Matisse found himself taking a stand that could only seem anachronistic. The way in which the avant-garde, and particular the literary avant-garde, seized upon cubism can be analyzed in terms of the empirical prac-

tice that was its own, a practice most often blinded by a previous ideology that it radicalized into revolutionary effects. Here we touch upon the very problems that constitute Matisse's system and practice. All the polemics that developed around Matisse (including the position of Gertrude Stein) are inscribed within this perspective; and the hasty recognition of the artist's importance in opposition to the avant-garde has produced similar misinterpretations within this field of inquiry.

As for the more or less metaphysical claims that one finds scattered in the texts and declarations of Matisse, they must be situated within the context of an ongoing struggle between two empirical effects of science, neither of which has at its disposal the necessary conceptual apparatus to reduce the contradictions that blind them. On the one hand, cubism: rational will seeking to reduce the field of inquiry for the practice of painting. On the other hand, Matisse: a practice whose complexity, for want of the theoretical tools to think through its rational production (in terms of a new rationality), is ultimately drawn to metaphysics. These two artistic stands are absolutely contemporary with one another and not unrelated, although the complexity that determined Matisse's work had, at this moment, more to gain in the confrontation with cubism's rival rationality than had cubism, which by virtue of its practice was locked into the impossibility of integrating discourses other than its own. This rivalry, if we can use such an antagonistic term to define the relationship between Matisse and the cubists, must have been a productive one indeed for Matisse. In effect, though Matisse often had recourse to vague notions that relate to a quasi-religious point of view, he never abandoned the complex totality that constituted specifically and historically his artistic practice; and even though he was only half conscious of it, this totality inevitably implied a reflection upon the system that permitted him to understand it as a total product. Thus, whatever the ambiguity of Matisse's formulations, his texts remain nonetheless, of all the texts by modern painters, those that best permit us to understand the nature and extent of the problems that faced the modern artist at that time.

Even in their mutual respect for Cézanne as well as in their treatment of the relations between painting and the models outside the tradition of Western art (African masks, etc.), Matisse's approach and the cubist approach remain quite distinct. Cubism borrowed

from Cézanne and from the African mask formal mannerisms with-
out specific concern for the origin of these forms, for what they
conveyed, or for the consequences of their appearance at a given
moment in the history of painting. We have already seen the impor-
tance Matisse attributed to Cézanne from a formal point of view of
course, but also from the specific point of view of the active trans-
formation that his formal development effected within a history.
Matisse writes, "Cézanne said: 'Beware of influencing masters';
Cézanne had no reason to be afraid of being influenced by Poussin
for he was sure not to take on the external appearance of Poussin,
whereas when he was touched by Courbet, like other painters of
his period, his work smacked too strongly of Courbet. So after this
period that whole group of painters went in the opposite direction:
Courbet had painted dark pictures, so the impressionists, who had
originally been his imitators, used the colors of the rainbow in-
stead."[36] Matisse's program, and the way in which he perceived the
history of painting, are presented here with careful precision: one
must not take on the "external appearance" of Poussin, Courbet, or
even Cézanne. Nevertheless, Matisse would never abandon Céz-
anne's stated ambition "to make something that would be like the
art of the museums"; that ambition responds to the transformation
of the past both in the *negation* of certain characteristics and in the
production of a new and different *quality:* "A painter who is sen-
sitive cannot lose the contribution of the generation that precedes
him because this contribution is within him, despite himself. He
needs nonetheless to detach himself from it so as to contribute in
his own turn something new."[37]

As for the borrowings from models outside of Western art, in
Matisse they never have the direct tacked-on, pasted-on quality that
they have, for instance, in Picasso: "Critics have been struck by the
very clear resemblances that exist between the *Demoiselles d'Avig-
non* and Iberian sculpture, notably from the point of view of the
general construction of the heads, the form of the ears, the shape of
the eyes."[38] This is how Matisse justifies his borrowings: "The
young painter who cannot disengage himself from the influence of
the preceding generation is slowly sucked in. To protect himself
from the magic spell of the work of those immediate predecessors
whom he respects, he may seek new sources of inspiration in ob-
jects produced by different civilizations."[39] A more complex state-

ment, to be sure, and one that justifies the borrowing of other contributions within the order of a transformational practice. Nevertheless, this statement does not respond practically to what it suggests as a theoretical necessity. In this text (on color), Matisse speaks of affinities between the artist and the different civilizations from which he will draw his samples of "inspiration," or "sincerity" as they relate to his own "profound feeling," etc. In other words, he is looking for a vocabulary that will allow him to go beyond the mechanistic explanation of the artist's evolution as solely conditioned by formal transformations. The terms he uses are, from the start, psychological: "The young painter who cannot disengage himself . . . to protect himself from the magic spell . . ."; they presuppose the completely irrational determination of painting. We have already noted the circumstantial conditions in which Matisse was himself drawn to the choice of a career as painter rather than lawyer (the appendicitis, the gift of paints from his mother, etc.). Clearly something occurred (or recurred) here that Matisse would never get a firm grip on, but to which he would not be limited. Matisse's entire development seems turned toward this point of origin, toward this question that fascinated him but by which he would not allow himself to be blinded; and just as he worked hard learning the craft of each of the painters who had preceded him, at the same time he never stopped questioning the irreducibility of this "origin" and the need to be aware of it—more precisely, the need to be aware of the method that this irreducibility dictated.

Matisse's project was not a didactic one, and the remarks he made should be understood as translations, more or less precise, more or less vague, of his "personal" practice of painting. Matisse's writings are neither lessons nor substitutes for painting—they are translations of painting, and it is finally to painting that they must refer. We might say then, that in the way they present themselves, they are effects of consciousness; effects found inevitably in many artists but which, in Matisse, in the complex field of reference that they set into play, acquire an exceptional quality. These writings and references are in some way of the same order as the recourse that Matisse had to what he calls "the objects of different civilizations." They are the cultural "exteriority" thanks to which, again to quote Matisse, the artist can escape "the magic spell" of his history ("to protect himself from the magic spell of the work of his imme-

diate predecessors"). We note that the psychological justification
that Matisse provides is, like most of his remarks, at once per-
suasive, exact, and unsatisfying to the extent that it contains a delib-
erate exaggeration that makes him say something more and some-
thing other than what it really suggests.

The Fragmented Body

It would seem that the different types of relations that modern
painting has entertained with non-Western cultures and arts (im-
pressionism and postimpressionism with Japanese etchings, cubism
with African masks, Matisse with the Orient: "My revelations always
came from the Orient"[40]) have never been adequately investigated.
And although there is no shortage of dissertations on this theme,[41]
they are far more likely to minimize or to avoid the problem than to
examine it. This is in part due to the fact that approaches to this
question are treated either by literary people (philosophers, so-
ciologists and other writers) or by art critics. In other words, in the
first case it is studied with the aid of a discourse that deliberately
ignores the specificity of the discipline of painting that it examines,
and in the second case it is studied with the aid of formal or histor-
ico-formal analyses that at best reduce to abstraction all the rela-
tions that painting inevitably shares with every field of knowledge.
On the one hand, an irrational, metaphysical discourse and on the
other, an approach determined by a mechanistic type of rationality;
these are the two types of investigation. Such also are the contradic-
tions at work in the practice of Matisse—so much so that the artist
cannot help but evoke them constantly in an attempt to both recon-
cile and resolve them.

Rather than repeating the clichés of the "end of civilization" or
"endurance of the history of Western culture" sort, we had best try
to situate the phenomenon in question as accurately as possible
within the framework of the history that produced it—that is, the
end of the nineteenth century and beginning of the twentieth—or
in the context of the ideological consequences that resulted from
the economic upheaval known as the Industrial Revolution.[42] The
revolutionary transformation of the means of production and its
ideological repercussions determined in the order of signifying
practices a "theoretical" reassessment that confronted these prac-
tices at different levels of their social activity and implicitly ques-

tioned and problematized their autonomy. ("Whether we like it or not, and regardless of how much we insist upon our state of exile, a bond of solidarity exists between us and [our historical epoch]").[43] Although it has constantly been presented as the background and objective of the history of modern painting, this problematic has never been addressed adequately. And it is from this critical lack of focus on the autonomy of pictorial practice as a signifying act of production that all the misunderstandings have arisen.

One might say very generally that this way of privileging ('empirical) practice over critical ("theoretical") articulations has produced, within the signifying practices that are under consideration, the hypostasis of one of the organs of the body: the ear for music, the eye for painting, etc. "Modernity" thus appears first as a fragmented body, with the top separated from the bottom (intellect from sexuality) but also with the various dissociations of smell, hearing, sight, gesture, and so on. The dissociated list can accordingly be grasped only in the always fragmentary idea (in the translation, in the ideological mirror) that it produces of itself. With the division of labor, the overdetermined and fragmenting economy, the body leaves an economy based on the least expense merely to fragment its own economy and find itself given over unconditionally to the overdetermination of the dominant ideology. The revision that modern painting operates on its formal determinations is totally caught up within the order of contradictions that overdetermine the entire ideological field (the fragmented body). Each discipline tries to dispose of the means (of "scientific" practice) that will allow it to think through its specific transformation in terms of the economic revolution; each discipline is thus inevitably drawn to ponder its evolution in terms of the criteria of truth (changes conceived of as quantitative augmentation or reduction, or as simple displacement) that the bourgeois modernist ideology conveys. Historically, we might say, this ideology (active as we find it in the discipline that preoccupies us here) is defined by the alliance of metaphysics and mechanistic philosophy with idealism, an alliance that is particularly well demonstrated by positivism. At the very moment when, trapped within the confines of the Industrial Revolution and the ideological decentering that this revolution supposes, a given practice is compelled to return to the structures determining its own specific mode of production, the "scientific"

criteria that it finds—which relieve it from the philosophical (and political) question—would seem to efface the decentering of that same practice by paralyzing it within the closed field of an illusory autonomy.

Here we touch on the central contradictions facing all of modern art. All the complex effects of the practice of modern painting may be drawn together to be read from the perspective of these several eccentric phenomena. However confused the statement of the problem may be, modern literature with Mallarmé and Lautréamont goes straight to the heart of the question of the history of language and the history of thought. Nor is this surprising, since even from the most mechanistic point of view, literature acknowledges its material support (given that its material support, irreducible to mechanistic effects, contains the history of thought as well). It is easy to see how painting would run across a different set of difficulties when put to the same test. Its relation to the dialectical production of the history of language and the history of thought is of a more ambiguous and indirect mode. Jacques Derrida, in his essay on Mallarmé,[44] circumscribes the origin of this gap: "As of this point, the appearance of the painter is prescribed, absolutely ineluctable. The way is paved for it in the scene from the *Philebus*. This other 'demiurge,' the *zōgraphos*, comes after the *grammateus*: 'A painter who comes after the writer and paints in the soul pictures of these assertions that we make. The collusion between painting (*zōgraphia*) and writing is constant. Both in Plato and after him.' "[45] The role attributed to the painter and his place in the history of thought can only be determined from the perspective of the history of language and philosophy. It appears that modern painting, in reflecting mechanistically on its apparent means of production (its material), would not find within itself any of the necessary tools to operate an ideological deconstruction of the network within which it was caught. Consequently, at the very moment when the contradictions that sustain the painter lead him to break—unknowingly perhaps—with the role attributed to him by the *grammateus,* he continues to maintain that metaphysical relationship by taking refuge rhetorically in *his* grammaticality. This awkwardness and its related rhetorical, formalist embarrassments can be read in the displacements, leaps, bounds, changes, and convulsions that mark a history of painting that has continued to main-

tain the (specular) dichotomy: writer/painter. The conceptual translation of reality that is implied in the mode of phonetic writing[46] inevitably closes the painter off within the narrow field of a metaphoric (specular) fantasm. If the order of social discourse that he illustrates no longer implies, or can imply, as a *cause of seeing* that serene perspective on vision that Nietzsche called "what happened in the invention of the 'subject' and the 'I'!"[47] the metaphoric reproduction is then reconverted as evidence of the subject's sensory experience—here optical. Perspectival illusion having disappeared, landscape is crushed, and the painter with his monstrously expanded organs of sight remains, one might say, tied to his own "subject." *Abstraction* drawn from reality: these are once again "precisely" the transcendental "notions" of the subject that the artist seeks to represent. The contradiction that is implied in the mechanistic and mechanical assessment of the material means of production in painting and the metaphysical perspective on the pure idea of the subject inevitably produces in the artist's practice transformational effects that can be evaluated and converted within the field of modern "theory." We may add that as an empirical practice dominated by a reactionary ideology (of Western metaphysics as transmitted through the subject and the self), painting demonstrates its progressive effects only through biographical accidents (ruptures within the subject) that come to disturb the order of economic division presupposed by the assimilation of the subject and the forcefully provoked eye.

Familiar Strangeness and Foreign Relations

This long detour seems to have taken us away from the work of Matisse and from his relationship with cubism and with the contributions of modern painters working within cultures that were more or less (generally more than less) foreign to them.

The central question of the *zōgraphos* and the *grammateus* in fact haunts the "revolutionary" practice of modern painting. As for the distance or belatedness of painting in relation to language (which paints in the *mirror* of the soul images that correspond to words), the modern painter is in a way unconsciously drawn to return to this, by appealing empirically to models and "movements" outside his problematic. The "theoretical" void characteristic of the pictorial discipline invariably submits such

movements to the reductive pressures of the dominant ideology; but that does not prevent these movements from inscribing themselves, each time a little more precisely, within the practice of painting. The greater or lesser degree of awareness of the objective reasons determining cultural borrowings explains the continual transformations that these borrowings necessarily produce.

The cubist borrowings from African masks stemmed from a felt need among painters for a formal vocabulary that was not invested with the expressivity of any particular specularity; a system, in other words, that—apparently at least—did not respond for them to the Western hierarchy of word/painting. At this same historical moment the need was also felt for figures other than those that were known and spoken, for designs (and projects) without words. However, caught in the pseudorationality of its own formal production, cubism could in no way work through the determinations of its gesture philosophically, and before long it too reduced these cultural determinations to mechanistic, anecdotal effects, in a style that was limited to decorative repetition.

Matisse, on the other hand, caught in the historical compromise and formal complexity of the irrational effects of his practice, was constantly drawn to reestablish the "theoretical" gaps that were his own, taking as his point of departure the irrationality that he declared constitutive of painting. At the same time, Matisse was drawn to invest his practice with effects that were apparently foreign to it and to transform this practice in terms of that investment. Where the pseudorationality of cubism was reductive—reducing the cultural borrowings that it made to an order that was not its own—the irrationality for which Matisse made his claim extracted from these borrowings the plural possibilities of the diverse cultural textures that were at play.

While Matisse's own borrowings from other cultures are numerous (art historians are in disagreement as to whether Matisse might not have been the first to discover African masks), they never appear as such in his work. Matisse's interest in African masks, Islamic art, Persian ceramics and miniatures, Byzantine mosaics, Egyptian art, Eskimo masks, etc., is evident in many of the comments and writings of the painter: "Revelation always came to me from the Orient. In Munich I found a new confirmation of my research. Persian miniatures, for instance, revealed to me all the possibilities of

my feelings. Through its accessories, this art suggests a greater space, a truly plastic space. It helped me to go beyond an intimate mode of painting. In fact, this art really touched me quite late and I came to understand Byzantine painting while looking at icons from Moscow."[48]

Similarly, accounts by close friends and relatives of Matisse emphasize his interest in other cultures: "In his room . . . four enormous sculpted, gold-plated Chinese characters recall the interest that the artist always maintained in the problems facing the fauves: 'space, expression, decoration.' "[49] If, as George Duthuit maintains, these characters echo Matisse's interest in problems related to the definition of space, expression and decoration, they are equally reminders of Matisse's interest in the (Oriental) exteriority ("revelation always came to me from the Orient"), where writing, painting, and reality are of the same design. However, just as it is impossible to find a specific figure belonging to one of these foreign cultures reproduced in any given painting by Matisse, it is just as impossible to establish any analogy between Matisse's painting and Chinese painting. Personally, I would isolate these borrowings—which are far from innocent—as marks of the differential and exceptional character of Matisse's practice. What limits the productive character of a cultural borrowing (as was the case with cubism) is in a way far less dependent on the quality of what is borrowed than on the quality of the cultural network that adapts the borrowing; the larger and more complex that network, the more likely it is that the intertextual and intercultural articulation will unfold in multiple, interdisciplinary consequences: "the purpose of a painter must not be conceived as separate from his pictorial means, which will be the more complete (and by complete I do not mean complicated) the more profound his thought."[50]

I have emphasized Matisse's biography and years of apprenticeship at length because from the first, and for reasons that we must now examine, the programmatic field of his practical experience showed evidence of great complexity. A complexity that Matisse, we have seen, never sought to reduce, but used rather to establish for himself an irrational system. This is particularly evident in his encounters with, and passage through, the different schools and movements of modern painting. However, neither the lessons that can be drawn from a formal analysis of the artist's

works (as compared to those of his predecessors or contempo-
raries) nor Matisse's own consciousness of the borrowings that he
made from other cultures can speak for the productive force of a
system lacking an operative scientific base. In this vein, it must be
said that the book by Georges Duthuit that is devoted to the fauves,
particularly Matisse, a critique of temperament, is infinitely richer
in its anticipation of the developments that would account for
Matisse's work than many books written in the academic style (the
respectful biographies and formal analyses). Georges Duthuit's
book on the fauves situates the transformation of modern painting
under the sign of Chinese painting; he quotes Rivarol and Lao Tseu:
"It is between things rather than in things that one must look for
the essential." "The Song or Yuan landscape artist, rather than fix-
ing upon the definition of bodies themselves, seeks above all to
convey the atmosphere that surrounds them."[51] The dialectical ef-
fect that is indicated here is unquestionably one of the clues to
Matisse's production that would eventually serve to theorize it
scientifically.

Here we might note that if the irrationality that determines
Matisse's career as a painter holds true for all the artists of his gener-
ation, not only does Matisse deliberately make the effort not to lose
this programmatic irrationality *from view,* but he goes out of his
way to use it in his work (that is to say, he attempts to rationalize it
to some extent in the productive order of his signifying practice).
He does this in such a way that he can include all the specific effects
in his work, however irrational they may be (including color and
line). This "view" that Matisse maintained, and that he would never
cease to maintain, was the awareness that gave him his precise vi-
sion. Nor would he ever give up that "weird flower that breathe(d)
perfume upon his lucid life, that in his infancy grafted upon his
soul's blue filigree,"[52] the force that he could not define but which
prodded him on—"a force that I perceive today as alien to my life
as a normal man." In 1939 he states in a similar vein: "I work with-
out a *theory,* I am only aware of the forces that I use."[53] In many
ways, and more clearly no doubt in the later years, Matisse's decla-
rations repeatedly introduce the inevitability of the biographical
element (event): "Rules have no existence outside of indi-
viduals."[54] Although the meaning of this sentence seems perfectly
clear, it cannot be used to reduce Matisse's practice to any kind of

artistic subjectivism. Matisse, the individual who makes claims for his own particular nature in 1908 (how could he do otherwise at the time?), would remain the test case of the artist aware of the need to know the "forces" with which he engages. We thus find, in the same text from the *Grande Revue* in which he makes his individualistic claim, the reverse suggestion: "An artist always has something to learn from being informed about himself." Matisse proceeds with his investigation by directly confronting the artistic practice (his own) to which the theoretical questioning is intimately linked and of which it forms indeed an integral part. It could even be argued that just as with the diverse cultures that Matisse encountered and assimilated more or less empirically, this investigation belongs to the artist's general system along with the productive borrowings that were linked to the radical transformation of the signifying practice of modern painting—a new kind of scenographic writing with no other resemblances, no other image.

From the moment the artist became aware of the cultural "spell" that he must avoid, Matisse's practice leaped dramatically beyond the chronological (programmatic) order that it had followed until that time. In mastering the work of the painters who had preceded him on the path of modernity, Matisse addressed himself to the "origins" of the modernity of his culture and the relations of similarity and strangeness (familiar strangeness) that his culture maintained with Oriental culture. In March 1906 he traveled to Algeria and visited Biskra, where he was particularly struck by the fabrics and the ceramics[55] (from 1909 to 1913 he would spend all his winters in Algeria and Morocco); in 1903 the "Exhibition of Islamic Art" at the Musée des Arts décoratifs "awakened in Matisse both the taste for pure tones and the feeling for the colored arabesque";[56] in 1907 he traveled to Italy, where he was excited to discover Piero della Francesca, Giotto, and Duccio. Matisse would remark much later to Raymond Escholier: "I never saw Gauguin. I instinctively fled his rigid theory, for I was a *student of the galleries of the Louvre* and I had gathered from them *an awareness of the complexity of the problem* that I had to work out in relation to myself; I was afraid of doctrines that were like passwords. I was not unlike Rodin at the time who said 'Gauguin is like a "curiosity" . . .' I returned to his work later, when *my studies* let me see where Gauguin's theory had come from. I could even add to Gauguin's theory Seurat's theory of

contrasts, the simultaneous reactions of colors and the effect of their
luminosity. All this is powerfully present in Delacroix, in Piero della
Francesca—in a word, in the European tradition and in part in the
Oriental tradition."[57] The confessional statement offers us a virtual
x-ray of Matisse's itinerary in all its various stratifications, overdeter-
mined as it is by the self-consciousness of the painter-subject: "in
relation to myself."

It is worth pausing here to consider the productive structure that
the artist put to use once he began to feel capable of mastering the
work of "the generation that preceded him." What does he mean in
fact when he says that the young painter, "to protect himself from
the magic spell of the work of those immediate predecessors whom
he respects, may seek new sources of inspiration in objects pro-
duced by different civilizations," when on the other hand he ob-
serves that certain aspects of Gauguin and Seurat's work "are
powerfully present in Delacroix, Piero della Francesca, in a word, in
the European and in part in the Oriental tradition"? Once again we
are reminded that Matisse is not, strictly speaking, an avant-garde
painter; the difficulties (the complexity of the problems) that he
encounters and resolves subjectively ("the eternal question of the
objective and subjective")[58] do not lead him to a hasty dismissal of
his own culture but rather to a more or less conscious elucidation
of its antagonisms and contradictions. He thus finds certain con-
stitutive features of modernity "powerfully present" both in the
history of his culture and in that of other cultures. It follows that
the "inspiration" that the young painter will seek in the produc-
tions of "different civilizations"—once again, we must not forget
that Matisse, the young painter, is an adult intellectually—is first
and foremost that which is *logically* "powerful" in his own work,
but which for some reason had been repressed at a certain histor-
ical stage.

Such an attitude necessarily calls for a new order and a new re-
structuring of productive forces. It is clear that Matisse continues to
stress something historical but that this history, for its lack of lin-
earity and chronology,[59] implies new and different relations of
force and a completely new range of thought. The rediscovery of
what was powerfully active in the European and, in part, Oriental
traditions opens up a new way of thinking about the European and
consequently a way of looking into Oriental culture with height-

ened awareness. That is, with a sense of the process of constant interferences, constant modifications, and constant transformations. Once might say that, in this process, Western culture gains what it had repressed and at the same time confronts the Orient to find a character, unrepressed, that may reveal what a culture always contains—more or less unconsciously—within itself.

Of particular interest to us here, given the empirical nature of the practice of this new "inspiration," are the subjective displacements implied by the new manner of dealing with "the complexity of the problem." Matisse himself says it almost literally: this could only take place within the problematic of a consciousness in search of itself. ("I had gathered an awareness of the complexity of the problem that I had to work out in relation to myself.") The awareness of the "in relation to myself" and of the productive irrationality that it set into play is the key to the artist's "forces." It may represent a psychological overdetermination, but it is one that is contained within a much larger framework, given that the artist himself makes a point of acknowledging it and of drawing wherever possible the necessary consequences: "One gets into the mood to create through conscious work. To prepare the execution of a painting is first of all to feed one's feelings through studies that are somewhat analogous to the painting; afterward the choice of elements can be made. It is these studies that allow the unconscious to surface freely."[60]

The Painted Woman

Just as he questioned and worked through the "program" of historical and formal determinations that govern modernity, Matisse, having arrived at this new historical scene by himself, would then go on to question, study, and work through the irrational determinations that had made him a painter. Matisse undertakes a double project: to return to the "cause of his vision" and to do so from the perspective of his position as "subject" and "self" ("in the relation to myself"). This is the contradiction that generates the very production of Matisse's work and the many antagonistic elements that his work constantly plays off.

At the very time when he confronted the many cultures to which he would compare his own, Matisse declared his unconditional admiration for Cézanne (according to Raymond Escholier, it was

around 1907 that "Matisse was in the habit of declaring in his al-
ways somewhat solemn voice: 'Cézanne is the master of us all' ").[61]
It was at this time that Matisse came to recognize the particular
importance of Cézanne, in part because of the Autumn Salon a few
years earlier (1904), where he was able to see the largest collection
of Cézanne ever assembled to that day (forty-two paintings); in ad-
dition, however, Matisse could also see in Cézanne's work the effect
of the constant questioning of the "cause of vision" that he himself
would later try to systematize. In this sense, Gertrude Stein is cor-
rect in saying that what Cézanne had produced by accident, Matisse
used systematically. If history and the Orient are then the instru-
ments of this system, they must be considered within the order of
thought that gives them this authority: the reflection of a subjective
consciousness that seeks in them its own reaffirmation in the very
gesture that contests it. Matisse's evolution finds in this "self-analy-
sis" its informing network. In a sense, it is no accident if most of
Matisse's statements about his practice show signs of the analytical
reasoning behind them. For instance, on the modern principle that
dictates the rejection of perspective—the emphatic display of pic-
torial planes and the plane of the canvas, the question of (another)
"depth," and above all, the multidimensionality of color ("these
colors, if they may serve for the description of things or natural
phenomena, contain in themselves, independent of the objects that
they are used to express, an important action"),[62] these formal ob-
servations are ascribed in Matisse's system with the multi-
disciplinarity that alone can allow them to be formulated into a
theory.

I would not want to imply here that I am establishing a neat line
of demarcation in Matisse's work, a before and an after, or a decisive
rupture that might have been determined by one or another event.
If I have emphasized Matisse's years of study, it is, on the contrary,
in order to mark the continuity that is specified in this painting.
Matisse remains a painter even when trying to figure out in his
study of the history of painting just how to become one. It is work
of this kind that allows him to discover laboriously that what
qualifies him and what qualifies his choices is not related simply to
the order of technical, optical phenomena; it is work of this kind
that leads him to think through the history of his discipline in a new
way. The first course that Matisse takes is a linear one that gradually

The Painted Woman

builds into a historical network (Duccio, Giotto, Piero della Francesca, Poussin, Delacroix, Gauguin, Seurat—the European and Oriental traditions) whose fullness would eventually expand to include, along with whatever determined the lawyer to become a painter, the entire structure of the scene of writing. What finally proved to be productive was so already at the beginning of the process, but was displaced and subordinated to a slippery tradition that the artist would have to traverse before he grasped its deter-

mining and overdetermining forces (cf. the distinction that Matisse draws between the "interior" and "exterior" of Poussin, Courbet, and Cézanne). In short, Matisse was both a painter and the master of a culturally diversified tradition, but he used this cultural tradition toward a very precise end: notably, to break out of the enclosure in which painting, such as it was (is) taught, was locked. The more Matisse studied the autonomous specificity of painting, the more painting seemed for him to need to be "thought" outside its autonomy.

There is little "before and after" effect in Matisse's work. Although he confided to Gaston Diehl, "The trips to Morocco helped me to achieve the necessary transition and allowed me to rediscover a closer contact with nature" (we know that he took his first trip to North Africa in 1906), as early as the fall of 1905, the *Woman with the Hat* (Madame Matisse) indicated that the transition had already been accomplished. There is nothing surprising in the fact that a trip or several trips abroad to another continent may have allowed Matisse to develop the quality that made him, in the determining ideology of the time, a "fauve," but Matisse's transition was already plainly evident in the *Woman with the Hat.* The travel, the recourse to the discipline of other media (sculpture, etching, etc.), even the biographical references imply for Matisse a heightened awareness of the ideological field within which he moved.

As early as 1908, in an article published in the *Grande Revue,* Matisse firmly argued the artist's obligation to *organize his ideas;* he would continue to return to this point, as in a letter many years later to Pierre Courthion: "I did sculpture because *what interested me in painting was organizing my brain.* I took up a new medium, I worked with clay in order to take a break from painting, with which I had done absolutely everything I could at the time. That is to say, *it was always a matter of finding the right organization.* It was in order to get my feelings in order, to find a method that suited me absolutely. When I found it in sculpture, it helped me in painting. My purpose was always *to possess my brain,* to find a *kind of hierarchy of all my sensations* that would allow me to conclude."[63] These few remarks of Matisse are of an exceptionally methodical nature and alone justify, where necessary, the broader and more precise investigation that his work invites.

The *Woman with the Hat* is striking first of all because of its

1905 date and the sensation it created. But it makes many other claims to our attention. Matisse writes in 1908: *"What interests me most* is neither still life nor landscape, but *the human figure; that is what lets me best express the almost religious feeling that I have for life."*[64] One might add that this preference for the figure is most clearly expressed from 1905 on. As of that date, figures appear more frequently and with more qualitative insistence in the artist's work. The *Woman with the Hat,* which states Matisse's decisive rejection of pointillism and the neoimpressionist method, is in fact a portrait of the artist's wife. Madame Matisse had already served, of course, as a model for her husband, and she would reappear in many works; it is, however, significant that the decisive painting for "fauvism" should be *this* painting. One may look at the way in which Matisse's defines his interest in the study that fascinates him most, the study of the figure and the portrait: *"The revelation of the life in a portrait study came to me while I was thinking of my mother.* At a post office in Picardy, I was waiting for a phone call. To pass the time, I picked up a telegram form that was lying on the table and drew a woman's head with my pen. *I drew without thinking, my pen moved along with a will of its own,* and I was surprised to recognize my mother's face with all its fine detail. My mother's face had generous features."[65]

This personal confession, published by the artist in 1954, is too loaded analytically for us not to consider it more closely, especially in conjunction with the moment when Matisse, in his *Woman with the Hat,* was moving away definitively from the traditional history of painting that he had studied until then. We must in any event consider together Matisse's remarks regarding the figure in 1908 and in 1954 respectively: "The human figure is what lets me best express the almost religious feeling I have for life." "The revelation of the life contained in a portrait study came to me while I was thinking of my mother."

Here we should stress the relationship between the "religious feeling for life" that Matisse expresses through the portrait and the "revelation of life" that he owes to his mother. Without for the moment dwelling on the incestuous reference to the fascination with the "maternal face," it is particularly interesting to note the artist's continued allusion to this information throughout his writings. In 1945 he writes: "One gets into the mood to create through

conscious work. To prepare the execution of a painting is first of all
to feed one's feeling through studies that are somewhat analogous
to the painting; afterward the choice of elements can be made. It is
these studies that allow *the unconscious to surface freely.*"[66] In
1939 Matisse had written in *Le Point:* "My line drawing is a direct
translation of my purest emotion. It is only when I have the feeling
of being exhausted by work that may have gone on for several ses-
sions that my mind is cleared and I can let my pen proceed with
confidence. Then I have the distinct feeling that my emotions are
expressing themselves through a kind of plastic writing. As soon as
my "emotional" outline has modeled and shaded out the light on
my white page without taking away any of its quality of tender
whiteness, I can neither add to it nor subtract anything from it. The
page is written, no correction is possible. All I can do if it is un-
satisfactory, is to start all over, just like in an acrobatic act . . . My
models, human figures, never figure simply as elements in an inte-
rior. They are the principal theme of my work . . . my plastic signs
probably express their state of mind [*âme*—lit. "soul"] (a word that
I don't like much), in which I am interested *unconsciously*—what
else could it be? . . . The emotional interest that they inspire in me
is not especially visible in the representation of their bodies, but
often in the lines or special values that are spread over the entire
canvas or paper and form its orchestration, its architecture. But not
everyone notices this. Perhaps it is a sublimated sensuality that is
not yet perceptible to everyone. . . . Someone once told me that I
didn't see women the way I represented them and I answered: 'If I
were ever to meet such women in the street, I would run away,
terrified.' First of all, I do not create a woman, I make a painting."[67]

 One could continue pointing out the subjective displacements
that Matisse notes when he speaks of his work and which all refer to
the determination of that "revelation of life in the portrait study."
These texts, studies, and remarks should in fact be analyzed line by
line. Together they form a corpus whose theoretical perspective is
extremely rigorous. But what I would especially like to emphasize
at a first level of decoding this texture is the analytical drawing that
is at the origin of production. Matisse's writings and comments all
apply in some way to various aspects of his practice—even the
most blatantly biographical references; and these biographical ref-

erences find productive justification in their application. On the one hand, one should therefore isolate the painter's declarations regarding his technique and his own posture when facing the model, while on the other hand try to understand how his painting responds to these various demands. We recall that Matisse appropriated for himself the method of the Chinese artist: "I have been told that Chinese teachers often tell their students, 'When you draw a tree, you should have the feeling of rising with it when you begin from the bottom.'"[68] Sarah Stein reports elsewhere a piece of advice that Matisse used to share with his students, which is clearly inspired by the lesson of the Chinese teacher: "If it be a model, assume the pose of the model yourself."[69]

The particularity of these statements emphasizes the importance of the position of the subject in the production of Matisse's work; so if we seek to understand his work, we must consider the many fields that produced this subject. If we want, for instance, to look into Matisse's radical emphasis on the problems of color (indeed, how can they be avoided?), we can hardly do so without referring to the information that the artist confided to Tériade on this question: "Paintings that are refinements, subtle degradations, mellownesses without energy call for beautiful blues, beautiful reds, beautiful yellows, elements that move the sensual essence of men." Much as one would like to avoid these problems, Matisse's work—and particularly, the "fauve" portrait of Madame Matisse, the *Woman with the Hat*—compels us nonetheless to return to them.

The biographical circumstance signaled by this portrait of Madame Matisse directs us anecdotally to a primary family structure: wife/son/mother. We have seen just how much importance Matisse attributed to the relationships and kind of relationships he had with his models; we are therefore justified in turn in attributing this same importance to the role played by the model who happened also to be the artist's wife and who largely determined Matisse's "radicalness." We cannot forget, however, that, according to Matisse himself, the revelation of the life contained in a portrait study came to the son while "thinking of his mother." Consequently, one might say that "the life" of *The Painted Woman* (the painter's wife) comes from thinking about the mother. And we can advance this interpretation because of what all the biographers offer—based on Matisse's own

instructive confessions—as to the determining factor in Matisse's decision to choose a new career: the gift of a box of paints from Madame Matisse, from mother to son.[70]

The relationship between mother and son has never been the object of any detailed study; it is as if all the biographers have deliberately tried to avoid the artist's own declarations. Outside of Matisse's statements, all we have are a few indications—occasionally contradictory and controversial—that generally converge in their ultimate confirmation of the very tight, subjective relationship between the mother, the son,—and painting. According to Alfred Barr, Madame Matisse the mother (Anna Héloïse) had "artistic inclinations" and painted on porcelain ("Matisse's mother, Anna Heloïse Gérard, was artistically inclined and painted china; his father was a practical man");[71] the same information is to be found in Raymond Escholier's 1956 work. Gaston Diehl, on the other hand, provides us with a detail that has yet to be verified. According to him, Matisse's mother encouraged her son to paint in recollection of the time "when she was a milliner in Passy."[72] If this last point were to be proved true, we would have yet another link between mother and son. We know in fact that at the time when the young newlywed couple ran into financial difficulty (around 1900), Matisse's wife (Amélie Noémie Alexandrine Parayre) opened a millinery shop on the Rue de Chateaudun, and that the artist, when in Nice, often found himself composing hats for his models with feathers and flowers. Whatever the case, from the senior Madame Matisse's artistic inclinations to her gift of paints and to the unconscious gift of "the revelation of the life contained in a portrait study" (and not forgetting the practical father), we can trace the course of Matisse's artistic programming in its unconscious, "revolutionary" operation. With respect to this "analytic" aspect, the importance, the strength, and the seriousness with which Matisse dedicated himself to his work should not be underestimated (he would continually return to this), nor should the pictorial screen (memory) that exploits, reveals, represses (sublimates) as exteriority (the painting) the specific contradiction (the taboo of incest) to the ideological field that was historically brought into question by "the subject." Thus we find the following observations at the start of Matisse's speech to his compatriots at Cateau-Cambrésis: *"Directed, I know not why,* toward the path of the Fine Arts, com-

ing from a milieu that had no reason to send me that way, *I found, as it were, a calling* in this work after all my other occupations . . . I hurried to get to work, pushed on by something I cannot exactly describe, *by a force that I perceive* today as *alien to my life as a normal man.*"[73]

The importance of the Oedipal conflict and the fascination with the maternal face ("I was suprised to recognize my mother's face") seem to convey a *cause of vision* (at a different level of depth) throughout a history (which is also that of the incest taboo) that they necessarily "revolutionize." The *Woman with a Hat,* Madame Matisse (who was also, we recall, a milliner) and in the same field of inquiry, the *Portrait with a Green Line,*[74] or the *Idol* (1906),[75] allow us to understand how this overdetermining cultural exteriority (the relation to incest) is brought to play upon (to transform) Matisse's work formally and historically. The spatial construction that can still be found in the pointillist diffusions of neoimpressionism (*Luxe, Calme et Volupté,* 1904), the division of the canvas into geometrical planes (a rectangle and two triangles for *Luxe, Calme et Volupté*) in the form of a right angle, a mirror, a painting within a painting, with the finished planes coming to play on the plane of the canvas—this plainly visible constructive apparatus disappears momentarily to give way to the more generalized space of the whole painting. The figure is no longer used *in* space as an eccentricity playing in more or less contradictory ways in relation to a spatial center; it is one of the elements of the space that it constitutes, that is constituted by it, and to which it sacrifices its (reconstructed) likeness: "I do not paint a woman, I make a painting."

It would thus seem that nothing in the *Woman with the Hat* refers to Madame Matisse, to a real woman. In this portrait, not one of the colored areas or fields, however large or small, is on the same plane. The whole painting is like a logical reconstruction of a fragmented figure in an artificial order. This holds for every figurative unit of reference or element of color, from those that "constitute" the woman (face and upper torso) to those that "constitute" the hat and those that "constitute" the painting in this rectangle. The green stroke of paint that touches the left cheek of a face that is like a jigsaw puzzle is neither more nor less solid than the face, neither more nor less "real"—it seems to be much farther forward than the

face; but as soon as one pauses to consider the face, it becomes clear that what constitutes it is equally intricated in a multiplicity of possible planes. The nose, mouth, eyebrow, eyes, cheek, forehead, ear (the red, yellow, green, orange, brown . . .) seem each to belong to as many different planes of space and create a figure that is all surfaces and holes, as if the face had been flayed in haste and the skin spread out, flattened on the canvas. Once again, what is pertinent at the level of the detail is also pertinent at the level of the whole. On the left, the red color (of the hair) seemes to compete for the foreground with the green brush stroke on the right (the stroke that touches the model's left cheek). The complex construction (the hat) that fills most of the upper third of the painting is at least if not more important than all the rest of the figure. Furthermore, the construction refers to a *hat* only to the extent that it happens to be located just above Madame Matisse's face (although on a completely different visual plane). When one isolates this construction, one gets a kind of still life or rather, a kind of decorative wallpaper of drapery motif, enlarged beyond proportion and brought to the foreground (a motif such as one finds in certain of Cézanne's paintings, as for example in the upper righthand corner of the *Still Life with Flowered Curtain and Fruit,* 1900–1906, Venturi, no. 741). We find another, and no less striking, example of this apparently brutal chopping up of the human figure in the magnificent portrait of Mlle Landsberg.

In the portrait of Madame Matisse, the *Woman with a Hat,* the formal structure, responding as it does to the problematic of modern painting, is in perfect proportion with the force ("that unknown force . . .") that subjectively works through modern thought with the destructive (*fauve*—that is, savage) drives that determine this force (Oedipal conflict—"sadistic" drives—aggression performed on the maternal body) and the biography of the artist (the portrait of his milliner-wife).

To understand fully what takes place, one cannot underestimate the social context that produced Matisse the Fauve, and the fauve movement. The entire "revolutionary" history of painting (from Cézanne to Matisse and beyond) comes into play here. "Fauvism" itself was of course baptized, like most modern art movements, by a token fool, the unconscious purveyor of the discourse of the dominant ideology of the time. And if the coloristic nature of Matisse's

painting could have raised the cry of "wild" (*fauve*), we must also consider the implications of this social manifestation in all its sociological effects. Nor should we dismiss any given information as merely anecdotal (the scandal, for instance, provoked by that other "fauve" painting by Matisse, the *Blue Nude* of 1907, which was burned in effigy in New York). Matisse painted and exposed (*ex-posed*) the *Woman with the Hat* in 1905: the twentieth century had hardly yet begun; indeed, the spirit of the times·was more an expression of the end of the nineteenth. An outmoded bourgeois morality still dominated society with absolute power, and explicitly questioned the respectability of any woman who painted her face. This is the very milieu from which Matisse himself emerged. Louis Aragon quotes the following anecdote in a chapter of his book *Henri Matisse, a Novel,* which appeared in *Les Lettres Françaises* on 15 April 1970: "It must have been in 1913, or rather 1914, since the painting is from Issy-les-Moulineaux, autumn 1913 perhaps, that my mother caught me with a photograph of the *Portrait of Madame Matisse,* seated in an armchair with a shawl (a reproduction of this painting would later appear in the selection of modern works that André Breton and I hung in the barrack-room that we shared, or rather in the little room adjacent to it, at Val-de-Grâce in 1917). On seeing it she cried out: 'If this is the sort of thing you are interested in, my poor child, you are a hopeless case! . . .' This photograph had been given to me by the woman who would later become Catherine Simonidze in the *Bells of Basel* (*Les Cloches de Bâle*)." The painted woman is a prostitute (the expression is still used today to designate a prostitute), a woman who seeks out men, the bad woman, the bad mother. This is what the newspaper reporter, the token fool, felt immediately: there is something "savage," "FAUVE," in the treatment to which Matisse subjects his model.

This apparently marginal point of view suddenly becomes central to the field of Matisse's system of painting when we juxtapose it to Sarah Stein's account;[76] she reports that Madame Matisse posed for this portrait of the *Woman with the Hat* dressed in a black dress and black hat, the only colored element being the ribbon she wore around her neck. Matisse thus really painted and colored his wife with "those colors that awaken the sensual essence of men." More exactly, choosing his wife as model, he painted not his wife but *his bad woman* (*sa mauvaise femme*), the mother who gave herself to

his father, the bad mother, the prostitute. One then understands how he could subsequently write: "If I were ever to meet such women in the street, I would run away, terrified."[77]

One may certainly ask to what extent this recourse to extrapictorial elements is justifiable in the analysis of an artist's work. That is precisely what I would like to demonstrate here in a general way. In fact, one could ask more specifically in the case of artists who use models what it means for them to disregard one of the major elements determining their work—for in creating this canvas, Matisse replaces *black* by other colors! He has in fact left us some helpful indications pertaining to this question: "I need nature in order to gather my own energy to take off";[78] and, "People who work in an affected style and deliberately turn their backs on nature are in error. An artist must realize, when he *thinks about it,* that his painting is an artifice, but when he *paints* he must have the feeling that he is copying nature. And even when he departs from nature, the conviction must remain that it was only in order to render it more completely."[79] The *Woman with the Hat* (Madame Matisse) must therefore be understood in terms of its utter closeness to the model; whatever distance the artist took from the model, it was only so as to render her (to work her, to work with her) more completely. It is the coincidence in the portrait study ("The revelation of the life contained in a portrait study came to me while I was thinking of my mother") of a historically justified formal evolution with that "force" that Matisse perceived as "alien to my life as a normal man"—in other words, the aggressive drives of the Oedipal conflict—that creates the systematic network that determined Matisse's productive force.

It remains to be seen how within this system, at the same time that he distanced himself from his model, Matisse could have had "the feeling" of having "copied nature." The distance that separates the woman from the portrait, the model from the painted woman, is not a feature of the *Woman with the Hat* alone; Matisse's entire career is marked by this distance. The portrait of Mlle Yvonne Landsberg (1914), whose chopped-up mask is pulled in every direction over the canvas, is certainly farther from its original model than the *Woman with a Hat* is from Madame Matisse. Especially striking in these works (the portrait of Mlle Landsberg probably suggests this most clearly, though a formal analysis of most of

Accentuated lines of force from the mask of Mlle Landsberg (traced from the paint-
ing). Alfred Barr finds in the *Portrait of Mlle Landsberg* the influence of futurist
theories. In my opinion, it is quite arbitrary to give so much emphasis to an avant-
garde movement that is relatively minor by comparison to the theoretical and formal
work that Matisse was doing at the time he painted this portrait.

Matisse's portraits would confirm it) is the masklike presentation of
a figure that is *other* (a different, other woman); and it is for this
otherness that Matisse would seek confirmation on other conti-
nents and in other cultures. At this moment in history, the Western
reading of the African mask and of Oriental art found in Matisse one
of the transforming forces that would finally permit the double de-
coding of East and West in a complex unity.

In order to understand the absolutely exceptional productive
force that first determined in Matisse-as-portraitist the conjunction
of formal transformations and Oedipal drives, we must go back to
the complex structure that produced these transformations and
whose field was equally decisive for the qualitative leap effected by
Matisse. If, as I have earlier suggested, we accept that the ideologi-
cal upheavals of the nineteenth century compelled each discipline
to rethink its practice in a fundamental way, the general question
that underlies this upheaval, this ideological reversal, and its subse-
quent effect on the restructuring of different artistic practices, is
one of language: the relation between the subject and his or her
language (Freud, we recall, was only thirteen years older than

Matisse). Each discipline, inscribed within the ideological field, was thus forced to rethink its signifying practice. We have already seen how the practice of painting found itself performing a mechanical detour, deviating from the ideological scene that programmed it ("the *zôgraphos* comes after the *grammateus:* a painter who comes after the writer and paints, in the soul, pictures of the assertions that we make"). With respect to this norm, the transgression that the practice of painting allowed itself at the turn of the century continually confronted that norm[80] with the forbidden language that it had taken upon itself to mask, by always deflecting it elsewhere.

Color/Flavor

Matter (obliterated by material), repressed (fragmented) bodies, forbidden language, force, desire detoured into summary effects . . . Language and sexuality mark the complexity of the (censored) stakes for which the arts, at best, provide the representative structure. To go beyond this superficial production (signified/fantasm), is to go into the *analysis* of the very material that must, beyond the code that justifies it, respond somehow in its own signifying articulation to the sexuality and language that dictate the multidimensional staging of signs.

For this staging, we may refer to the work of Melanie Klein. The first relation that is established focuses on the mother: "Both the capacity to love and the sense of persecution have deep roots in the infant's earliest mental processes. They are focussed first of all on the mother. Destructive impulses and their concomitants—such as resentment about frustration, hate stirred up by it, the incapacity to be reconciled, and envy of the all-powerful object, the mother, on whom his life and well-being depend—these various emotions arouse persecutory anxiety in the infant. *Mutatis mutandis* these emotions are still operative in later life."[81] This statement corroborates the judgment of Philippe Sollers when he writes: "We can say in general about woman, from whom we all come, that she is the only sign capable of eliciting unlimited desire."[82] Desire is programmed by the signifying network (mother and/or wife—wife and/or mother) in which signs are swallowed up: wife and/or mother, that is desire/anguish, food/flavor.

In this awakening, the *material ground* of the sexual drives (de-

spite their general diffusion, these drives continually return to the material source; they evoke it through multiple networks of signs and through the structure of the object-choice that is marked by the barrier against incest) is constituted by its *and/or* displacement: "We must reckon with the possibility that something in the nature of the sexual instinct itself is unfavourable to the realization of complete satisfaction . . . As a result of the diphasic onset of object-choice, and the interposition of the barrier against incest, the final object of the sexual instinct is never any longer the original object but only a surrogate for it. *Psychoanalysis has shown us that when the original object of wishful impulse has been lost as a result of repression, it is frequently represented by an endless series of substitutive objects, none of which, however, brings full satisfaction.*"[83] This barrier, this major prohibition "between the two" (and/or), takes the form of figurative discourse against the material background that it situates: "The prohibition does not merely apply to immediate physical contact but has an extent as wide as the metaphorical use of the phrase";[84] the prohibition diffuses the activity of its own material background into discourse ("the metaphorical use of the phrase").

We can refer to the productive elements that determine this material ground in the field of painting—associating *flavor,* as Democritus does, with form and color—in relation to affect and to the destructive impulses of the infant toward its mother. According to Democritus: "There is no form that is pure, that is not blended with others. Each flavor, on the contrary, contains several forms at once: the smooth, the rough, the round, the sharp, etc."[85] "Democritus asserts that color does not exist in nature. For elements are deprived of qualities, there are only compact particles and the vacuum; the composites that are formed out of them acquire color through the order of the elements, their form and their position. Outside of these, there are only appearances. Color takes on four kinds of appearance: white, black, red, yellow."[86] "Democritus claims that black corresponds to roughness and white to smoothness, and he links the tastes to atoms."[87] The complex relation that is established here between *flavor* and *color* remains to be examined; for the moment we may retain the analytic sequence, which according to Democritus, determines the acquisition of color: the *order of elements, their form, their position.* Is this not the analyt-

ical structure that we might use to describe the sexual drives of the
infant at the oral stage?

Consciousness, that abyss of signs accompanied by oral desires,
tests reality in a cleavage that constitutes the limits of the ego. The
atomistic analogy (?) anchors itself in the materialist definition of
the first stage of libidinal development, the oral phase—the phase
that links the sexual drives predominantly to the arousal of the
mouth and lips and to the organization of postnatal alimentation,
which permanently mark the nature of satisfaction and desire. In
this regard, Freud asks a question that relates to the flavor/color
problem: "We do not know whether this process [the instincts of
the oral phase] is regularly of a chemical nature or whether it may
also correspond with the release of other, *e.g.* mechanical forces.
*The study of the sources of instinct is outside the scope of psychol-
ogy;* although its source in the body is what gives the instinct its
distinct and essential character, yet in mental life we know it mere-
ly by its aims."[88] It should be noted that this oral phase corresponds
to the *state* of primary narcissism[89] and that it is elsewhere qual-
ified by Freud as "cannibalistic."[90] This means that the emphasis on
this phase is not limited to the oral erogenous zone, but also to the
mode of relationship that it implies: the incorporation (can-
nibalism) that in infantile fantasms can be transposed onto other
functions (breathing, vision). Freud, like Melanie Klein and Karl
Abraham, continually returns to the determining formative char-
acter of this phase. Karl Abraham writes: "The displacement of the
infantile pleasure in sucking to the intellectual sphere is of *great
practical significance.* Curiosity and pleasure in observing receive
important reinforcements from this source, and this is not only in
childhood, but during the subject's whole life";[91] "a character thus
rooted in oral erotism influences the entire behavior of the indi-
vidual, *as well as his choice of profession,* his predilections, and his
hobbies."[92] This theme obviously demands far more serious atten-
tion; for the moment, however, we shall consider it primarily in
order to emphasize the *organizing* of signs, which the Oedipal con-
flict then splits apart.

The ideological problem that the nineteenth century specifies for
us is directly linked to questions of the position of the "subject" in
discourse, and to the metaphysical concept of the "sign." These are
questions that draw attention to the emerging sciences of the time,

linguistics and psychoanalysis,[93] both of which were implicitly set into play, with greater or lesser rigor, by certain psychological structures relating to the ideological decentering of the subject. Matisse, by linking his drawing practice to the maternal face and his use of color to the "sensual *essence* of men," refers us to the secrets of the overdetermining, double articulation of the oral phase and the Oedipal conflict. An articulation in which the sublimated painting of woman "wife and/or mother" is acted out: the *matter* that moves the sensual *essence* of men"—sexual drive—taste—flavor "that splits the object" (good *and* bad)—the mother drawn/the painted woman.

Speaking of a film that showed him drawing, Matisse once said: "There was a passage that showed me drawing in slow motion. Before my pencil ever touched the paper, my hand made a strange journey of its own; I never realized before that I did this. I suddenly felt *as if I were being shown naked*—that *everyone could see this* [this strange journey, this displacement]; *it made me deeply ashamed.* You must understand this was not hesitation. *I was unconsciously establishing the relationship between the subject* that I was about to draw *and the size of my paper.* I had not yet begun to sing."[94] This double movement of exposure and repression, exposing in order to repress, in order to hide—Matisse would not cease to expose, develop, and question it. He wrote to Bonnard in 1940: "It is certain that our constant anxiety hurts the *unconscious work* that normally has a grip on us." In his technical explanations, or more often in the metaphoric concepts that he uses to illustrate his practice, the precise indications that Matisse gives us refer back to the productive structure, to "that force alien to my life as a normal man." These borrowed "concepts" all share a similar conflictual structure at their productive core.

Sign/Nature

In the *Grande Revue* article of 1908 in which Matisse signals his particular interest in the portrait, he writes: "An artist must realize, when he thinks about it, that his painting is an artifice, but when he paints he must have the feeling that he is copying nature. And even when he departs from nature, the conviction must remain that it was only in order to render it more completely." In the same vein he would tell Gaston Diehl: "I need nature in order to gather my

own energy to take off." This concept of "nature" (like all the concepts that Matisse uses) cannot in any way be reduced to the classical, rational schema; it serves rather to take the place of (to expose while repressing) the signifier to which the artist owed "the *revelation* of the life contained in a portrait study."[95]

The religious character of certain of the artist's statements (notably in *Jazz*) is also directly related to that "revelation" of life that sublimates what it hides in order to best draw attention to it: "In art, the truth, reality, begins *when you no longer understand anything at all about what you're doing,* about what you know; when you are possessed with an energy all the more powerful for being opposed, compressed, restrained. You must then come forward in the greatest humility, all white, all pure and innocent, your brain apparently empty, *in a state of mind analogous to that of the communicant approaching the altar.* Of course, you must have a store of acquired knowledge behind you and know how to have maintained the freshness of Instinct." "Do I believe in God? Yes, when I work, when I am submissive and modest. *I have the intense feeling that I am being aided by someone who makes me do things that are beyond me. I don't,* however, *feel any gratitude toward Him* . . . I am *ungrateful,* remorseless."[96] The place of this discourse and the negations it contains (white, pure/the freshness of Instinct) seem to evoke the preconscious psychology of the infant in its relation to the omnipotent object. The religiosity in the semantic chain of *nature, reality, unconsciousness, the altar, aid, ingratitude* . . . is plainly reminiscent of Melanie Klein's analysis of the oral phase in *Envy and Gratitude.* The "someone who makes me do things that are beyond me," the "holy," "nutritious" moment, the "nature" from which one "departs" in order to render it more completely (and which is the wife of the painter in *Woman with the Hat,* and generally a woman in the great majority of portraits by Matisse), this unconscious "reality" that produces "energy," is it not in the *and/or* conflict (wife and/or mother) the absent "sign" which comes to take the place of that which produces and programs the desire for all signs ("substitutes, none of which is fully satisfying"), the displaced signifier to whose place all signs rush in? Incomplete bliss ("then I find myself frustrated by the benefits of the hope that should have been the reward of my intent—I am ungrateful and remorseless"),[97] where the desired and de-

graded object is ceaselessly reconstituted and consumed (cannibalism) in all forms; above all in the general form of *mother nature* (good and bad). "The principal interest in my work comes from an attentive and respectful observation of nature, as well as from the dualistic feelings it has inspired in me."[98] The painter stands in relation to this Nature as both a cause and a part (castration); a Nature which is generous (woman), nurturing (maternal), which the artist observes, and in which he forgets himself in order to render it more faithfully.

These statements and confessions are commented upon and supported by all of Matisse's paintings in one way or another, and they are further confirmed by the surprising theory of the sign that accompanies and reiterates their implicit premise.

Matisse's theory might at first appear suspect, given that it served the artist primarily to communicate with a writer (Louis Aragon); like all of Matisse's theoretical pronouncements, however, it is sufficiently elaborated throughout his career to demand at least as much attention as the rest of his work. His remarks regarding the sign are to be found not only in the dialogue with Louis Aragon (1941–42) but also in his teaching (1907, at the Rue de Sèvres School) and in numerous other statements. What characterizes all of his remarks is again an absence, the absence of a sign, indeed an absence in the sign: "It was *absolutely necessary* that I prepare a *new development in my life as a painter* through *a search for signs*"[99]—"there is no dictionary for painters"[100]—"an artist's importance is measured by the number of new signs that he has introduced into plastic language"—"Why do people say that Delacroix never made any hands . . . ? that he only made claws . . . ? Somewhere he had to finish the movement, the line, the curve, the arabesque that would finish the painting. He brought it right to the end of the arm of a character in the painting, and there he bent it, he finished it by a sign, do you understand, by a sign . . . always the same, the hand done in the very same manner, not a specific hand, but his hand, the claw."[101]

These apparently rational notes (this apparently rational quest for the sign) were complicated and divided as soon as the artist introduced them into the order of his practice. Thus he says to Louis Aragon: "You have to create an object that resembles a tree. The sign of the tree. And not the sign of the tree such as it exists in the work of

other artists . . . as for instance, in the painters who learned to repre-
sent foliage by drawing 33, 33, 33 . . . that is just the remains of the
expression of others . . . Other people invented their own sign . . .
to recuperate it is to recuperate a dead thing."[102]

We see right away that these propositions cannot be reduced to a
normative theory of the sign, to the extent that they have to agree
with what Matisse wrote to A. Rouveyre: "I have been told that
Chinese teachers often tell their students: 'When you draw a tree,
you should have the feeling of rising with it when you begin from
the bottom.' " Similarly, Sarah Stein, a student of Matisse's at the Rue
de Sèvres School, reports this lesson from her teacher: "A tree is
like a human body, a human body is like a cathedral . . . You may
consider this Negro model as a cathedral, composed of parts that
form a solid, noble, towering construction—and as a lobster . . ."
and finally, in a remark to Tériade: "A Vesubian acacia tree, its
movement and slender grace, may have made me think of a wom-
an's body dancing."[103] Thus no "sign" is adequate (no tree, no
woman, is adequate); there is no sign that cannot be replaced by
another. Without twisting Matisse's thought, one could say that he
wants a sign always to "resemble" another ("an object that resem-
bles a tree"), to "resemble" all signs, and that all signs resemble a
sign that—for not being there—is in them all, constitutes them all,
rises up with the tree that dances in him (her). We may again quote
from Matisse on his relation to the model: "When I take on a new
model, it is in the way she relaxes when resting that I guess the
pose that will suit her and to which I enslave myself. I often keep
these girls for years, until I have exhausted my interest in them. My
plastic signs express no doubt their state of mind [*âme*] (a word I
don't like much) in which I am interested *unconsciously*—what
else could it be? Their form is not always perfect, but they are al-
ways expressive. The emotional interest that they inspire in me is
not especially visible in the representation of their bodies, but often
in the lines or special values that are spread over the entire canvas
or the paper and form its orchestration, its architecture. But not
everyone notices this. Perhaps it is a sublimated sensuality that is
not yet perceptible to everyone."[104]

The sign here does not resemble its model: *projection:* "My plas-
tic signs probably express their state of mind (a word that I don't
like much) in which I am interested unconsciously—what else

could it be?"; *introjection:* "The emotional interest that they in-spire in me is not especially visible in the representation of their bodies, but often in the lines or *special values* that are spread over the entire canvas . . . and form its orchestration." The "sign" here is the expressive and absent—expressive because absent—product of the sensual pleasure that the generalized nurturing body, "spread over the entire canvas," contributes to this game—feeding and "giving life" to every possible representation. This "graphic," "plas-tic sign" cannot be reduced to a normative code ("there is no dic-tionary for painters"); the "grammar" is the grammar of instinct (mother = flavor/nature, color/sign = language) before it is that of the law. And since castration plays the "text" inevitably (*"whoever wants to give himself* to painting [*la* peinture] must begin by *cut-ting out* his tongue"),[105] thenceforth the painted woman (Ma-tisse)[106] arouses, with savage ("fauve") vigor, "the sensual essence of men."

3. PAINTING AND SYSTEM

The System

Once the system of an artist's productive "irrationalities" has been established, one is inevitably confronted with the com-monplaces that this system sets into play. The organization of a signifying "space" is in fact unthinkable outside of the material ground (shared by all) that it brings to the surface and transforms. Indeed, we might say that it is these commonplaces and the un-equal division between biography and history that authorize the establishment of an intelligible system of productive "irrationali-ties"; it is, after all, the individualized work alone that allows us from the start to undertake the consideration of the more general common material ground.

In the case of Matisse, that is, as a result of the broadest reading that Matisse proposes, no sooner do we discover or rediscover the traces and mutations of this material ground of color than it comes to impose itself as a generality. This point is important because Matisse's discoveries (and he dis-covers what has been covered up) in effect serve to open up every pictorial practice to the possibility of reading. In Matisse (and through Matisse) this discovery follows a *particular* course at the same time that *that course itself* con-

stitutes the discovery. In other words, the discovery is closely and historically linked to Matisse's own complex *practice*; it can only present itself as knowledge in the form of recoverable traces and mutations according to the (structural) order of that practice once that same practice has been reassessed. The material "ground" that Matisse reveals is a common ground, but the order of relations that are productive within or upon that ground can in no way be exchanged, or passed from one artist to another (we must not forget that this is an "order" of instincts and "drives").

As in the practice of Matisse, it is clear that there is a systematic order at work here, but that the status of this ordering (the order of the system) is always based on contradictory dependences that are thinkable historically in terms of a dialectical relation—for example, the dependence of the specific practice on its historical situation, but also the historical dependence on this specificity (given the rule that individual practices vary in their relative development). Similarly, one can look to the dependence of the painter as "subject" on the history that constitutes his (biography) or the historical reality within which this history is constituted (for example, the constitution of a "subject" within the totality of a social practice: the class struggle), and so on. Within the framework that interests us here, scientific generalization might propose the following: (1) the objective ground common to every subjective practice; and (2) the dialectical overdetermination (productive interdependence) of a consciousness that can in no way be reduced to itself or to either of the two moments that it (the signifying practice) sets into play.

The texts that Matisse wrote to accompany and punctuate his pictorial practice are proof of his awareness of the texture of contradictions that constituted him as a productive force in relation to this referential "ground." A complete presentation of these productive elements is to be found disseminated throughout numerous writings and statements by the artist. In the following remarks to Tériade in 1936,[107] we can trace the workings of Matisse's sensitive awareness to the system that was his own:

Material ground: "In my last paintings, I have incorporated the attainments of these past twenty years to *my essential being,* to my very essence." It is in this discussion with Tériade that Matisse declares: "When the means are so refined, so pared down as to be

stripped of all power of expression, *we must return to the essential principles that formed human language.* Then it is *the principles* that 'resurface,' that take on new life, *that give us life.* Paintings that are refinements, subtle degradations, mellownesses without energy, call for beautiful blues, beautiful reds, beautiful yellows, *matter that moves the sensual essence* of men. This is the point of departure for fauvism."

Biography/history: "Our senses have a certain age of maturity that is not determined by the immediate environment but by a moment in civilization. We are born with a sensibility that comes from a period of civilization. And this counts a great deal more than all we can *learn* about a period. The development of the arts comes *not only* from the individual but also from the strength acquired from an entire civilization that precedes us. We cannot make just anything. A talented artist cannot make just anything. If he didn't use his talents, he would not exist. We are not masters of our own production. It is imposed on us."[108]

When he tries to sum up his work, Matisse most often comes close to a quasi-scientific definition. The imprecision of the notions that he uses (civilization, sensibility) and that he tries to delimit as narrowly as possible, continually suggest the concept that is lacking, at the same time that they seem to design a field of action around it. Starting from the principle, "What we acquire consciously lets us express ourselves unconsciously with a certain richness,"[109] Matisse continued to develop different areas of knowledge, largely through the reading of writers, poets, philosophers, and mathematicians. "The reverie of a man who has traveled is significantly richer than that of a man who has never traveled. All that the meanderings of a cultivated mind and an uncultured mind have in common is a certain state of passivity."[110] While the artist seemed to know that his practice was the subject of great imponderables, his knowledge of them was, and would remain, limited to an obscure recognition of their existence as such. ("We are not masters of our own production. It is imposed on us.") Matisse was familiar with the means for using and reducing his share of imponderables; they came from the violence of upsetting the "refinements, the subtle degradations, the mellownesses without energy" to the "beautiful blues, beautiful reds, beautiful yellows, matter . . ." But the means are not the end, and this end was empirically

overdetermined by something that Matisse named only negatively. The movement of knowledge was playing here with the elements at its disposal in such a way that the "imponderables" could double their force, but also make it falter, give way, or be reduced. The artist's unconscious is actively included within the system ("it is these studies that allow the artist to let his unconscious surface freely"); it obeys a movement whose effects are not necessarily productive and can even be regressive. Thus the "essential being" emerges more or less; it more or less "forms" Matisse's "language." Hence the artist's constant preoccupation with having to produce a "new sign"—new signs (not to be confused with the linguistic notion) of the proper working of the element that serves as *productive motor* (not the hand but the *claw*, the claw that is "perched" in the portrait of Yvonne Landsberg).

Certain drives, as we have seen, are linked in Matisse to the common material ground through a historically productive structure. Nevertheless, these drives are not always in a privileged position, and the analysis of their (to a greater or lesser extent) productive manifestation is conditioned by the consideration of transformations stemming from the historicocultural field that they invest, as well as by the "chances" that these transformations offer to the unconscious structure of the "subject" who conveys their language. In the case of Matisse, historical and biographical elements are closely related; their effect on the artist's practice is clearly indicated throughout his work[111]—for instance in his correspondence with Bonnard. Matisse's system goes far beyond Matisse's "theories" by playing against a background that these theories ultimately have no means of controlling. ("What a life of torment when I, with my acute sensibility, must rely on a method; or rather, when an acute sensibility prevents me from settling upon one method of support.")[112] The common material ground, prey to the history and biography of a subject who is not equipped to think it out in all its dialectical articulations, invests itself, in certain circumstances, in the accidental "chances" that the unconscious of this "subject" provides. Whatever the fortuitous productive adequation of an unconscious structure with a given historical moment, this structure is no less prey to the displacements, the slippages (death of the father or mother, etc.) that can, if not transform fundamentally, at least fixate temporarily upon variants and polarities that are not in

all cases progressive. What needs to be stressed is the extent to which the common material ground that Matisse discovered was linked, in the mutuational traces that he produced, to a career that can in each instance only be apprehended in terms of the accidents that were inevitably produced by the limits of a "subject." Accidents that mark the ordering and the economy of these traces (signifying practices), "that have formed human language," and which, in his practice, continue to form language, painting and "the artist."

On Painting: The Two Lessons

If I have dwelt at some length upon Matisse's first "fauve" productions, it is because in themselves they constituted for the artist a standard of theoretical reference to which he would return repeatedly throughout his career. Fauvism for Matisse was the decisive accentuation of a type of relation with color that he cultivated diligently: the very nerves of his system. Matisse would speak continually of fauvism from 1905 to 1929 and in 1934 and 1936. Thus, when called upon to define the "Interiors" of 1947–48, Pierre Schneider could refer quite naturally to a "new fauvism."

As we have seen, Matisse was not the sort of artist who bet blindly and indiscriminately on modernity; each time his practice effected a radical transformation, the artist judged it against the history of painting in its most recent as well as most ancient manifestations. Nevertheless, his act of verification, positive in many of its aspects, was not without ambiguity. To be sure, the gesture of verification reveals the determining role played in a dialectical structure by the law of conversion of quantitative into qualitative changes; but once again we must consider the ambiguities that intervene in the space that separates a scientific reference from the subjective effects that authorize it without being able to control or understand it. We might thus conclude that the stubbornness that dictated in Matisse a constant articulation of the artist's practice against the quasi-universal history of painting was also somewhat idiosyncratic.

We have noted the effects of Matisse's social class on the two decisive moments in his choice of career (attorney and painter); they are characterized by the principle stated in the family motto, "Hurry up." We have also seen how this petit bourgeois principle prepared Matisse for an academic career (Bouguereau, the Salon,

etc.) and how the artist found himself called upon in his practice to make use of this "principle" toward other ends. This force, however capable of diverting a given ideological structure (of class) from its objectives, was not entirely stable, and the relation could very easily be reversed; indeed, the many stages of this relation were dichotomized and dialectical. Matisse expresses this dialectical awareness metaphorically in speaking of the *Dinner Table:* "The jury understood that there were microbes at the bottom of my carafes." As Gustave Moreau suggested, the carafes were realistic enough "for you to hang your hat on them," that is, realistic enough to respect the academic-ideological *principle;* at the same time, however, the principle was already weakened from within. Hence the complex and decisive importance of this painting, in which the introduction of instinctual components of the artist's practice poisoned, as it were, the ideological structure of academicism and diverted Matisse from its objectives. Having at first been subordinated to the dominant ideology, Matisse's idiosyncratic structures would then go on to render productive through a dialectical relationship the contradictions (drives) of the artist: those very drives that reason and resonate through the decision to invest a measure of irrationality in the social field.

From the *Dinner Table* (1897) to the *Woman with the Hat* (Madame Matisse, 1905) this relation of forces was set in place in such a way that the social class structure of the subject was enlisted to interact dialectically with the contradictions (neurosis-repression) that constituted that subject historically. The force that at an earlier moment had anticipated an academic setting for the *Dinner Table* (the Salon) would be progressively subverted by an ideology that would exclude it from this same setting. From the *Woman with the Hat* on, the conflicts that define the complex nature of the artist-subject were assimilated to the "qualities" of the social field that produced and transformed the order of those conflicts.

The period spanning 1905 to 1916 saw the production of such major works as the *Blue Nude* (1907), *Harmony in Red* (1908), *Dance* (1909–10), *Music* (1910), the *Red Studio* (1911), the *Blue Window* (1912), the *Portrait of Madame Matisse* (1913; Hermitage Museum), *Yvonne Landsberg* (1914), *The French Window at Collioure* (1914), the *View of Notre-Dame* (1914; Centenary exhibition catalogue, no. 126), the *Italian Woman* (1915), *Women at a Spring* (1916; Art Institute of Chicago), and *The Piano*

Lesson (1916–17). Matisse's mastery and the remarkable number of revolutionary transformations that he effected over the course of those years are such that no one of his canvases may be considered outside the general complexity of their intricate developments.[113] Critics are nonetheless absolutely correct to stress the consistency in Matisse's career of two simultaneous movements: tradition and the avant-garde. To stop at that, however, is to limit oneself to a schematic and descriptive point of view that does not lead very far. While these two moments, these two movements, can indeed be effectively traced throughout Matisse's career, the relation of one to the other (qualitative and quantitative) is rarely stable. While we have seen how the artist's class origin and the "principles" of his class could in a certain way contribute to the rigorous evolution of the most advanced aspects of his works, it should be noted that the struggles arising from these constraints were not always equally productive.[114]

If we accept the descriptive schema that historians have traced for Matisse's career, and if we accept the way they divide his work into a certain number of "periods," which is justifiable from the simple point of view of formal analysis, we must nonetheless recognize that, with very few exceptions, these formal periods are never entirely independent. Formally strong and "revolutionary" works by Matisse are often accompanied by more traditional works; and a certain period that appears to be dominated by more or less academic concerns may nevertheless include a number of avant-garde works. After a given moment in the artist's evolution, we also find in Matisse's work the inevitable reworking of formally advanced elements for more or less traditional—and often decorative—ends.

The Piano Lesson (Museum of Modern Art, New York), *The Music Lesson* (Barnes collection, Philadelphia) and *The Moroccans* (Museum of Modern Art, New York) make 1916 an important date for this "stylistic" confrontation of Matisse's "periods." Alfred Barr notes in this regard that the winter spent in Nice produced "the *relaxation* . . . of Matisse's style,"[115] while Raymond Escholier, quoting Gertrude Stein ("The Matisses were still living in Clamart Issy. They felt alone and worried; Matisse's family was caught in Saint Quentin behind the German lines, and his brother was a hostage there") emphasizes Matisse's patriotism—he was then seeking to enlist in the army ("to take part in the Battle of Verdun"). Escholier quotes the artist as saying: "Everyone who, like myself,

could still work felt their means depleted."[116] While World War I may not provide a sufficient explanation, it is extremely unlikely that the war did not directly affect the transformations that began to appear in Matisse's practice (a similar sort of confusion appears in Matisse's work in 1939–40). One such indication is that life in Paris became intolerable to him and he left for the south of France where, as Barr notes, the winter spent in Nice produced "the relaxation of Matisse's style."

A number of questions must be asked regarding the changes that appear in Matisse's work during this time; what was the effect, for instance, of the proximity and influence of Renoir, whom Matisse met for the first time in December 1917? One would first, of course, have to establish that Matisse's work somehow demonstrates formal evidence of this influence; in fact there is no such evidence, and what Alfred Barr calls the "relaxation" of Matisse's style had already begun before he met Renoir. Historical events (World War I), the geographical move (the stay in Nice), repeated encounters with one of the old masters of impressionism (Renoir)—all these are important events to be sure, but not sufficient to justify fully the metamorphosis suggested by the new "manner" that Matisse undertook. We still await the careful biography of the artist that will provide the significant pieces of information that are missing. The analysis of a practice that is given—as this one is—to subjective effects cannot forgo precise biographical documentation regarding the elements that condition it. Should we not emphasize the fact that the stay in Nice separated Matisse from his family? Should we not also consider Matisse's observation to George Besson, "Love . . . [is] not very compatible with intensive work . . . it is hard to express yourself in all directions at once"?[117] Indeed, why not also point out that during the first years of his marriage and his career, Matisse had three children, of whom the youngest, Pierre, was born when the artist was barely thirty-three? One can only hope for a definitive biography of Matisse in the not too distant future that will illuminate all of these questions and provide the documentation still lacking for a rigorous approach to his work.

The problems that historians run into when they try to establish the chronological relation between two paintings like *The Music Lesson* and *The Piano Lesson* can only be resolved by addressing the overdetermining influences in Matisse's production at the time. It is surprising, and in my opinion symptomatic, to see just how

much importance historians seem to attribute to family testimonies for the chronology of these two canvases. The most serious investigation has been that of Alfred Barr, who interviewed the artist's wife and son (Pierre) separately and thus received perfectly contradictory information: Madame Matisse put the more traditional painting (*The Music Lesson*) chronologically ahead of the more formally advanced one (*The Piano Lesson*), while Pierre Matisse seemed certain of the contrary. Alfred Barr emphasizes the difficulty of dating Matisse's work exactly for the years 1916–17, but he leans nonetheless toward the testimony of the son rather than that of the wife; he dates *The Piano Lesson* 1916 and *The Music Lesson* 1917. Jacques Lassaignes also accepts the dates established by Alfred Barr.[118] And the recent publication of the Matisse-Camoin correspondence ultimately confirms Pierre Matisse's judgment, yet without reducing the considerable "stylistic" distance that separates these two paintings. What produces the two movements they represent cannot be reduced to anecdotal coincidence; it is sufficiently rooted in the order of Matisse's system for their dates of composition, very close in any case, to be immaterial. What we do, however, retain from this new moment in Matisse's career is the disagreement between the wife and the son regarding the dating of a family painting, *The Music Lesson* (in other words, the role that the family structure may have played at that time). There is of course also the matter of the title of the two works, where the word *lesson* reappears, rendering abstract the objects in the more naturalistic painting (*The Music Lesson*) and adding extra emphasis to the object in the more abstract painting (*The Piano Lesson*).

From one painting to the other there is the exchange of two elements:

The Music Lesson		The Piano Lesson
Madame Matisse	=	two large fields of color
the oldest son	=	a sculpture of a woman
a Haydn score	=	a greenish-yellow candlestick
the artist's violin	=	a metronome

The piano teacher does not figure in *The Piano Lesson;* and, outside of the general structure of the two paintings, which stays the same,

the only two elements to pass from one work to the other are the youngest son at the piano (though in *The Piano Lesson* his face is marked by a form that recalls the form of the metronome, inverted) and the painting of the *Woman on a High Stool* of 1914.[119]

The Piano Lesson privileges the cultural dimension that constitutes it and draws attention to representations of this dimension: sculpture, painting, geometric abstraction. *The Music Lesson* uses these cultural referents only as the decor for a naturalistic family setting. This is made particularly explicit by the way Matisse uses the painting of the *Woman on a High Stool* in each of these canvases. In *The Music Lesson,* the *Woman on a High Stool* is sketched high up on the right side of the canvas; the way it is painted and presented leaves no doubt as to the reality of its frame; in *The Piano Lesson,* Matisse presents the *Woman on a High Stool* as a figure in the same color field as his son Pierre's head and, one might say, at virtually the same level of reality (to such a degree that Gaston Diehl and Johannes Itten, among others, were taken in by it).[120] Whatever the exact chronology of the two paintings, one must admit that it is the more abstract of the two (*The Piano Lesson*) that responds most clearly to the "theoretical" claims Matisse would make throughout his career and that justifies the most advanced character of his work. It was certainly not the first time that Matisse produced two versions (one traditional and the other avant-garde) of the same painting (cf. for example, *Notre-Dame* and *View of Notre-Dame,* 1914).[121] Something new emerges from these two "lessons," however, that is rather like the definition of a dichotomy whose contrary effects had until then been diffuse but which the artist could now firmly posit in terms of the oppositional unity of these two pieces. We read the dichotomy in the two "lessons" according to their order: music/piano, violin/metronome, picture/painting (in *The Music Lesson,* the *Woman on a High Stool* as a picture within a family picture; in *The Piano Lesson* it stands for painting in painting).[122] It is also obvious that Matisse's position in painting *The Music Lesson* is not at all the same as that of the artist

painting *The Piano Lesson;* to repeat a statement I have already quoted, I would maintain that Matisse's attitude in painting *The Music Lesson* is, in a way, not "alien to his life as a normal man," whereas the rigor (the metronome) demanded by *The Piano Lesson* is foreign to the "normality" of a family picture. In this respect, Alfred Barr is not wrong in suggesting that *The Piano Lesson* turns more toward an immediate past, whereas *The Music Lesson* anticipates paintings to come, though we should not forget that what would be produced in 1931–32, with the *Dance* panel for the Barnes Foundation, and around 1952, with the large paper cutouts, is to a certain extent also enacted in the ordering of these two "lessons" of 1916–17.

With an artist like Matisse, the pictorial work must constantly be imagined in terms of its relation to the position of the artist-subject. The formal articulation that is established in these two "lessons" cannot be read from a simple mechanistic point of view as a series of purely formal effects cut off from the context that produced them. The "machine" that produces them (Matisse) is linked to and in part constituted by his production and in such a way that at a certain point in the production, the displacements that take place refer back to the general economy of the entire apparatus (machine-product). Thus what can be read in the two "lessons" (normalized sensuality / sexual dictates or tradition / avant-garde), can also be thought in inverse terms from the order of formal effects, that is to say in terms of the economy of a subject which is also actualized through structural dichotomies. The curious result is, in almost all instances, that this dichotomized distribution systematically inverts the discourses it establishes.

The *Music Lesson* and all that it suggests of the lengthy "Nice period" in Matisse's career, a period marked by sensualism and generally qualified as happy, is entirely placed, as painting, under the constraining signs of a law (tradition and specularity) that is illustrated in the comfort of a family picture.

The *Piano Lesson,* on the contrary, emphasizes the constraints imposed by a work freed from the rules (guardrails) of tradition and specularity and contains no measure other than the immoderate measure of irrational "impulses" or drives.

It is clear from these two pieces, from these two signifying chains, that it is not necessarily the painting that the artist chooses *at that time* that best defines him; rather, in the play of contrary

forces that constitutes the painting (one canvas divides into two), Matisse finds himself at that moment able to gamble for the economy that will permit him to continue to paint with the least loss (at the least expense) to himself. When he chooses tradition, he makes the choice of economizing on his force (saving his strength), so that when the time is right he may once again risk the rigorous danger (metronome) of expending himself.

In the meantime, there are many displacements of interest in the artist's practice; for a period of several years, alongside the production of many more or less academic paintings, one notices a kind of decorative adaptation or reduction of the great formal transformations of the years 1905 to 1916–17. From 1916 on, a painting like *The Moroccans* testifies to Matisse's virtuosity in the formal treatment of referential, naturalistic pretexts in the organization of his compositions. We can clearly see in this painting how Matisse's technical know-how prevails over the work demanded by the production of new knowledge. In this admirably well-balanced painting, what Matisse calls his "plastic signs" emerge from the formal vocabulary he had been working on during the preceding years, which culminates in a mastery that is more a justification of the structure of this vocabulary than of the work that produced it. When Matisse denounces the systematic reproduction of what he calls "plastic signs," when he attacks artists who learn to make foliage by drawing 33, 33, he is establishing the very distance that separates his work from the formal vocabulary his work deals with. In the course of its development, this work eventually achieves a certain self-mastery; if the mastery does not result in the continued production of additional transformations, it risks becoming fixed in the reverse effects of what determined it. Thus *The Moroccans* demonstrates essentially that daring virtuosity of an artist in perfect possession of his means; yet it will be read, by inversion, as a demonstration of the way in which means can master an artist when he is reduced to reproducing them—to reproducing the 33 of the fine foliage master—and is committed thenceforth to academicism or decoration.

Dance

The three movements of Matisse's practice (transformation, tradition, decoration) constitute, at different levels, the force of his

work. The variations in the structural ordering of this force (the accentuation of any one of these three moments) stem from an economy whose most surprising feature remains, throughout the artist's entire career, the constancy of his effects of transgression. Matisse would never totally abandon the transgressive energy that generated the most important developments in his work. Indeed, even during the period of mastery and appropriation (from 1917 to 1930), the new forms that seemed to repress this force were ultimately reconverted into the artist's system of production. What needs to be stressed is the awareness that Matisse eventually gained as a result of these effects of mastery and knowledge—the way each time, one way or another, he ended up confronting his knowledge in the field of painting with a discipline (and a neighboring field of knowledge) in which he had everything yet to learn. The double game of knowledge/ignorance was "systematically" placed in the service of effects of knowledge testing their revolution in it. Matisse would insist (and an overview of his work confirms this) on the necessary recourse to extrapictorial disciplines. Sculpture, among others, would give him the possibility to think through and to test in another order the problems that painting presented him with elsewhere; similarly, the artist constantly returned to drawing, as still his greatest ignorance, his greatest weakness, his greatest gap to fill. In drawing he searched continually for that subjective charge that he needed to thrive. One might explain Matisse's interest in music from this same perspective, an interest that did, indeed, motivate him to take violin lessons.[123]

Thus it was that in 1930–32 the confrontation with a new element, mural painting, effected a decided transformation (evolution) in the artist's practice. The history of his "mural" (destined for the vaulted walls of the Barnes Foundation in Merion, Pennsylvania) demonstrates in many ways the quasi-"revolutionary" importance of its intrusion into Matisse's practice. We know that as a result of a mistake in dimension the panel had to be entirely redone. In January 1934 Matisse wrote to A. G. Romm:

> I am caught here in my present work, where I have nothing to refer to for details on my previous work . . . For the two full years just passed (1931–32 and 1933), I am enclosing a photograph of an important work that I have just completed for the Barnes Foundation (Philadelphia); it's a panel of 13 × 3.5

meters placed above three glass doors 6 meters high. The photograph of the whole thing with the doors, assembled together from different photographs, may give you an idea. The painting forms a kind of pediment to these three doors—like the upper part of a cathedral portal—a pediment located in the shade that must, nevertheless, by continuing the large mural surface that is opened by these three luminous bays, conserve all its own luminosity and consequently its plastic eloquence (a surface in the shade juxtaposed to a violently illuminated bay without destroying the continuity of the surface); this effect has been made possible by modern discoveries about the properties of color. The perspective, if you can imagine it, reduces the painted part because it is really three and a half meters high and the doors six meters . . . *This work is the most important I have done in the last three years;* in addition, the subject, analogous to one of my important works in Moscow (the *Dance*) might interest you in the juxtaposition of these two works. These panels are painted in flat hues. The surfaces between the doors, the *entreportes,* continue the decoration of the black surfaces and give a unity of surface from the ground right up to the top of the arch, $6 + 3.5$ meters $= 9.5$ meters, which, along with the pendentives that are supported by these black surfaces, gives the allusion of monumental support for the vault. Other colors—pink, blue, and the nudes in a uniform pearl gray color—form the entire musical harmony of the work.

The frankness of the contrasts and the determination of the relationships are in some way equivalent to the hardness of stone and the pointedness of the ribs of the vault, and confer the work with a great mural quality—very important since the panel is located in the upper portion of the large hall in the Barnes Foundation which is filled with paintings—from which it was only logical to differentiate my work of architectural painting . . .

The Merion panel was made especially for this setting. Separately I consider it only as an architectural fragment. It cannot really be moved out of context, and so I expect that these photographs will interest you only moderately despite my explanations.

You will find here two or three photographs representing two different versions of this dance. This is because, *due to a mistake in the dimensions* of the two pendentives, to which I had given 50 cm. instead of 1 meter at the base, I had to start

my first panel all over again when it was finished after a year of work. I am therefore including this first execution. The second is not simply a copy of the first, because, as a result of these different pendentives, which had to be composed with architectural masses twice as wide, I had to change my composition. The work I did even has a different feeling: The first is warlike, the second dionysiac; the colors, which are the same, have changed nonetheless; when the quantities changed, so did their quality: the colors are used with such frankness that it is the relations of quantity that determine their quality.

Since I am speaking to you about my work in so much detail, I should tell you that *I did another large work* of 60 etchings *to illustrate the "Poems of Mallarmé."*[124]

The letter to A. G. Romm clearly demonstrates the importance that Matisse objectively attached to the work on the panel for the Barnes Foundation; as such it also calls our attention to the subjective importance it held for the artist. An importance that was here brought into focus by the slip ("due to a mistake in the dimensions of the two pendentives . . . I had to start my first panel all over again") that forced Matisse to go over his work twice, to double it.[125] The letter in fact addresses the entire process that Matisse followed (cognition = knowledge/ignorance), the new problems that he set for himself as a result of this work, and the determining event that this work would eventually represent for him.[126] In addition, there is the curious conclusion to the letter in which Matisse suggests a certain equivalence between two apparently disproportionate productions: the "mural" and the sixty etchings that were to illustrate the "Poems of Mallarmé."

The relation between painting and drawing is established in two instances, which the letter to Romm seems to unite anecdotally. We may first look at the way Matisse brings together his two works: speaking of the "mural" he refers to "an important work"; of the etchings he mentions "another large work." This is not the place to quote Matisse's many remarks that stress the importance of his drawing for the development of this painting, or his remarks on the various problems that the relation between drawing and painting raised for him. What should be recalled is that Matisse would look for and find the solution to the problematic relation between drawing and painting ("then I am just an old crackpot who wants to start

his painting over again in order to die satisfied. That, however, is impossible. I want to make the kind of painting that relates to those drawings of mine that come to me directly from the heart and are traced with the greatest simplicity; and so I have committed myself to a very difficult path that seems inordinately ambitious given the little time remaining to me at my age. And yet, to be at peace with myself, I cannot do otherwise)[127] in his paper cutouts: "*Papier dé-coupé* [cut-and-pasted paper] lets me draw in color. It is a matter of simplification for me. Instead of outlining the contents and then filling in the color—the one modifying the other—I draw directly in color, which is all the more measured as it is not transposed. This simplification guarantees a precision in the reunion of two means, which become one."[128] The decisive relationship to what Matisse calls "a new means of expression" finally resolves a dichotomy (painting/drawing) by making it productive: a dichotomy that is in its subjective economy close in many ways to the dichotomy we have noted between the two "lessons" (the *Piano Lesson* and the *Music Lesson*).

Nevertheless, this privileged approach to the work of cutout drawing in colored paper did not come about through a sudden miracle of artistic inspiration. Here, as with everything else, Matisse's apprehension of the problem underwent a long period of elabora-tion; the overt origin of his use of colored paper cutouts goes back to 1931–32 and to the preparatory work for the Barnes mural. With this mural, Matisse found himself for the first time confronting prob-lems[129] that the letters to A. G. Romm do not fully take into account. In those letters, Matisse seems anxious to emphasize the objectivity of his approach; Romm writes to Matisse that in the Merion mural "the human element" is less pronounced than in the "dance" of the Shchukin collection, and, in a way, Matisse is of the same opinion. Nevertheless the artist's practice was far too vast and complex for him to allow himself to be locked into any rationalistic reduction for a work of this importance. At the time he wrote the letter to Romm quoted above, an interview that he had given to Dorothy Dudley appeared, in which he stated: "Calculated is not the word. For forty years I worked without interruption, I made studies and experi-ments. What I am doing now comes straight form the heart. Every-thing I paint is done in this way."[130] Much later he would write more precisely in a note to Raymond Escholier: "Perhaps it would be

worth indicating that the composition of the panel emerged from a body-to-body confrontation of the artist and 52 square meters of surface, which the artist's mind had to take possession of; and not through the modern procedure of projecting a composition 'on demand' onto a surface several times as large, and tracing it."[131]

It is this "body-to-body" confrontation and the *theoretical* distance that Matisse takes from the rational procedure of projection that gives the Merion panel its fundamental importance for the artist's practice. Nor can we ignore the analytical impact that such a formulation[132] calls forth along with the unconscious inscription it presupposes; at the same time, we must not forget the role of the objective reality that determined its production. When Matisse took on Dr. Barnes's commission, he was already sixty-two years old and physically unable to respond to the effort such a work demanded; this is the objective justification for the body-to-body confrontation of the colossal work (fifty-two square meters) with the physical possibilities of the artist who was obliged to use (and thus authorize the use of) paper *cutouts.* This obliged-authorization, or authorized-obligation, marks the transformational importance of this moment in Matisse's career. Several versions have been proposed for what was experienced at the time only as a technical process. Alfred Barr tells us on the strength of Pierre Matisse's account (the artist's son) that Matisse hired an assistant ("he had to hire an assistant to do some of the 'leg work' while he directed from below"),[133] while Pierre Schneider[134] maintains (unfortunately without quoting the source of his information) that "Matisse has *female assistants* color pieces of paper (with colors, it is true, chosen by him), and he then cuts them out with scissors and pins them—or has them pinned—to the wall."[135] From one account to the other we see the assistants not only multiply but change sex. A detailed analysis of the Merion panel would require additional information on this point. Indeed, in the "body-to-body" confrontation that Matisse speaks of, the intermediary of one (male) assistant or several (female) assistants changes the perspective on the analytical moment quite significantly.

For the moment, we may limit ourselves to the general adventure that the production of the Merion panel represented for Matisse, that is, the event—in every sense of the word—that produced and reproduced this work and the *cutting,* or *cut,* that it demonstrates

in so many ways. Body-to-body contact for the sixty-two-year-old artist with an enormous painted surface, effective cut: woman/ music/ dance. Once again, what is cut in color and will dance is Matisse's design (by design) of *the woman:*

I would perpetuate these nymphs . . .

Proud of my murmurs, I'll talk by the hour
Of goddesses; and using painted idols,
Shall from their shadow still make off with girdles:
So, having sucked the brightness from the grapes,
To banish a regret my laughter keeps
At bay, I lift the cluster to the sky
Empty, and puffing up its clear skins, dry
For drunkenness, look through it till day dies . . .

I hold the queen!

O certain doom . . .

(Mallarmé, "The Afternoon of a Faun")[136]

Drawing with Scissors

The break that took place in 1930–32 would over the next fifteen years find its articulation in Matisse's great *papiers découpés.*[137] That real act of cutting ultimately allowed the artist—in a continuation of the moment that had produced the Merion "mural" and the illustrations for the *Poems of Mallarmé*[138]—to cut himself off from the false divisions and neatly cut dichotomies. The painting/drawing, color/design problem had established itself very early in Matisse's canvases and was structurally linked to the order of the artist's system. A painting such as *The Red Studio,* for example (1911, Museum of Modern Art, New York) already shows evidence of this preoccupation. In the studio that is colored red, in the studio (the factory), in the production of the red, in the red, the works, paintings, and sculptures of Matisse appear as so many holes, and openings—not windows onto the world but escapes from colors into an overwhelming master color—while the figures of "reality" (the furniture in the studio) are presented in silhouette, *cut against a uniform background of color.* High on the right, *Le Luxe* (1907), low on the left, on the table, curled *in a plate,*[139] a sleeping woman. This drawing in color establishes the productive organization of Matisse's system. In its structural model, it alone permits us to understand the

double negation of 1916–17 (piano-music); the relation of drawing to color in that system again emerges in the problems that the sixty-two-year-old artist had to confront "body-to-body" in the Merion panel *The Dance.* Equal emphasis is placed on the act of cutting (that is, the use of paper cutouts) and the drawing that is cut, that cuts into a surface (the etchings on copper for the illustrations to the *Poems of Mallarmé*).[140]

This *cutting* (castrating) side of Matisse's design (project) comes also from what he *himself* cuts from the painting (from color). The aggressive quality of color (cf. above, "the painted woman" and fauvism) is also the object of this cutting (*MA,* the feminine possessive adjective—*TISSE,* weaves, interlaces), which is not a separation (a division into two *lessons,* piano/music, tradition/avant-garde, etc.) but the negation of negation (the Merion Dance). It is the inscription of castration ("Whoever wants to give himself to painting must begin by cutting out his tongue" . . . "to draw with scissors, to cut *to the quick* in color").[141] So it is with his great paper cutouts that the artist, at the age of seventy-nine, after over fifty years of work, converted an old, stubborn force into a new intelligence.

Papier Collé

The account that I have here proposed of Matisse's work does not claim to be in any way exhaustive. Within the project of establishing the "program" that conditions the Matissian model, I have obviously been able to touch only briefly upon most of the artist's paintings. Each of these readings necessarily demands to be taken up again and developed further.

April 1970–July 1971

Rereading once again this essay on Matisse (February 1976), I note that close to the end, in my attempt to conclude the essay, I allowed myself a play on words based on the artist's name. This could provide a conclusion of sorts, since the essay was subtitled "Introduction to a Program," and since the play on words, which may have been somewhat empirical then, now seems to me to be a possible key to the Matissian program. In my essay, Matisse, situated and understood in terms of a castration fantasy ("whoever wants to give himself to painting must begin by cutting out his tongue," *Jazz*) was interpreted: *MA*, the feminine possessive adjective–*TISSE*, interweave. I would like to return to that play on words today to develop the hidden meaning it contained: *Ma*, it/she who is mine, *Tisse*, weaves. To provide some distance from what might appear to be too personal an obsession on my part, I refer the skeptical reader to the first appearance of Matisse's name in the work of Louis Aragon. It is curious that Matisse's name does not in fact appear for the first time in one of the articles devoted to the artist and collected in *Henri Matisse, a Novel* (a "novel" that Aragon himself tells us was an "obsession"). Matisse appears for the first time in a piece signed by Aragon in *Le Libertinage* (1924). In a short story entitled "Madame Goes up to Her Tower" and dedicated to André Breton, Aragon uses the name Matisse as a woman's first name: "Exceptionally, Matisse is not a Russian woman (*une Russe*) but a redhead (*une rousse*) who was born in Batignolles a good twenty years ago." Needless to say, this text was not reprinted in *Henri Matisse, a Novel.* If we are to believe the different preambles, prefaces, and inserts that comprise the work, however, it is entirely possible that it acts as the book's unconscious program: "A young man, presumptuous but very rich, who wished to inspire Matisse with the desire for his own person, had given her an authentic Rembrandt and bust by Houdon [*Le Libertinage*], in the belief that women of taste always adore the Fine Arts." This is just one example among many, of course, selected not to prefigure the role of the artist's own name in the future admiration of art lovers before his work, although that role is certainly an important one, taking part as it

does among the particularities "woven" [*qui se tissent*] into the genius of the painter. MA-TISSE, as the displaced interest expressed by Aragon shows, is located somewhere between a feminine character ("Madame Goes up to Her Tower") and Henri Matisse the painter; it contains and evokes more or less consciously something like the enigma that children find in the anatomical difference between the sexes. If *MA* is a feminine possessive adjective, *TISSE* (weaves) evokes the activity whose invention, according to Freud, should be attributed to women: "It seems that women have made few contributions to the discoveries and inventions in the history of civilization; there is, however, one technique which they may have invented—that of plaiting and weaving [in French, *le tissage*]. If that is so, we should be tempted to guess the unconscious motive for the achievement. Nature herself would seem to have given the model which this achievement imitates by causing the growth at maturity of the pubic hair that conceals the genitals. The step that remained to be taken lay in making the threads adhere to one another, while on the body they stick into the skin and are only matted together." ("Femininity," in *New Introductory Lectures on Psychoanalysis*). In the space between *Ma* (my own—fem.) and *Tisse* a curious castration fantasy seems to be enacted; from that same space comes the painter's genius as well. (Cf. my article "La Folie Thétique," in *Tel Quel* 65, Spring 1976.)

The whole universe is stripped of reality, the image of a magic spectacle . . . External objects depend on knowledge, and therefore this world is empty.

Vijñana bhairava agama

2 Mondrian, Twenty-five Years Later

1. TESTING THE MODEL

Detour

In 1970, twenty-five years after the artist's death and a little more than thirty years after his last stay in Paris, French museums devote a retrospective exhibition to the work of Piet Mondrian. This long detour should have promised a critical (or autocritical) undertaking to look back on the double history of Mondrian's reputation: Mondrian twenty-five years ago and Mondrian today. Given the self-satisfaction with which the French have tended to publicize their "virtues," the least one might have expected from this exhibition was more precise information regarding the sources and influences of French painting on Mondrian (Mondrian and the postimpressionists, Van Gogh, the pointillists; Mondrian / Jan Toorop / Manet; Mondrian / Jan Sluyters / Matisse, etc.).

Yet none of this is even hinted at in the retrospective at the Orangerie, which has simply seen fit to repeat Michel Seuphor's old argument regarding Mondrian and "naturalist" abstraction, an interpretation based on the "flatness" of Dutch landscape and the famous theory of the horizontal and the vertical taken in part from the *Sketchbooks of 1911* and "Natural Reality and Abstract Reality" (1919, 1920): "In this landscape the horizontal appears to us only in the line of the horizon. A single position is thus positively expressed. On the other hand, neither the contrary position, the vertical, nor any other, is exactly expressed in this landscape, that is, in

a linear fashion. Nevertheless, an opposition *is* expressed by the sky, its elevated position appearing as a vast plane—an indeterminate plane, it is true, but one on which the moon makes an exact point. Thus, the plane of the sky is defined from this point to the horizon. The definition is a vertical line, even though such a line is not apparent in the scene before us. It is for us to trace it in order to express positively the opposition of the horizontal."

Within this perspective, Mondrian's discovery of cubism (at the exhibition of the Modern Art Circle, Amsterdam Municipal Museum, October 1911) and his first stay in Paris (1912 to 1914) are the decisive moments in the artist's rejection of an immediate naturalist reference and in his move toward geometrical "translation." At issue here is a kind of interpretation which, for its likeliness and success, is essentially hinged upon an uncritical reading of aspects of certain published writings by the artist that are at times admittedly naive. Simiarly, Michel Butor, in "Le Carré et son habitant" (*NRF,* January–February 1961), in effect repeats Seuphor's thesis. This *noncritical* point of view comes from a cultural model that considers painting in its autonomy (as a standard of specularity) and finds in Mondrian its idealist justification. We must question Michel Butor's remark regarding the nontragic definition that Mondrian seeks to maintain in painting: "We can see that Mondrian is plainly conscious of the tragic character that a cross may represent in his compositions, especially a Latin cross, of which the lower vertical branch is visibly longer than the horizontal branches. As for the 'rather literary' idea that he spoke of, it is very familiar to us; it is a traditional religious idea that haunts the consciousness of every person in the Western world. It is all the more remarkable, from 1935 on, to see this cross literally invade his paintings." Might these comments not suggest—indeed, do they not suggest—that Mondrian's cross, the passage from the "tragic" to the nontragic cross, is nothing other than a passage to the heights of Hegelian idealism? In the vertical and the horizontal that cross each other to form a nontragic cross, in this square occupied by a nontragic cross, the secular thus rediscovers the transcendental justification that the disappearance of the naturalist figure as immediate referant necessarily put into question.

As presented to us at the Orangerie—indeed, as it has always been presented to us—Mondrian's work is nothing but the evolu-

tionist addition of a work and an author to a closed history that sets out to repeat itself in the form of an "abstract" *idea*. Seen from this point of view, the catalogue edited by Michel Seuphor (*Piet Mondrian*, Flammarion, 1956) is significant: It is the *figure*, isolated outside of any chronology, that determines and serves to organize the *œuvre*. The *œuvre* in turn is reconstructed from that angle as a vocabulary whose representative effects Mondrian's work simply serves to confirm. Not surprisingly, the self-portrait begins the list, since a figure must be assigned to the artist's name if we want to valorize that name as the signature of representative effects. In his self-portrait, the artist proves his "talent" for ordering figures, and consequently assures his authority in the cultural order which can thus accord him the accuracy of his verification from nature. First of all then, we have the self-portrait; then come the portraits of women, nudes, landscapes, cows, farms, windmills, chrysanthemums, millstones, trees, dunes and beaches, piers, towers, building facades, etc.

All this is made possible from the restricted perspective of a cultural model that is in fact capable of functioning solely at the level of its "verification" and whose specular system (the work/the author) assures, under the name of Mondrian, a singular totality (the *œuvre* of . . .) only to better censor the contradictions that might eventually disturb its order.

The Little "a"

It must be understood from the start that our point here is not to reject an entire portion of Mondrian's work, nor to pretend that Mondrian did not paint portraits of women, landscapes, dunes, towers, piers, facades, etc. Nor are we advocating that certain aspects of his writing be ignored. For surely it is precisely the contradictory totality of Mondrian's work that allows us to think out, in all its various effects, the problematic at work in it.

Mondrian was nine years older than Picasso and ten years older than Braque; as such, the artist's maturity at the moment when he discovered cubism can certainly not be overlooked. Mondrian, born in 1872, was almost forty at the time. We should, however, take note of the gap that separated Mondrian's painting of that period from the cubist painters'. While the nature of this gap is difficult for us to appreciate fully, Mondrian's trip to Paris in the months

following the Modern Art Circle exhibition at the Amsterdam Municipal Museum (October 1911) may serve nonetheless as a point of reference. This trip was only the second that Mondrian had taken outside of his country; the first, in 1901, was a trip to Spain in the company of Simon Maris—a trip, it would seem, that bore no influence on Mondrian's work. The trip to Paris, on the other hand, would constitute an important event for Mondrian's painting; indeed it was then that the painter decided to change the spelling of his name (from Mondriaan to Mondrian) in order to mark that period in his evolution. Given that he would maintain that spelling of his signature until his death, the trip to Paris can be singled out as the determining moment, above all others, in his evolution.

The passage from Mondriaan to Mondrian at this decisive moment can be viewed from several angles—from the evolutionist perspective of critics and biographers or from the perspective of deliberate cultural propaganda, as in the remarks of Jean Leymarie, president of the organizing committee for the exhibit at the Orangerie: "The Dutch painter and theosophist, Mondrian, who, on settling in France, decided to write his thenceforth historic name with a single *a*, Mondrian, lived in Parris from 1912 to 1914, then from 1919 to 1938. Only the hazards of war separated him briefly from his adopted city or forced him to leave it" (Preface to the exhibition catalogue).

In the move from Amsterdam to Paris, it seems clear to me that the fact of leaving Amsterdam is at least as significant as the choice of cubist painting. What this departure allows us to understand is the distance that separated Mondrian's practice from that of the cubist painters. We must not forget that, at the time he left Amsterdam, Mondrian was far from being an unknown artist: he had his critics and his supporters, and he had already participated in two group shows at the Amsterdam Municipal Museum (1909 and 1910), which drew considerable attention—indeed, they made something of a sensation; the painter was subsequently treated as "sick and abnormal." Mondrian was thus more or less caught at the center of various polemics in the Dutch press, attacked by N. H. Wolf, defended by Conrad Kickert. By the time he left Holland, he was on the directing committee that organized the international art exhibits at the Modern Art Circle. Here, however, we should pause to consider more closely those paintings of 1908 to 1911 that

aroused the sensation; they range from *Woods near Oele* (1907–09) to *Evolution* (1910–11). *Evolution* appeared at the Modern Art Circle exhibition next to a tribute to Paul Cézanne and paintings by Braque and Picasso.

These canvases by Mondrian, starting with the *Woods near Oele* and the various series paintings—the millstones, the trees, the dunes, the towers—are enclosed in a subjective space that the artist seeks to reduce by flattening it out. He focuses on the vertical plane of the subject (this holds true particularly for the series of millstones and towers as well as for the three nudes that the *Evolution* triptych comprises) at the same time as he creates a more or less naive—or decorative in the case of *Evolution*—dramatization of the dominant figure (and this holds true for the trees as well, their branches grabbing the surface of the canvas). We can clearly see how the stylized contour of the three female nudes in *Evolution* attempt, with only partial success, to reduce the emphatic, indeed dramatic, accent that the figure acquires when it occupies the full plane of the canvas; the nudes, like the towers, stretch across the full height of the painting. In making the overgrown figure touch the frame of the picture, however, the artist does not succeed in reducing naturalistic space; attention is simply drawn to the nature of the figure, which in its stylization becomes essentially decorative. It would not be until the Hague *Nude* of 1912 that one would find the figure diffusing onto uneven planes and surfaces, blurring at the edges and losing its anecdotally emphatic massiveness. But here the cubists had already left their mark.

Without a doubt the two versions of the *Still Life with Ginger-Pot* (1911–12) best trace the passage of the Cézanne retrospective and the exhibition of Picasso and Braque paintings in Amsterdam. One may well imagine the effect they must have had on the painter. Robert P. Welsh (*Catalogue to the Toronto and Philadelphia Exhibitions*), juxtaposing Mondrian's painting *Evolution* to the paintings of Cézanne, Braque, and Picasso, thinks it possible that *Still Life with Ginger-Pot, No. 1* may have been started in Holland before Mondrian's departure for Paris. He bases this hypothesis on the fact that Mondrian, before leaving Amsterdam, might have given a ginger-pot to his friend A. P. van Briel. The hypothesis is feasible, although it in no way explains the reasoning behind these two still lifes with kitchen utensils, completed and abandoned in the middle of a

period of artistic endeavor that was entirely organized around the production of various series. No doubt ginger-pots are common objects in Dutch households, given the colonial interests in Indonesia; no doubt the choice of subject may even recall the still lifes with breakfast of the great seventeenth-century Dutch painters, even though one may well ask whether the presence of a ginger-pot is indispensable at breakfast. None of this, however, explains the sudden discovery of still life by an artist who until then had ignored it. In the entire catalogue there are only two other still lifes, dating from 1893 and 1900. For this reason it would seem that even if we grant Robert Welsh his hypothesis that the still life is of Dutch tradition, we must address the iconography of these two Mondrian paintings more carefully. The subject may indeed be Dutch, but the form is hardly so and surely recalls more pertinently any of Cézanne's still lifes (especially *Still Life No. 1* with its white rag, which breaks and displaces the lines of the table edge) than any still life of the Dutch tradition. I have been unable to verify which twenty-eight Cézanne paintings were displayed at the first Amsterdam exhibition of the Modern Art Circle; nevertheless it would be surprising indeed to find that they did not include a single still life painting—one of those still lifes in which the plane of the table top is raised upright while a wrinkled dish towel breaks the table edge and the realistic illusion of the plane; one of those still lifes whose iconography, although not Dutch, often contains a ginger-pot of a grayish-green steel-blue color as, for instance, in the Munich still life (Bayerische Staatsgemäldes-ammlungen) or the still life in the S. C. Clark collection at the Metropolitan Museum of New York. Indeed, the examples of Cézanne's still lifes that contain the famous ginger-pot are too numerous to list.

What is of particular interest in this more than likely encounter (even if no still life with ginger-pot figured in the 1911 Amsterdam retrospective) is the important fact that the cubists were introduced here, historically, within the perspective opened up by Cézanne. If the work produced by the cubists seemed to resolve certain of the problems that had been preoccupying Mondrian for some years, the twenty-eight Cézanne pictures exhibited at the same show could not help but make the Dutch artist see both the time he had lost trying to escape from the academic Dutch tradition—that critics today would like to lock him back into—and his theoretical lag behind the artistic breakthrough that had been de-

finitively effected by Cézanne: the same breakthrough that he himself was seeking, unsuccessfully, to achieve in his own work.

The departure for Paris and the change of name symbolically reproduce within the artist's biography the rupture that he sought to effect in his practice as a painter within the continuity of a historicized field of knowledge. This rupture, to the extent that it was already theoretically assumed by others, would be acknowledged by Mondrian first as a biographical event before taking effect in the artistic transformations that are familiar to us.

The two *Still Lifes with Ginger-Pot,* strategically and historically isolated within Mondrian's production, thus occupy a very important place in Mondrian's passage through cubism and in the emerging specificity of his own practice. Furthermore, we should not overlook the fact that the artist deliberately numbered his passage from one still life to the other; the first is dated 1912 by Seuphor, while the Gemmeentemuseum catalogue (the Hague) as well as the Toronto and Philadelphia exhibition catalogues hesitate between 1911 and 1912. Nor should we forget that the transformation of Mondrian's name takes place in the space of these two paintings, from the first, signed with two *a*'s (and Cézannian in inspiration) to the second, which is signed with a single *a* (Seuphor and the Orangerie catalogue date this painting 1912; the Gemmeentemuseum dates it 1911 or 1912).

What is played out in the passage from the first to the second of these paintings is of the greatest interest. In the first, Mondrian, without being in the least bothered by the figure (or the heading "Ginger-pot") manages to break out of the space that is dramatized in large "towers" by giving the same value to a multiplicity of planes that play off more or less similar surfaces. In the second painting the surface is fragmented into small geometrical surfaces that turn about the ginger-pot; this ginger-pot is raised to a kind of apotheosis that is reminiscent of the decorative naiveté and modern style of *Evolution.* John Golding, in the conclusion to his book on cubism, correctly notes that "Mondrian, without entering deeper into the spirit and significance of Cubism, had seized at once on the methods of composition evolved by the Cubists." More than any other painting, *Still Life with Ginger-Pot, No. 2* serves to confirm this interpretation at the same time as it emphasizes one of the aspects of the pictorial problematic particular to Mondrian himself.

It remains to be seen how and why Mondrian did not enter deeper into "the spirit and significance" of cubism; just what did this "restraint" allow him to both gain and lose? Given the artistic strength at the artist's disposal before as well as after 1912 (by this I mean the strength to produce a transformation within his work), if we are led—as indeed we are—to identify in his practice a radical *shift*, we must try to define all the effects of that movement. Even in considering the encounter with cubism as a determining factor in Mondrian's work, we must at the same time acknowledge the limits of its "effects." The *Still Life with Ginger-Pot, No. 2* is certainly exemplary of the reappropriation of "the methods of composition" found by the cubists toward ends that were not absolutely those of cubism. The painting, in this regard, is far from being isolated, and compositions such as *Flowering Appletree* (1912; no. 38 in the Orangerie catalogue) and *Composition in Oval* (tree series 1912–13; no. 190 in the Seuphor catalogue) provide ample evidence of the differences that would separate Mondrian from the cubists. From this point of view the Toronto exhibition, which made a point of stressing the very earliest paintings by the artist, is infinitely more interesting than the show at the Orangerie.

In an Unconscious Manner

Piet Mondrian, born in 1872 and nephew of Frits Mondriaan, a professional painter, had an essentially academic education. It was his uncle (born in 1853) who gave him his first drawing lessons, before he went on to the more classical studies (perspective, stylization, etc.); these in turn led him to a diploma for teaching drawing in elementary schools (1889) and later (1892) to a similar diploma for secondary school teaching. 1892 was also the date when Mondrian entered the Amsterdam Academy, where he would continue to take courses for five years. The article by Robert Rosenblum, at the beginning of the Toronto exhibition catalogue, is of particular interest regarding Mondrian's artistic formation. In it Rosenblum argues for Mondrian's double adherence to the nineteenth and twentieth centuries, and he discusses, in particular, Mondrian's relations and connections with the first generation of German romantics (especially Caspar David Friedrich). This despite an autobiographical essay published in 1941 in which Mondrian openly denied his links with romantic painting: "By the light of the moon I sketched cows standing or lying down, motionless on

the flat meadows of Holland or houses with darkened, deathly windows. But I did not paint as a romantic: I observed with the eyes of a realist." In this instance, however, it is the art historian who is correct rather than the artist who reads his desire to escape from the space of his academic knowledge as a reality. Until very late in his career, Mondrian's work would remain variously marked by this "romantic" emphasis.

The episodic influence of Vincent Van Gogh would not change anything of the illusion that the artist continued to cling to: interpreting his desire as reality, the desire to "observe with the eyes of a realist." The text of the autobiographical essay, "Toward the True Vision of Reality," contains a curious contradiction. Shortly after saying, "I observed with the eyes of a realist," Mondrian writes: "Nevertheless, I was urged by my entourage also to paint things according to *ordinary vision*" (my emphasis). The contradiction is barely apparent, and we must read beyond the words to find just what Mondrian is trying, awkwardly, to define. The opposition that we find here between "the eyes of the realist," the "gaze" of the eyes of the realist, and "ordinary vision" is apparently supposed to reduce the contradictory space within which the artist, at least until 1912, was struggling. This is the same sort of opposition that makes Cézanne say that it is necessary "to give the image of what we see, all the while forgetting everything that has appeared prior to us" (Cézanne to Joachim Gasquet). It belongs indeed to the set of oppositions that produced the theoretical breakthrough of Cézanne and cubism. Mondrian became aware of this breakthrough in 1911, after proceeding in a manner that he himself recognized as empirical. This is confirmed a little farther on in the autobiographical essay: "After several years of hard work, my works started deviating more and more from the natural aspect of reality. *This in an unconscious manner,* while I was working away. I didn't know much about the moderns. What I knew of them I admired; nevertheless, I had to find my own way" (my emphasis). Mondrian is clearly singling out the period when he knew little about the moderns, that is, the period preceding the Modern Art Circle exhibition in Amsterdam (1911), a date after which he could no longer claim to know nothing of them.

Thus it is the artist himself who alerts us via various detours to the elements that let us define the specificity of his work, seen from the perspective of a precise historical lag ("I didn't know much

about the moderns"). As an artist attached to both the nineteenth and twentieth centuries, Mondrian participated at once—but here very empirically—in the Cézannian deconstruction, which also had its sources in "romanticism," and in its cubist and postcubist aftermath.

What the 1911 exhibition offered Mondrian was an awareness of both his unnecessarily slow work, produced "in an unconscious manner," and his own historical backwardness. This backwardness had as its first logical consequence the arbitrary use of methods of composition borrowed from cubism without the artist's total penetration into "the spirit and meaning of cubism," but it also had the long-term effect of offering Mondrian the possibility of seeing cubism as something other than an end or a style. He could use cubism not as a way to establish yet another style in the history of painting but as a way to return to the deconstruction which until then he had practiced "in an unconscious manner." In other words it gave him the chance to use the achievements of Cézanne's followers as a rational base or springboard.

One certainly would not want to suggest here that Mondrian moved suddenly from an empirical practice to a theoretical one; it can be argued that following his encounter with cubism he would try, in his work as a painter as well as in the essays that accompany his work (starting with the *Sketchbooks of 1914*), to rationalize his research by theorizing it—by finding theory in it.

Twenty-five years after Mondrian's death, it is this return to the historical "shifts" and determinations of his work that alone can provide an adequate approach to the very paintings that the Orangerie exhibition emphasizes without the least bit of critical information (the catalogue for the 1970 exhibition does basically no more than reproduce Michel Seuphor's argument, itself already quite dated in its critical approach). The period these pieces date from, 1914 to 1944, is no less fraught with ambiguities than the period ending in 1911 with the transformation of the artist's signature and his departure for Paris.

2. THE CUBISTS

Color and the Object of Knowledge

If we want to avoid falling into the mythology of the isolated genius whose "originality" defies both our understanding and our

explanation—if we want to understand positively what distin-
guishes Mondrian from the cubists and why this distinction ex-
ists—in short, if we want to see how and why the specificity of
Mondrian's work functions in the first half of the twentieth century,
we must return to and insist upon the gap between "Mondrian and
the moderns" that we have already noted. In the autobiographical
essay that he edited at the end of his life, Mondrian stressed the fact
that he didn't "know much about the moderns" and that he had to
find his own way; but all this seems too vague for us to accept at
face value (as critics too often do, reading into these remarks
Mondrian's claim for some sort of "creative genius" detached from
history).

The ambiguity of such a remark allows in fact for a great many
interpretations. From the *Landscapes, Woods and Trees,* and *Sea-
scapes* of 1888–90 to *Broadway Boogie-Woogie* of 1943, Mon-
drian's course was (is) too consistently marked by the work of
historically determined investigations and formal confrontations for
us to dwell on a single subjective effect in a biographical note. What
does strike me, however, as particularly important in this note is not
so much that subjective effect as the distinction that Mondrian
seems to draw between his own work and that of the cubists.

When Mondrian wrote this essay (1941), he was perfectly aware
that his biography was marked by the passage of the Cézanne and
cubist exhibition through Amsterdam and by the transformation
that he had effected in the spelling of his name. If he insists, then, on
his lack of familiarity with the moderns, is it not also a way of signal-
ing on the one hand the distinctive gap that may have existed at
that time between his practice and the practice of the moderns and,
on the other, his own personal itinerary through the history of
painting? A path, an itinerary that inscribes the encounter with the
cubists in a totally different perspective than the one envisaged by
cubism. The distinction that is made at that time is important to
emphasize. For one thing, when Mondrian discovered cubism, it
was no longer at the point of searching for or questioning "the
meaning of Cézannian construction." John Golding isolates the
paintings done by Picasso at Cadaqués in 1910 as the achievement
"of a Cubism that would never be more abstract or hermetic"; it is
therefore more as an established style than as a method of investiga-
tion and research that Mondrian confronted the cubist contribu-
tion, retaining no doubt for his own account "the methods of

composition" (Golding) but not "the spirit." And it is in fact this "spirit" that must be questioned if we are to arrive at a definition of the relation between Mondrian and cubism around 1911.

At that time, cubism was and would remain blinded by the importance of the formal effects that it had produced by reducing the space of Cézanne's work—blinded to the point of being unable to consider the fact that the critique implied by and contained with Cézanne's work was concerned with the differential specificity of the pictorial code and could not be reduced to formal effects alone. To limit oneself to that formal character alone would be to establish a new code of (specular) representation as phenomenological description (a description of phenomena of light as, for example, in some of the paintings by Juan Gris). This amounted to replacing the conventional space of so-called scientific perspective with another convention, summoned, like the first, to play out the repetition of the dominant ideological structure decoratively.

We might say that in discovering cubism as a "style" among others (a discovery made possible by the lag in Mondrian's work behind more recent manifestations in art history), Mondrian perceived well before the cubists the impasse that would end in the decorative illustration of the same, always repeated, space—an impasse that Picasso and Braque implicitly recognized shortly afterward when they abandoned once and for all the questions raised for them by the powerful work of Cézanne.

It should also be stressed that if the cubists *thought* painting in its autonomy (in the autonomy of its own history), Mondrian, a member of the Theosophical Society since May 1909, conceived of it in what one might call its cosmic aspects. One need only look at the theories he developed three years later in the *Sketchbooks of 1914;* there his primary mysticism tries to go beyond the reduction of painting to a fundamentally decorative object. Naive as these texts may be, they merit our attention for they help us to see the kind of empiricism that can, in a certain historical "climate," prove briefly productive. We read for example: "Art exists beyond all reality, it has no direct relation to reality. Between the physical and the ethereal spheres there is a frontier where our senses end. Nevertheless, the ether penetrates the physical sphere and acts upon it. In such a way the spiritual sphere penetrates reality." In order to go beyond the purely formal aspect of the vertical and the horizontal, Mondrian

adds more precisely: "As the masculine principle is represented by the vertical line, man will recognize this element, for example, in the trees rising in a forest. He will find his complement, for example, in the horizontal line of the sea. Woman will recognize herself rather in the extended lines of the sea and will see her complement in the vertical lines of the forest, which represent the masculine element. Impressions thus differ from one sex to the other."

One could go on quoting these speculations which are, to say the least, tentative. From them we retain principally a disruptive effect at the level of the fiction of representation, of verification from nature. Without going beyond the metaphysical "definition" of art, Mondrian disrupts the system by basing its empirical functionality on a symbolic structure that is theoretically inadequate to reveal the contradictions of the system. In other words, by displacing the mode of logical representation ("the masculine principle is *represented* by the vertical line . . .") onto a purely subjective model, Mondrian allows himself, empirically, the possibility of upsetting it and temporarily questioning it from the outside.

Mondrian's very first contacts with cubism are marked by the distinctive accent of "irrationality" that led Apollinaire to write of "the highly abstract painting of Mondrian": "Mondrian, an offshoot of the cubists, is certainly not their imitator. He seems to have been influenced above all by Picasso, but his personality has remained wholly his own. His trees and his portrait of a woman reveal an *intellectual* sensibility [my emphasis]. This kind of cubism is heading in a direction different from that currently pursued by Braque and Picasso" (1913).[1] In fact, from 1912 to 1913 (the painting Apollinaire refers to is quite probably the *Female Figure,* dated 1912), the work by Mondrian that is closest to Parisian cubism is also quite distinct from it; in contrast to the profusion of planes that the cubists use, it offers a symbolic kind of abstract reduction that ultimately transcends the chosen subject of the painting. To illustrate this point we can compare a Braque painting, such as *The Man with a Violin* (1911; Bührle collection, Zurich) to one of the *Oval Compositions* (tree series) of 1913, to see just how much Braque's choice—however "abstract" this painting may otherwise be—allows him to make anecdotal quotations and to scatter referential elements throughout: musical notations, the stave, etc. Mondrian, on the other hand, from 1912 on, actively erases all references that

are not inscribed in the symbolic structure, designed to "represent" through a transcendence of the chosen subject. From the *Flowering Apple tree* (1912; Gemmeentemuseum, the Hague) to *Composition No. 7* (1913; Guggenheim Museum) the artist's procedure, dictated by a reduction of the symbolic structures of the chosen subject, constantly reaffirms itself, gradually stripping away all elements of anecdotal reference. The few traces of referential signs that are scattered throughout the paintings of 1913 and 1914 function only to the extent that they overlap with the grid that has already been symbolically set into place; such is the example of the famous letters KUB on the 1914 facades (*Oval Composition*, 1914; no. 281 in the Seuphor catalogue).

When he returned to Holland in 1914 Mondrian tried to work his project into a system and to think it out in more theoretical terms; this eventually led to both the very important series of horizontal oval studies called *The Sea* (nos. 224–29 in the Seuphor catalogue) and the notes in the *Sketchbooks.* Cubism, in short, helped Mondrian to disengage himself from a symbolism expressive of the figure as in *Evolution* or even *Still Life with Ginger-Pot, No. 2.* Given the practical and theoretical lag in the artist's work when compared to the "School of Paris," this prepared him to go beyond cubism's essentially realist interest in the "subject," and helped him, in his desire for symbolic abstraction, to investigate a space designed to overturn the cubist reduction.

It should in fact be noted that Mondrian's relation to cubism was not primarily a relation to cubist space, nor to the way in which cubism inscribed the figure *in a tridimensional space* with little depth. Mondrian used the cubists' way of decomposing the figure but not their way of inscribing it in space. This is particularly evident in the choice of model, which for the cubists had to respond to the order of a composition in which it was generally centered and focused upon in such a way as to display its personality in space: the Pernod bottle, the bottle and glass, the violin and pitcher, etc. Nothing of this order is to be found in the work of Mondrian, except perhaps at the very beginning of his contact with cubism (1911–12). He rediscovered at that time through his own selective interest problems that had already been apparent to him in 1908– 10 when he was working on the series of lighthouses (1909–10), trees (1909–11) and millstones (1908): that is, the problem of ob-

jects viewed as close-ups, which somehow close (fill by closing) the surface of the canvas.

The series of lighthouses are particularly indicative of Mondrian's desire to break out of the picture frame, a desire that we find actualized in his last paintings. One need only recall the rectangular paintings of towers painted in their full height; they fill almost the entire width of the canvas and—with very few exceptions—touch the top. Mondrian would continue to practice this overrunning of the canvas systematically through the intermediary methods of decomposition that he learned from cubism. Nevertheless—and here the choice of subject is important—where the cubists' method was to decompose the figure, Mondrian's was to reflect the object abstractly in its structural components.[2] Thus, practically no objects appear in the middle of the picture that might assume a fictive (artistic) effect of the real or give the picture a kind of unity that is representative of a reality transcended by art. Mondrian, at this moment, chose almost exclusively subjects that would *close* the canvas. He devoted himself to painting surfaces (facades of churches, scaffolding, the sea, a tree, the wall of a house, etc.) which in their design, reduced to its structural components, covered the entire canvas. At the same time, between the lines that emphasize and repeat the structure determined by the artist, the way in which the small rectangle of paint is placed seems to summon a space that the "picture" could not possibly account for.

Beyond the Frame

What is articulated by the whole series of surfaces painted in the cubist "style" (1913–14) is first the impossibility of accepting the conventions (even a modern, cubist one) of the fictitious representation of space within the frame of a painting. Here the empirical practice (as opposed to Mondrian's metaphysical ambitions—cf. the *Sketchbooks of 1914*) operates a displacement (Mondrian's cubist-facade space) of the pictorial space within the framework of a unity of representation (the cubist painting) onto a unity of painted surface (the facade), in such a way that in its horizontal and vertical components the surface can account for another depth, no longer that of the "picture."

The breaking out of the picture frame, which dates back to Mondrian's early career, was motivated by a consideration of the

production of painting not in its autonomy but in its differential relation (cf. Mondrian's theosophy—the *Sketchbooks of 1914*). This breaking out—or attempted breaking out—from the frame would lead Mondrian in 1917, after the work done in the wake of the cubists, to consider the surface of the painting as a visible *given*. The surface can be covered from one edge to the other; it will never say anything more or express anything other than its effect as surface, an effect that is inevitably limited and easily repetitious. It will inevitably remain within the rectangle of a more or less decorative object, more or less effaced by its decorative "role."

The systematized reduction of space in cubist painting led naturally to a questioning of the dimension it had abandoned: the study of the possibilities that depth can offer, once the surface has been acknowledged. All the 1917 compositions with planes of color are devoted to this investigation of depth. Once the frame and the surface had been recognized as visible givens, there remained the fiction that would have two colored rectangles produce an effect of space on that surface and within that frame. One rectangle would be placed in front of the other and a fictive space established between them. It is this space, returning to the surface, that ultimately designates the surface as the common place of transparency, as an impenetrable but transparent convention—like the glass in the frame, behind which every depth is clearly possible but rendered fictive precisely by that frame.

A composition like the *Composition in Blue B* (1917) points to this series of possibilities and determinations. Here the colored rectangles are functionally disposed according to the format of the canvas, a format that is not meant to be emphasized or idealized but nevertheless determines, if only negatively, the arrangement of colored rectangles. The passage that is effected from *Composition No. 3 with Colored Planes* to *Composition in Blue B* provides a useful clue to Mondrian's research. In the first, planes of color are arranged side by side and play one another off in terms of their repetition of color and surface at points that are more or less spread apart and more or less repetitive of the depth that they produce. In the second, *Composition in Blue B,* the planes of color touch each other, partially overlapping, and are punctuated by surfaces that are distinctly differentiated from them (small, fragmented stripes); in terms of depth they create an ambiguity—Is any given colored rec-

tangle in front of or behind the one it touches?—which thus focuses on the pertinent question of the transparency of the framed surface.

Mondrian paused to study these problems from 1917 to 1920 (*Composition: Lozenge with Gray Lines*, 1918, no. 29 in the Seuphor catalogue; *Composition: Checkerboard with Bright Colors*, 1919, no. 292 in the Seuphor catalogue). And just as it was his very subjective theory of line (masculine, feminine) that let him think out his painting in a relation of differential specificity, it was a no less subjective and no less empirical theory of color that let him foresee the possibility of breaking out of the constraints of the "picture" or, as he put it, from "the particular and thus from the representation of the tragic."

The usefulness of the subjective theory of color, as in the case of the subjective theory of line, stems from its dependence upon a system of relations that is presented as real but operates symbolically: "Neoplasticism has succeeded in *obeying the principal law of painting, which demands only the expression of the relations between line and color*" (my emphasis).[3] The theory of color, which is just as subjective as the theory of line but far more complex, would have "unfilled space count for non-color" (black, white, and gray) and materials count for color (red, blue and yellow). In general, it seems to be based on certain works by Ostwald, which Robert Welsh tells us (in the Toronto exhibition catalogue) were highly valued by the De Stijl group. Ostwald's harmonic system was itself nothing more than a transcription of Goethe's theories[4] in the language of natural science. Empty space counts for non-color, and matter and reality count for color—we can see how all of this might have had its origins in Goethe's text: "The colors that we see on objects are not qualities entirely strange to the eye; the organ is not thus merely habituated to the impression; no, it is always predisposed to produce color of itself, and experiences a sensation of delight if something analogous to its own nature is offered to it from without; . . . If again the entire scale is presented to the eye externally, the impression is gladdening, since the result of its own operation is presented to it in reality."[5] This system, both defensible and indefensible in the absolute, has for our purposes the sole merit of symbolically playing off different relations ("I say that relation is the principal thing.");[6] in this case it is the relation

of color/non-color and emptiness/matter. These relations, accord-
ing to Mondrian, should be thought not in terms of the evidence of
dualities but as "evolving towards the balance of a duality": "As
man evolves toward the balance of his own duality, he will create—
in his own life too—more and more relations of equivalence, that
is, balance, equilibrium."[7] These are fantasies no doubt, but fan-
tasies that have the merit of letting the painter question that object
(the painting) that he no longer knows how, or from which angle
(surface, depth), to tackle. If color is material and white is emp-
tiness, what remains of the object (the painting)? An architectural
structure that lets itself be penetrated by the space outside it, that is
destroyed as an object by the space in which it presents and in-
scribes itself, by the space it sets off by setting itself forth—a struc-
ture, in short, that loses its autonomy through the differential order
that governs its situation.

Mondrian worked out this transformation in several stages. The
planes of color and of white, bordered by lines, grew progressively
bigger from one painting to the next until they became clearly anal-
ogous to the surface upon which they were inscribed (cf. the pas-
sage from *Composition: Checkerboard, Dark Colors,* 1919 to
Composition: Bright Color Planes with Gray Lines, 1919). In a
second phase, the transparent surface of the compositions of 1917
(the empty space within which the planes of color are situated),
this empty white surface would take on more and more impor-
tance, becoming the point of departure around which the painting
would be *organized.*

The possibilities facing the painter in his investigation were enor-
mous, and it is difficult, if not altogether impossible, to establish the
precise chronology of an *œuvre* that covers almost twenty years.
Once the symbolic apparatus of color/matter and white/emptiness
had been set into place, Mondrian would never cease playing it out
from all angles until the painting opened up onto a new space, a
space on which it no longer stood as a real object (of art), but as an
object of knowledge (the white of the painting responding to the
white emptiness of the general architecture, itself articulated as a
determination of matter-color). Thus, although there is no strict
chronology, we might say that there is nevertheless a didactic order
that spreads over these twenty years. The painting, *Composition 2*
(1922, Guggenheim collection), a white surface within a square, or

an almost square, is presented framed in the canvas; this, in addition to the white surfaces that do not repeat the format (here rectangular), suggests that the square white painting is only there as a didactic signaling of the space that it claims not to reproduce but to deconstruct. The canvas, object of knowledge, sets into play and deconstructs the conventions of the historical texture that is its own. To this end, the white area has to be framed (in a symbolic repetition of the painting) before opening onto the edge of the canvas (framed only on three sides), a square within a square, or an almost a square, always a sign of the repetition of the surface that otherwise appears as a totality (picture).

Mondrian, however, would soon go beyond this repetitive structure of the surface within the surface in, for example, the canvases with squares that are turned on their point, most notably in the *Composition with Two Lines* of 1931. Turned on its point, the square canvas accentuates the arbitrariness of its format by only partially repeating it in surfaces that can be completed only outside the square—starting with the four right angles that command unequal fields. Such is the case with the rectangular surfaces divided by an ever-growing number of lines which, beginning with the *Composition with Red and Black* of 1936, led to Mondrian's reconsideration of his work on the line and to *Broadway Boogie Woogie:* "Only now ('43) I become conscious that my work in black, white and little color planes has been merely 'drawing' in oil color. In drawing the lines are the principal means of expression, in painting the color planes."[8] The rethinking of his work on the line and on black and white represented for the artist a simultaneous rethinking of his theories of color.

Mondrian's last painting (*Broadway Boogie Woogie*), far from being a last painting, leaves one to suppose that having accomplished the considerable task of formal deconstruction that he had set for himself, the artist was in fact preparing to return—in light of his thinking on color determinations—to an ever more revolutionary empirical practice. By progressively displacing the problem of the picture as an autonomous representative unit onto the question of differential relations in the mode of pictorial production, and by linking the active signifying practice of painting to that aspect which had been repressed throughout its history,—i.e. color— Mondrian made a permanent mark on this history with a theoretical

problematic whose total effects continue to demand serious reflection if painting is not to fall into regress.

3. The Theoretical Problematic

In a flat painting look for space.

Lieou Tao-Chouen
(Song Dynasty)

It is the ripened culture of a *form* that is about to die.

Piet Mondrian

Of Optical Repression

To insist upon the theoretical activity in Mondrian's painting implies a necessary reassessment of the question of the "theory" of painting; it also implies that the painter's work cannot turn back upon itself to form a closed *œuvre* with no other consequence than its own closure.

We have been able to see how Mondrian's work was clearly articulated along the lines of its history (the history of its specific object: painting) and how the very (empirical) effects of this articulation determine the productive force of the work. Twenty-five years later, it now remains for us to examine the effects that were produced and to consider the inscription of Mondrian's work within the general workings of what might be a "theory of painting." A dialectical passage is called into play here, from the ideological *raw material* (academic painting) onto a historically determined practice (Cézanne, cubism), to produce an effect of knowledge.

Nevertheless, a retracing of the activity specific to Mondrian's work cannot be undertaken without first stressing a particularly significant phenomenon in the history of painting over the past twenty-five years: that is, the illusion of production that the accelerated pace of modernism and avant-garde art have served to illustrate (supported, as they are, by capital interests, far more considerable than one might imagine for painting). Within such an accelerated accumulation of products, twenty-five years seem to make up an entire history. Each year has witnessed the emergence of so many

schools and avant-gardes, each "newer" than the last, each more anxious to play the role that is its own objective: to eliminate from the production of painting any sign of work, in other words, any theoretical effect. The twenty-five years that have elapsed since Mondrian's death are rich in examples of this sort, which, if occasionally frivolous, still share in part the same effect of censorship. The same can be said of a kind of criticism that, in trying to be "formalist,"[9] is caught in the impossibility of thinking in terms of any kind of differential practice (for example, the role of Mondrian's theoretical texts in relation to his pictorial production); it is thus obliged to reduce its activity to the phenomenological field.[10]

It is, indeed, from the point of view of these two diverging tendencies that Mondrian's work has been considerably debased. Mondrian's ideas, removed from the textual context that questions them and tries to inscribe them in a painterly practice that cannot be reduced to a mere formal game, have found themselves accounting for surfaces and paintings that he never in fact painted. The disappearance of the picture from the logical system of what Mondrian tried to think of as "relations" (a logic that implies in the same equation the disappearance of the surface and a questioning of the space "that must be destroyed"), indeed, once the very model for thinking of painting as differential practice was cast aside (the relation: white/color, emptiness/material, dualism/balanced relations, space/the room, the painting, etc.), Mondrian's work was finally recuperated by a "postcubist" space, by the space of "postcubist" formalization, objectively playing the same reductive role vis-à-vis Mondrian that cubism may have played vis-à-vis Cézanne. The disappearance of the picture—leaving the specific realm of the signifying practice of painting for the phenomenological realm of the real object (picture)—would eventually be translated in terms of an extensive accentuation of surface (cf. Pollock). In order to surpass themselves, paintings continue to grow bigger and bigger until they exceed the visual measure of our single perception; they draw attention to their absolute dependence upon the gaze of the observer. It was no doubt inevitable that at a second stage during the past twenty-five years, it had to be this dependence that would stand out, marking as it does the limits of the phenomenological field. The art that identifies itself within the confines of this latter movement (the

confrontation with the gaze of the viewer / the concept of form and meaning [sense]) can only be understood within the context of the breakthrough achieved by Mondrian.

A Measure of Knowledge

Any attempt today to formulate the theory of painting that emerges from Mondrian's texts (the *Sketchbooks*, etc.) along with his practice as a painter demands a necessary reappraisal of the subordination of painting to the senses and the gaze—in other words, a renunciation of the rule of "verification from nature," even as it is reduced to the representational unity of perception.

In numerous texts that lack, we again note, neither naiveté nor contradictions, Mondrian maintains a distinction between "verification from nature" and "abstract verification" ("Natural Reality and Abstract Reality") and he tries to dialectize, without real success, the effect of knowledge, insisting as much as possible on his conception of abstraction. A conception that was doubtless based on notions as vague as "vital Energy," "pure Beauty," "Harmony," "Evolution," and so on, but that nevertheless permitted Mondrian to write in 1920: "*It is the ripened culture of a form that is about to die.* This culture is visible everywhere in all its beauty, but on the other hand, it everywhere *obstructs the path of that to which it has given birth,* I mean, the bright and balanced plastic art of limitation and expansion considered as equivalents" (my emphasis).[11]

From these texts (and given the artist's production) it is possible, through formulations that are more generous than precise, and playing with a vocabulary that is not fully mastered, it is possible, I repeat, to isolate certain irreducible points in Mondrian's work. We may first single out the opposition between *nature* and *abstraction* (the real object and the object of knowledge), an opposition that must ultimately subordinate every *particularity* to an *abstract generality,* every effect of the real to an effect of knowledge. The well-known passage from "Natural Reality and Abstract Reality" is indicative of this play: "In this landscape, the horizontal (*generality*) appears to us only in the line of the horizon (*particularity*). A single position is thus positively expressed. On the other hand, neither the contrary position, the vertical (*generality*), nor any other is exactly expressed in this landscape . . . Nevertheless, an opposition *is* expressed by the sky (*particularity*) whose elevated position

appears as a vast flat surface (*generality*)—an indeterminate flat surface, it is true, but upon it the moon (*particularity*) places an exact point. In this way, the plane of the sky is defined from this point to the horizon. The definition is a vertical line (*generality*) even though such a line is not apparent in the scene before us. It is for us to trace it in order to express, positively, the opposition to the horizontal." As we see, all the particularities (or effects of the real) are included in the vertical/horizontal opposition, whose function is to *define* them; this (vertical/horizontal) opposition is de-realized for Mondrian, so much so that for him it ultimately belongs to the order of the symbolic (masculine/feminine). We note again within this same perspective the opposition *primary colors / non-colors* (red, yellow, blue—white, black, gray), an opposition that is doubled by the appeal to generalize it and to denaturalize any phenomenological effect pertaining to it: "In architecture, un-filled space can be counted as non-color, materials as color."[12] Here we already begin to see just how Mondrian intends to inscribe his practice and how a sentence like: "The ripened culture of a form that is about to die" commits him to serious consequences. In point of fact, he would never cease trying to define its implications at the time of his collaboration with de Stijl, as well as during his second stay in Paris.

Starting with the precise historical implications to which the artist's practice both testifies and responds, Mondrian would continue his attempts to theorize just what he confronted in the rigor of his practice. Once again he exposes his naiveté and all sorts of contradictions—naiveté and contradictions that are determined by the mediocrity of the conceptual apparatus at the disposal of the artist, who most often had recourse to an approximate vocabulary that might even be completely foreign to his object. Mondrian thus seems at once very much aware of the fundamental transformations that allowed him to undertake his practice, and caught in the impossibility of being able to realize them fully—given that these transformations determined the interdependence of his practice on disciplines that were far from being all equally familiar to him.

The key to this play of ambiguities can be found in the somewhat privileged position that Mondrian accorded to architecture and, moreover, to urban planning. It is through these two disciplines that he would attempt to draw an impossible differential synthesis.

To be sure, architecture and urban planning clearly exclude the possibility of autonomous practice in their unescapable commitment to history, the economy, and society. A text such as "Home— Street— City" tries to use the interdependent activity of the disciplines on which it concentrates to lead painting out of its formal enclosure and its autonomy.

From 1919 to 1920 ("Natural Reality and Abstract Reality") to 1926 and later still, Mondrian tried to define more closely this emergence of painting, representation, and form so as to establish painting within a framework outside of its frame: a specific object of knowledge interdependent on other objects of knowledge ("Home— Street—City") and on other levels of social existence, with other practices that are themselves specific and differential. This can be already detected in the dialogue "Natural Reality and Abstract Reality": "The form and color of a piece of furniture, its general aspect, should be in accord with the general aspect of the room; moreover, the relations of measurement, and the interrelations of color should also suit the room . . . Because of their form, which is usually rectangular, the canvases of naturalistic painters are indeed suitable to the rectangular form of a typical room, provided that we do not look at what is painted inside the frame! It would be preferable to turn the faces of these pictures to the wall, so as to use them merely as elements in the articulations of the wall." This last statement is not to be taken as a joke, far from it. Already in 1920 Mondrian was thinking of his canvases as elements to divide the wall, itself an element of division in the room, itself an element of division in the home, etc. These are early indications of what he would later resume when arriving at the conclusions that become manifest in "Home—Street—City." Conclusions that can be summed up in the following notes: "And man? *Nothing in himself,* he will be part of the whole" (my emphasis)— "I have always fought the individualist in man and tried to show the value of seeing things in a universal way." A rather vague generalization, to be sure, but one that assumes special status when we refer back to the artist's practice and remaining notes that never ceased raising such questions; I am thinking in particular of the following: "Already in our own day there are groups who could live communally if they were not scattered throughout the world." The artist's reflections throughout these years—years that are among the most important

in his production—continued to dwell on the disappearance of "the individual," of the "tragic," of the unit of representation, of the subject, of form at the expense of that *abstract spirit* that "cannot be annihilated by the past" and which "assembling all its expressions now scattered in space . . . *constructs* abstractly." "and in these creations *it is realized and transforms without destroying.*" One could hardly find a better definition of the theoretical project—the inscription of a practice in the theoretical space that alone can actualize it.

The search for the "space" in which Mondrian's large canvases are "defined" (his large, seemingly flat paintings) can only take place through the intervention of the theory (which is, strictly speaking, their real space) that specifies their role (stripped of reality: these paintings as such have no reality) and the dependence of this role on the process of knowledge. "Elements in the articulations of the wall," Mondrian's large paintings mark the disappearance of the representational model (the painting: model, representation, consciousness, and knowledge,[13] that is, the order that distinguishes all real collective practice). But in marking this disappearance, which is not destruction but transformation, these paintings cancel out in their own non-hierarchical traces ("Which will be nothing in themselves but will function as constructive elements"[14]) the very specular space of the subject ("the application of these laws will destroy the tragic expression"), the painting as well as the wall, the house, the street, the city . . .

One has finally to admit, however, that Mondrian's "theoretical" notes lead up to a logical "revolution" that the artist is incapable of formulating and that he then finds himself forced to *express* through metaphysical concepts. All the contradictions that we find in the artist's texts are conditioned by his inability to formulate the new logic (no longer Aristotelian) that he tries to put into effect, and also by the *expressivity* that would henceforth take the place of the logical model for him. This expressivity reintroduces in full all the concepts that the practice and the theoretical notes had taken upon themselves (and continue to take upon themselves) to overthrow.

Thinking about the canvas and the disappearance of its representational model (subject, consciousness, knowledge) leads us in fact to question in that painting (which no longer is one) the white (non-color) that Mondrian "counts as *empty* space." What are we

to think of this painting, whose function is to inscribe itself while effacing itself, to mark the "nonrepresentation" that does not empty but institutes *emptiness?* And what about those "neutralizing" and "annihilating" oppositions?[14] What are we supposed to say about this painting, whose role, in disappearing, is, we might say, to "un-define?" Here the object of knowledge comes to "play" the formal space of knowing by inscribing its presence/non-presence in the order of real objects. Object of knowledge, the painting is not a painting, it is what renders impossible any "picture," any ex-haustive "table of contents." The "neutralizing" contradiction that it plays off (non-representation at the very place of representation) overturns and transforms the order of Hegelian dialectic (of the thought of the subject-sign and of transcendental truth) by under-mining its claims to synthetic truth; it does so by rendering infinite the possible order of relations that are no longer sanctioned by a unity of meaning but by the productive multiplicity of contraries.

Mediated by the annihilating contradiction that it signals through self-effacement, this thinking seems to take a "distance" from itself and from the culture where, in a similar movement, it is already inscribed as exteriority. It appeals to a science that can respond to the (infinite) non-finiteness of the code that is its own, and today, through Mondrian, it alone can permit us to consider a theory of painting that is detached from a finite formal system ("It is the ripened culture of form that is about to die"; "concerning the sub-ordination of sense [meaning] to the gaze, of sense to the sense of sight").

It is clear what sort of radical transformation this break must pro-duce (form—surrender to the gaze) in the system of Western painting. The disappearance of the picture that Mondrian theorizes can no longer occur in the order of phenomena; it returns in the form of a questioning of the entire pictorial production of the past twenty-five years. The extensive accentuation of surface, such as we find in the practice of American painting, which apparently seeks to spill out of the frame, only serves to emphasize the field in which this problem of the disappearance of the picture is located: formal and phenomenological, it reinforces the institution of the cultural (pictorial) code that Mondrian worked to overturn. In any event, the disappearance of the picture, as Mondrian conceives of it, is in no way a "modernist reduction" to a formal code; it is an

infinitization of the antagonistic relations that constitute the infinity of a space in the void.

The relation established by the artist between Colors (matter) and White (emptiness) allows us to see the way the system of relations proposed by Mondrian functions. It is well known that the theory of colors that Mondrian used is based on the harmonic laws prescribed by Ostwald (themselves a transcription of Goethe's theory). As elsewhere in his practice, Mondrian's use of these theories of color is empirical. Ostwald's theory, just like Goethe's, is in fact entirely determined by the dependence of color values on perception. Thus, the speculations on which the artist based his argument are of less interest here than the way he used and transformed them. For Ostwald as for Goethe, "the complementaries supplement each other to form *white* when they come together as colored light; and they mix to make at least a colorless gray of a middle value of the single colors if one mixes them optically on a rotating disc."[15] Taking this as his point of departure, Mondrian establishes color as *matter* and the sum of colors as *emptiness*. In other words, we see that Mondrian did not follow Goethe in defining the totality of colors as dependent on a unity that transcends them: "If again, the entire scale is presented to the eye externally, the impression is gladdening, since the result of its own operation is presented to it in reality;"[16] he identified this totality rather as the *disappearance* of any possible reduction to a unity.

The element repressed from the history of painting (color) thus appeals here as determining the very possibility of painting (matter); through the transformational mediation of theory (knowledge), color would seem to efface itself in its totality (the sum of its complementaries). It is this emphasis on the emptiness of the sum totality that alone may allow us to consider today what Mondrian's last canvases (*Broadway Boogie Woogie*) produce theoretically. Color, whose sum produces non-color,[17] takes charge of the canvas that cancels itself out. In her analysis of a similar semiotic relation that she calls "paragrammatic," Julia Kristeva concludes that "at issue is a thought that opens onto death, onto the sexual act *in the productivity of a writing that is anterior to the text.*"[18] It can clearly be seen how the irrationality of color, contained within the system to which Mondrian submits it, appeals in the end to the pretext (pre-text) that produces it indefinitely—death, sexuality,

the "trace."[19] Within the system's double effect of cancellation (color/non-color, the picture / disappearance of the picture), this irrationality refuses any kind of metaphysical reification.

For twenty-five years, painting, in the most significant aspects of its production, has continued to reproduce Mondrian's radical gesture, positivizing and reintroducing it into a metaphysical enclosure. Among the artists most particularly interested in this double problem (color/white, the picture / disappearance of the picture), it would seem to me that, from Barnett Newman, still caught in the phenomenological illusion (the extension or retraction of surface), to the most recent exhibitions by James Bishop (two artists separated by some twenty-five years), it is the return to the problematic set into play by Mondrian that has reemerged in full force today, leaving behind the fads of any given season.

In the theory of pictorial production, it is decidedly the thought of "the end of the culture of form" that determines today an object of knowledge which, while no longer "subordinated to the gaze,"[20] can at least be contemplated in its productive cancellation and disappearance.

February 1969

Let me recite what history teaches history teaches.

GERTRUDE STEIN

3 The Bauhaus and Its Teaching

A Movement, a School, a Workshop, or an Academy?

Should we understand the Bauhaus within the perspective of the various avant-garde movements that became manifest throughout Europe during the twenties? Or should we consider it in its autonomy as an isolated movement? Was the Bauhaus an avant-garde movement, a progressive school, an art workshop, or a modern "academy?" It is practically impossible to give a definite answer to any of these questions, and a Bauhäusler himself would probably say that this is what generates both the interest and the character of the Bauhaus. In any case, it is certain that the Bauhaus profited from these and other ambiguities. When in March 1919 Walter Gropius was named director of the Grand-Ducal Academy of Fine Arts and the Grand-Ducal School of Decorative Arts, which joined together on that occasion to become the "State Bauhaus of Weimar," the Bauhaus was clearly not a movement; in the mind of its founder its mission was simply to form a new generation of architects. Even then it already distinguished itself from avant-garde movements such as Dada, futurism, and de Stijl in that these latter movements conceived of themselves, spontaneously and empirically, in direct opposition to the power of academic institutions. This school of architecture, on the other hand, for all its academic trappings, would teach just about everything but architecture during the first eight years of its existence. There was, for instance, no "department" of architecture at Weimar—it would be founded only in 1927 in Dessau by the Marxist director Johannes Meyer and would

111

not last much beyond five years. No architecture department at the Bauhaus, whose three directors (Gropius, Meyer, and Mies van der Rohe) count among the greatest architects of modern times. An architecture school, an architecture studio that nevertheless from the time of its establishment entrusted its basic preliminary course, expressly designed for the specific formation of Bauhäusler, to a painter, Johannes Itten. From the time of the foundation of the Bauhaus, Gropius assured himself of the collaboration of two painters, Itten and Feininger, and a sculptor-engraver, Gerhard Marcks. The ambiguity that seems to have been minimized in Gropius's mind by his desire to realize a synthesis of the technical and the artisanal may lead us to suppose that during its relatively brief existence (fourteen years) the teaching of the Bauhaus was for the most part essentially conditioned by the practice of painting. It was another painter, Laszló Moholy-Nagy, who would succeed Itten in 1923; indeed, from 1919 to 1933 most of the teachers would be painters: Feininger, Itten, Kandinsky, Klee, Marcks, Moholy Nagy, Muche, Schlemmer. The most faithful of the Bauhaus students (he joined the school in 1920, became a teacher in 1925, and stayed until 1933) and today the most famous, was yet another painter, Joseph Albers. The Bauhaus, however, was not a school of painting. As for determining whether it was an avant-garde movement, one can recognize from a simple glance at the list of names of the teachers gathered together by Gropius the emerging coherence of a movement that would, and *did,* profoundly mark all of modern art.

The fact remains that this avant-garde, by the very fact that it came together at the State Bauhaus, was compelled to become a school, to take into consideration the social order that authorized it, and to define its teaching precisely in terms of its insertion into a specific social context. Indeed, here we touch upon one of the most fundamental contradictions of the Bauhaus. A contradiction that is certainly at issue in all avant-garde movements but which is more particularly apparent in the Bauhaus to the extent that it had to confront its institutionalization right from the start. Gropius would continually return to this problem, insisting upon the special vocation of the Bauhaus to "promote the new type of industrial collaborator, uniting the qualities of artist, technician, and businessman"; he demanded that his students be familiarized with industrial modes of production and sent the best students to work in

a factory for a period of time during their study. From the initial conception of the Bauhaus, as a training place for the artisan-journeyman, Gropius moved toward the idea of "art and technique as a new unity." In his stand against naive "Rousseauism," he engaged in a polemic with Itten, a partisan of individual work, that ended in the latter's departure. Furthermore, from October 1924 on, the Bauhaus's production venture was transformed into a limited liability corporation, and its collaboration with industry was called upon to yield substantial profits. Itten's departure, however, does not seem to have succeeded in resolving the ideological problems that arose from the group's confrontation with its social context. Feininger would never declare his solidarity with the new unity of "art and technique"; in 1924 the municipality of Weimar decided to rid itself of the Bauhaus which left to reestablish itself in Dessau; in 1928, the students demanded a more solid pedagogical formation. Gropius left the Bauhaus, and Johannes Meyer was named director; a communist, he would be forced to resign in 1930 as a result of proceedings initiated by Kandinsky.[1] His replacement by Mies van der Rohe, (at a time when the Nazis had won a majority in the elections), did not prevent the municipal council of Dessau from dissolving the Bauhaus in 1932. Mies van der Rohe then transformed the Bauhaus into a private establishment, which he moved to Berlin; in the early summer of 1933 he was forced nonetheless to dissolve it definitively; "the demands of the Gestapo were unacceptable" we are told in the black humor of the catalogue to the traveling exhibition.[2]

As we can see, it was not long before the ambiguities and contradictions of the real world, which at first seemed insignificant, expanded to considerable proportions. One can of course pretend to believe that the Bauhaus was only an art school whose avant-garde teaching would naturally meet with the hostility of retrograde minds. This might, on the other hand, also lead one to suppose that, as an institution, the Bauhaus might have found in the official representatives of the Weimar Republic some real current of progressive and sympathetic forces. But it is certain that if we keep to this version, basically that of the editors of the catalogue that accompanied the traveling exhibition, we must by the same token minimize the conflicts, internal as well as external, avoid the details of the break with the municipality of Weimar, pretend to believe that the mayor

of Dessau simply "invited" the communist Johannes Meyer to re-
sign, and finally say that the Bauhaus was dissolved in Berlin in
1933 because "the demands of the Gestapo were unacceptable"—
which implicitly suggests they might not have been. This version is
possible only if we content ourselves with the surface effect that
allows the colors and forms produced by the Bauhäusler and their
masters[3] to dominate. It is a version that is nonetheless curiously
contradicted by the very undertaking of the traveling exhibition; a
version that must finally lead us to investigate the nature of the
relations that an institution like the Bauhaus may entertain with the
social structure that fosters it and the manner in which the teaching
and production of the school can respond to and guard it from that
social structure. This is all the more important since—as has al-
ready been remarked—during the course of his administration
Gropius would evolve from his initial idea of the Bauhäusler as ar-
tisan-journeyman to the idea of students trained more and more in
technique and industry, and indeed, more and more closely associ-
ated with the (economic) social structure that authorized and was
destined to make use of their training: "In its collaboration with
industry, the Bauhaus attached special importance to bringing stu-
dents into closer touch with economic problems. I am opposed to
the erroneous view that the artistic abilities of a student may suffer
by sharpening the sense of economy, time, money and material
consumption."[4] I shall be returning to what Gropius means by
economy.

The History of the Bauhaus

The Bauhaus was born and grew in one of the more historically
marked social contexts of modern times. The fourteen years of its
existence correspond exactly to the dates of the ephemeral Wei-
mar Republic and, in the words of Brecht, to the "resistible ascen-
sion" of Hitler. On 11 February 1919, Ebert was named president of
the Reich by the National Assembly of Weimar—Gropius was
named director of the "State Bauhaus of Weimar" in March 1919;
Hitler became chancellor of the Reich on 30 January 1930—Mies
van der Rohe dissolved the Bauhaus at the end of July of the same
year. In the intervening years, Germany experienced one of the
darkest periods in its history, but unfortunately not *the* darkest.
"Resistibly" the Fascists moved into power.

If we stop to think about it for a moment, the founding of a school like the Bauhaus, less than a year after the 1918 defeat and the signing of the treaty of Versailles (which, as we know, stripped Germany of all its colonies, an eighth of its territory, and a tenth of its population and imposed a tax of 132 billion marks for war damage) must appear an act of the most extreme irrationality. This kind of "irrationality," it may be noted, would systematically mark all the acts, political as well as economic, of the young republic. Not only was Germany in a state of ruin in 1919, but internally it was faced with political turmoil that, for fourteen years, no coalition could reduce. Riots, revolts, assassinations (of Rosa Luxemburg and Karl Liebknecht among others), political uprisings (no fewer than three in fourteen years, and the first, that of Kapp, as early as 1920) created a climate of constant political disintegration that the Social-Democrat party (founded in 1890), torn between the extreme right and the extreme left and determined to seek alliances on the right (the Weimar coalition), could never manage to stabilize.[5] All this in addition to staggering inflation and the complete collapse of the entire German economy between 1922 and 1923. At the beginning of 1922 the paper mark was worth $.02; at the end of the same year it was barely worth $.00001. In the interim, prices had gone up 70 percent and salaries 60 percent. At the end of 1923, after the occupation of the Ruhr Valley by France and Belgium, the exchange rate of the mark was 160,000 to the dollar and, soon after, one billion. It was on 8 November of the same year that Hitler, whose party counted fifty thousand members at the time, would come to power in Bavaria.

In such a context, the little history of the Bauhaus could obviously not advance very smoothly, nor could it avoid confronting at any given moment the major drift of history in the making (and unmaking) at its very doors. Without pushing the parallels too far, it is clear that, on closer analysis, the institutional nature of the Bauhaus put it in the position of reproducing to some measure, on its own scale, the contradictions of the larger social context that harbored it. The passage from Weimar to Dessau was thus conditioned by Germany's economic situation at the beginning of 1924 and by the repercussions of that economic crisis on the elections in Thuringia, where the Social-Democrat government was replaced by a right-wing government with the power to dismiss the *masters* of

the Weimar Bauhaus. Similarly, the installation of the Bauhaus in Dessau was conditioned by the rapid restoration of the economy around 1925 (the Dawes Plan, the reassuring election of Hindenberg) and the doubling of the Reichswehr budget (among other industries, Dessau possessed the airplane factory that produced the *Junkers*).[6]

So much, in short, for the economic picture; we could chart similar parallels at the ideological level. Suffice it to recall the famous *Gelbe broschüre* (yellow brochure) put together by a master craftsman and "by employees of the Bauhaus dismissed without notice,"[7] and the firing of Johannes Meyer as a result of his political opinions and "steps taken by Kandinsky." At the reduced scale of the Bauhaus, these events reproduce on an ideological plane the contradictions and the sharp divisions between the extreme right, the center, and the left that all of Germany was then experiencing.

In his essay on "the spirit of the Weimar Republic,"[8] Heinz Winfried Sabais is rather too prone, it seems to me, to minimize these contradictions with the aid of anticommunist slogans that demonstrate the kind of naiveté in historical analysis that political passion alone can engender (the passion extends in this case to treating Brecht as a "crypto-anarchist plagued by asceticism"). The slogan of the communist parties politically beholden to Moscow, for all its persistence, is particularly inappropriate for qualifying the activity of the German Spartacists during the twenties. On this subject one need only consult the text of 1920 that Lenin devoted to left-wing communism in Germany, "Communism's Infantile Disease, The Left Wing," or look to the role of these same Sparticists in the second-round elections of 25 March, when the communist candidate Thaelmann, against the recommendation of the Komintern, refused to withdraw from the running and caused a majority swing to the extreme right.

Neither passion nor slogans will resolve the ambiguities and contradictions that made the Weimar Republic and the Bauhaus what they were. This is not the place, nor is it my purpose here, to study the spirit of the Weimar Republic; I leave that to the scholars who have already devoted themselves to that subject and to those who will do so in the future. In what concerns the Bauhaus however, its "spirit" and its teaching, I think it is possible within the framework of the historical outline provided above to advance a critical read-

ing that might allow us to better see in what way the theories it developed could render productive (or limit through repetition) the contradictions it was historically and economically forced to confront.

The Painters and Their Theories

Before going any farther, one point must be made. If a simple list of the names of the *masters* that Gropius brought together at the Bauhaus traces the coherent outline of a movement wé have come to call modern art, it is true, as Hans M. Wingler, director of the Bauhaus-Archiv in Darmstadt, has noted, that all the "determining factors in the creation of the Bauhaus were already present some time before its founding." The fact remains that "these determining factors" are, as we have seen, for the most part represented by painters, Gropius having taken as his point of departure "the fact that since the beginning of the century painting [has] taken the lead among the arts and created a new aesthetic which should govern the . . . principles of the architecture of the future."⁹ What we discover here is the same effect that marks all movements, however minor, in the history of modern art—the transformation produced by painting at the turn of the century.

Whatever their theories and the nature of their respective genius, the painters that Gropius selected to direct the teaching at the Bauhaus were not unprepared to undertake their new responsibility, influenced as they invariably were by recent events in history and the pictorial production that characterized it. If we want to understand what Gropius solicited in his attempt to transform the training program and create a new school of art, it is first to painting and its most recent history that we must look. It could be said, for example, that when Kandinsky decided to theorize his work, he had already realized at the pictorial level certain accomplishments that were far from unfamiliar in the recent production of painting at the end of the nineteenth and beginning of the twentieth centuries. Thus, well before writing *On the Spiritual in Art* (1910), Kandinsky was already examining the problems raised by French artists at the end of the nineteenth century (the impressionists, and more particularly Cézanne). Before he ever decided to devote himself to painting, Kandinsky had discovered Monet during a visit to the exhibition of French impressionists in Moscow (1895), and admired

his work. And if between 1902 and 1904 his painting indicates an interest in particular formal problems (*The Old City,* 1902, Nina Kandinsky collection; and *Dutch Beach,* 1904, Gabriele Munte Murnau collection), it is really only from 1908 on that a genuine transformation takes place in his understanding of pictorial space. This transformation can be traced back to a period about five or six months after a year's stay near Paris. (Especially representative of this transformation are the *Landscape with a Tower,* no. 72, 1908, Nina Kandinsky collection; *Blue Mountain,* no. 84, 1908, Solomon R. Guggenheim collection, New York; *Winter,* no. 62, 1909, Municipal Museum of Modern Western Art, Moscow; and *Improvisation II,* no. 102, 1910, Russian Museum of Leningrad.)

From 1908 to 1910 and long after, Kandinsky was preoccupied with the legacy of Cézannean problematics; this was an influence he explicitly acknowledged: "All of these constructive forms have a simple inner value like every melody. It is, for this reason that I call the composition melodic. Brought to light by Cézanne and later by Hodler, these melodic compositions, in our time, are designated as 'rhythmic.' "[10] Contrary to what Paul Klee wrote about him—"He expects no enlightenment from museums, nor they from him, and the greatest masters cannot make him doubt the value of his own spiritual universe"[11]—Kandinsky, like Klee himself, was a product of that very recent history that he looked to for strength. In the same text (suggestively titled *An Approach to Modern Art*), just before his qualification of Kandinsky, Klee refers quite naturally to impressionism and cubism in his outline of what he calls "the procedure of abstraction." "In order to speak of expressionism, we must go back to impressionism. These are in fact the two major '-isms' of the time; both respond to fundamental attitudes toward forms."[12] We note with interest, however, a curiously weak spot in Klee's text, where he reproaches impressionism for failing to understand construction—"pure impressionism ignored construction"—and on the other hand implicitly reproaches the cubists for excessively rationalizing their formal work: Kandinsky is assigned the great role of synthesis while Cézanne is effectively forgotten or ignored.

This last point merits further attention in light of the idiosyncratic foundations of the Bauhaus. On one hand, the teaching of the Bauhaus fell back on and, indeed, developed out of the strong mo-

ments in pictorial production at the end of the nineteenth century; on the other hand, as we have seen, at the Bauhaus as elsewhere, there was no theoretical return of any consequence to the specificity of modern painting at the time when it was taking shape. Thus Klee, who in 1909 (at the age of thirty) wrote in his *Journal,* "I was able to see eight paintings by Cézanne at the Secession. Here is the master who can instruct me",[13] in 1912 passes surprisingly from "pure impressionism" to cubism, as if between the one and the other nothing had taken place. He could do so only by virtue of the dominant illusion that perceives schools succeeding each other in absolute autonomy and never pauses to question the foundations upon which they rest: "It is admirable to see this child of Russia [he is speaking of Kandinsky who was forty-six at the time] evolve without any burden, in this our Europe, where we trod along, tired and weighed down. . . "[14]

Kandinsky, like Klee, would make use in much of his painting of transformations effected by the late nineteenth century French artists, especially Cézanne. He would use them as a historical, indeed formal, argument when necessary but never actually paused to ask whether the work he was using might not in practice be the effect of an unspoken theory, sufficiently strong to have produced this radical transformation in history. In other words, neither he nor Klee ever really questioned the way in which the influence they came under was justified in their work, nor how their work—not to mention their theories—responded to that influence. We must recall moreover that these were both artists who accepted the responsibility of teaching and who, in that capacity, produced and published literary works.

The theoretical (literary) works of Kandinsky and Klee have as their fundamental object the artists' own works, and never refer to the history that produced (or influenced) those works in any way other than the occasional aside. This, for instance, is what Kandinsky has to say of Cézanne's *Bathers:*

> A good example of this [what I have just described] is Cézanne's "Bathing Women," a composition in a triangle (the mystic triangle). Such buildup in geometric form is an old principle which was finally abandoned, because it led to stiff academic formulas which no longer possessed any inner sense or any soul. Cézanne's application of this principle gave it a new soul

and the *purely artistic purpose* of the composition became particularly emphasized. In this case, the triangle is not an aid to the harmony of the group but the accentuated artistic aim. Here the geometric form is, at the same time, the means to the artistic composition; stress is laid on the purely artistic will with a strong accompaniment of abstraction. Therefore, Cézanne, with full justification, alters the human figure. He not only makes the entire figure point to the head of the triangle but also individual parts of the body are constantly driven more and more strongly from the bottom to the top, as by an inner impulse. They become lighter and lighter until finally they expand visibly. (My emphasis)[15]

This analysis, the most elaborate to be found in Kandinsky's literary work, contains in brief all the misunderstandings that the Bauhaus would popularize, including those pertaining to Klee and Kandinsky themselves. If I have emphasized the "purely artistic purpose" in the text, [*l'élément purement pictural*], it is to show to just what extent the artist's entire analysis persistently avoids this aspect. From the first line, the triangular composition becomes "the mystic triangle"; there follow the "internal meaning," "the soul" (several times), "a purely artistic will," an "inner impulse," bodies projected into the air that "get lighter and expand,"—in short, everything one might expect in the subjective and irrational order of the (metaphysically) expressive, except the pictorial element. Kandinsky uses the *Bathers* here as a canvas upon which he *projects* his ideas. He uses Cézanne as a kind of quotation, although he never really raises the question of knowing (1) the specificity of Cézanne in relation to the history of painting ("old principles," "academic formulas," etc.) and the implicit theory that in Cézanne's work authorizes his "modernity"; (2) the relation that Kandinsky's theory and practice engage in with the specificity and theory of Cézanne.

It is from this perspective that Klee is absolutely right to say of Kandinsky: "He expects no enlightenment from museums, nor they from him, and the greatest masters cannot make him doubt the value of his spiritual universe." In his own writings, whatever the doubts he may think he has, the problem is identical for Klee.

Needless to say, this attitude differs fundamentally from the project of Cézanne, who not only recommended the study of painting and its museums but who aspired to "produce something that

might be like the art of museums." On the other hand, the projection of theoretical ideas into the absolute without establishing their historical foundation has as its necessary consequence the complete detachment of the theoretical object from any reality (cut off from "the purely pictorial element"—see note 15). The result is an irrational discourse in which everything can be justified (by and in relation to everything) since in fact it doesn't acknowledge any reasoning other than its own. When Klee writes, "Through this cult of exactitude, our merit has been quite simply to define the bases of a science that is specific to art, including the unknown,"[16] we must question the word "basis," since it is the very basis of this science that would remain ultimately unknown (blind to its historical precedents); in the end this "scientific" project aspires to nothing less than the "romantic fusion in the Great All."[17]

Teaching at the Bauhaus

What ultimately characterizes the Bauhaus, faced as it was with the state of painting and architecture in the twenties, was the need for a theory capable of accounting for (and developing the consequences from) the formal upheaval effected at the end of the nineteenth century ("painting had taken the lead among the arts . . . it had created a new aesthetic"). In bringing together Klee, Kandinsky, Itten, and later Johannes Meyer, and in establishing the Preliminary Course as the "indispensable prerequisite for all further work,"[18] it is clear that Gropius's intention was to teach the basic new theories that seemed to determine for him the most recent productions in the field of modern painting. And his particularly rich intuition was matched by equivalent reactions elsewhere in Europe at the same time (for instance, Piet Mondrian's dialogue "Natural Reality and Abstract Reality," 1919–20).

It remains the case, however, that no theory—or, to use Klee's term, "science"—however comprehensive, can be constructed from intuitions alone, fine as they may be. Theory demands first of all the working through of a problematic in the painter's practice in order to produce a real "revolution," and this is as true today as it was then. Let me explain.

It has always been the case that the painter, "the artist," considers the specificity of painting (if he considers it at all) as autonomous (a theology). In order to outline a theory he must engage in a

relation with literary language. He thus has to take into consideration the autonomy of the language he uses, the history of that language, and more precisely still the historical itinerary of the concepts (philosophical, for instance) that he is led to use. That is to say, he must contemplate his own discipline, painting, no longer in its specific autonomy but rather in its differential specificity (a specificity whose reality is equally constituted by what differentiates it from other disciplines and by the relation that it maintains with these differences).[19]

In questioning the relation of the Bauhaus *masters* to theory, it is clearly the conceptual transcription of their practical experience as painters that is at issue. Klee's and Kandinsky's writings,[20] and even those of Gropius, are full of philosophical references and pretensions: "The progress made [by the person who studies] in the observation and vision of nature gives gradual access to a *philosophical vision* of the universe that lets him freely create abstract forms" (my emphasis).[21] Nor do Kandinsky's famous essays (*On the Spiritual in Art* and *Point and Line to Plane*) or the numerous texts by Gropius (*Apollo in Democracy*) contradict this statement of Klee's. However, even if we admit that, of all the plastic arts, painting may be considered tohold one of the more "advanced" avant-garde positions at the beginning of the twenties, it is not by any means the only discipline to have registered the ideological transformations proper to the end of the nineteenth century. Literature, with the examples of Lautréamont and Mallarmé among others, and philosophy, with Feuerbach in the first part of the century and the advent of Marxism in the second half, effected equally fundamental transformations.

The problem that is raised then is one of knowing whether in the conceptual transcription of their experience as painters, the *masters* of the Bauhaus were concerned with the evolution of the disciplines they subscribed to, and, if so, how? Whether, within the specific perspective of their own discipline, painting, these artists were able to contemplate the specificity of other disciplines—the only possible way to consider the reality of painting (in its difference)—and to propose a teaching thereof. If only by reference to the writings of Klee and Kandinsky that I have chosen to stress, it is all too clear that the answer to this question is negative. The painters of the Bauhaus held an entirely theological view regarding

their art, and they never abandoned it. One need only look at the concepts they use and the origin of these concepts, and the use they make of them in their literary transcriptions.

Neither Gropius nor Kandinsky ever used scientific concepts in any but their vulgarized sense. Gropius speaks of "economy," "merchandise" and "consumption," etc.:

> In its collaboration with industry, the Bauhaus attached special importance to bringing students into closer touch with economic problems. I am opposed to the erroneous view that the artistic abilities of a student may suffer by sharpening the sense of economy, time, money and material consumption. Obviously, it is essential clearly to differentiate between the unrestricted work in a laboratory on which strict time limits can hardly be imposed, and work which has been ordered for completion at a certain date; that is to say, between the creative process of inventing a model and the technical process involved in its mass production. Creative ideas cannot be made to order, but the inventor of a model must nevertheless develop trained judgment of an economic method of subsequently manufacturing his model on mass production lines, even though time and consumption of material play only a subordinate part in the design and execution of the model itself.[22]

Needless to say, in his use of these concepts Gropius refers to neither Adam Smith nor Ricardo, nor John Stuart Mill (nor certainly to Marx). He would be hardly more precise in the sixties when trying to analyze the reasons behind the failure of *design* when faced with the distribution of the commercial product, or the flagrant contradiction between his theory of the "multistoried" building and the functional use made of the skyscraper: "The problem is one that can only be solved by control of building density in relation to transport facilities, and by curbing the crying evil of speculation in land values: elementary precautions which have been signally neglected in the United States."[23]

We find the same vulgarized use of concepts in Kandinsky when, at the beginning of his book *On the Spiritual in Art,* he speaks of materialism: "After the long period of materialism from which it is just awakening, our soul is full of seeds of despair and disbelief, ready to drown into nothingness. The oppressive weight of the materialist doctrines that make of the life of the universe a vain and

detestable joke has not yet been dissipated." In Kandinsky, however, the reference to "materialist philosophy" and to Marx is explicit: "The spiritual triangle moves slowly onward and upwards . . . The dwellers of its [largest and lowest] segment bear various religious titles . . . In politics, these people are democrats or republicans . . . they know about parliamentary procedures, and read the political editorials. In economics they are socialists of various grades and shades and are capable of supporting their 'convictions' by numerous quotations (starting with Schweitzer's *Emma* via Lasalle's *Iron Law on Wages* to Marx's *Capital* and so on down the line)."[24] Even though his vocabulary may seem colored by scientism, none of the definitions that Kandinsky provides for materialism draw upon an analysis of the scientific concept but upon the vulgarized use of that concept (it is plainly impossible to write scientifically that Western history has known "a long period of materialism"). And in the same way when Kandinsky refers a little farther along to energetics: "Electron theory, that is, the theory of dynamic electricity, which is supposed to replace matter totally, has found of late daring pioneers," it is, with reference to the theory of Ostwald and the disciples of Mach, once again to a vulgarized concept that he has recourse (the substitution of scientific representations concerning the structure and properties of matter for the notion of matter as a philosophical category).

This type of deformation was characteristic of all the texts produced by the *masters* of the Bauhaus, and would have a fundamental effect on the nature of their teaching. As for the origins of this deformation among the *masters* of the avant-garde, we must look for it in the academic traces that invariably trail behind any theology of art.

As early as 1919, with the publication of the manifesto that accompanied the founding of the Bauhaus, Gropius insists upon the metaphysical irrationality of art: "Art is not a 'profession.'" Starting from this point, he produces a series of propositions whose theoretical anachronism may be considered representative of the play of irreconcilable contradictions that the Bauhaus would produce. Here are some of Gropius's propositions: "There is no essential difference between the *artist* and the craftsman. In *rare moments of inspiration, moments beyond the control of his will, the grace of heaven* may cause his work *to blossom into art.* But proficiency in

his craft is essential to every artist. Therein lies the real source of *creative imagination*" (my emphasis).[25] From 1919 until the last lectures that he gave in 1964, Gropius would never abandon this type of argument or vocabulary—a vocabulary that remained close to that of Klee and Kandinsky, who made use of the same concepts. They, like Gropius and perhaps more than he, saw the purpose of their theoretical discourse (whatever the technical determinations it was obliged to consider) as none other than the transcendence of art, the "Great All." For these artists, in other words, it was altogether unthinkable that the specificity of their practice might be placed in a differential relation with other practices. From the perspective of their belief, that art transcends all disciplines, the evolution of theories of knowledge matters little; the only acceptable theory is clearly the one that recognizes this basic postulation and reaffirms art in its transcendental truth.

The referential system of Bauhaus philosophy follows in logical sequence from this point on into its technical developments (theories of form and color). In their conceptual references, the *Bauhäusler* seem deliberately to ignore the entire history of modern philosophy (particularly Hegel); in fact, they remained tied to the old debate between Kant, Schiller, and Goethe regarding the metaphysical conciliation of contraries. Each of the writings produced by the Bauhaus, without clearly defining any philosophical position, aligns its conceptual reference alternately to one or the other of the positions in this byzantine quarrel (the subjective unity of the reconciliation of opposites; speculative thought achieving a unity and consolidation in art that is the sole expression of truths; the experimental attitude that rejects scientific study as the simple activity of rational understanding and its errors, and proclaims the independent being and the total freedom of beauty).

Whether in the ideological texts of Gropius or in texts with "scientific" pretenses, the referential field remains fundamentally the same. For example, behind the energy theories of Klee's *primary approach to form,* "Active surface. Passive line. Energy of the plane. Stress. Etc.,"[26] and behind the color theories of Kandinsky and Itten, we find Ostwald; behind Ostwald, Kant and Goethe. Furthermore, the reference to Goethe is explicit in Kandinsky as in Itten. In his chapter "The Language of Form and Colors," Kandinsky writes: "Balance and proportion . . . are not [found] outside of the

artist, but within him, and consist of what may also be termed a feeling of limitation and self-restriction, an artistic tact, qualities which are inherent to the artist and which are increased through enthusiasm to ingenious revelation. This is the sense in which the basic fundamentals of painting, as foretold by Goethe, may be understood."[27] In that text, we recognize the influence of Kant: "since, for all that a product can never be called art unless there is a preceding rule, it follows that nature in the individual (and by virtue of the harmony of his faculties) must give the rule to art, i.e. fine art is only possible as a product of genius."[28] In this text, we see Kant coming to the aid of Goethe. Kandinsky's theory of colors is in many ways so similar to Goethe's that it seems that one could almost interchange the metaphors they choose to illustrate their respective arguments.

In the same way, all the concepts that support Kandinsky's theories of form in *Point and Line to Plane* can be rethought from this perspective, starting with the famous "Also in nature, the point is a self-contained thing."[29] Nevertheless, it is not my purpose here to enter upon an exhaustive analysis of the theories of the Bauhaus *masters,* but simply to establish their historical origin within the evolution of intellectual theory.

As we have seen, the "literary" transcriptions that correspond to the practice of Bauhaus artists do not refer to a conceptual field contemporary with their (pictorial) practice; indeed, they hardly refer at all to the formal transformations at the end of the nineteenth century that determined their practice.[30] While pictorial practice defined to some extent the avant-garde at the beginning of the twentieth century, the theories and teaching it proposed fell back on an ideological context that dated from the end of the eighteenth century.[31] To be sure, this *gap* between practice and theory may well be characteristic of all avant-garde movements in modern art. The contradictions it raises, however, are particularly striking when it appears within the context of an official teaching program; for, "until its disbandment in September 1932, the Bauhaus at Dessau maintained its academic rank."[32]

What Does History Teach?

One could of course object to the outline of Klee's and Kandinsky's theories as sketched above by refusing to "reduce" these

painters' texts to their literary dimension and choosing to see in them (to feel in them, rather) only a "spiritual fragrance,"[33] evidence of their interests and culture. We must not however forget that the painters in question were professionally employed by the Bauhaus as teachers for as much as ten and eleven years respectively, and that their texts are, to a large extent, evidence of this teaching. Many of Klee's essays, as well as Kandinsky's *Point and Line to Plane*, "the organic continuation of my book *On the Spiritual in Art*,"[34] were published by the Bauhaus. Moreover, even if one were to restrict consideration of these artists to their pictorial production alone, it would remain to be proved, for instance, that Kandinsky's theories did not have an influence on the later evolution of his pictorial *œuvre*. Personally, I think that a formal analysis of the entire evolution of Kandinsky's work would reach the same conclusions: that is, that a theory based on anachronistic ideological ground cannot have a progressive effect.

To the extent that the transformation that takes place in painting at the end of the nineteenth century demands a new school, a new method of teaching, "a new sort of corporation,"[35] the definition of the "scientific bases specific to art,"[36] it is also true that this transformation cut itself off empirically from the ideology of a preceding period, and that it had to find its own specific identity—in relation to this particular ideology—in order to develop.

In conclusion, we note that the theories elaborated by the Bauhaus did not in any way do away with the problem, nor even prepare the ground for a possible approach to the interdisciplinary work that it supposes. The Bauhaus, to be fair, produced successful transformations in the field of the decorative arts. In terms of art and more specifically painting theory, however, it is still the case today that movements and schools continue to speculate empirically on problematics generated by the radical transformation that took effect in the order of the plastic arts at the end of the nineteenth century. In short, it is as if nothing had happened in between. The pseudotheories and the "avant-garde" movements that follow each other in rapid succession strongly suggest that, when all is said and done, history continues; these various movements lead us to believe ultimately that history is not ready to change since it can continue as if nothing had happened. One need only read the last writings of Gropius; the very stubbornness and

occasional bitterness of this eighty-one-year-old man, a prisoner still today of the same contradictions and passions as forty-five years ago, demonstrates convincingly that the teaching of history is no easy matter to unravel.

Finally, what strikes me most in the rereading of the Bauhaus adventure that I have here tried to undertake, is the fact that in 1919, as in the years following, the ideology informing all the conceptual references of the *masters* of the Bauhaus was the dominant ideology of the time in the Germany of the Weimar Republic.[37] For not having been able to think the deconstruction of this ideology in its specificity,[38] the Bauhaus was reduced to being just one of its reflections; yet had this not been the case, the Bauhaus probably would not have existed as such. Could it have existed otherwise, in any other form? While history, in the end, may repeat itself, *that* perhaps is the lesson that we must finally retain.

August, 1969

The "sanctity" of the work as an autonomous entity has been destroyed.

VARVARA STEPANOVA, 1921

4 The Russian Avant-Garde

"Art History" and History

When we think of the trouble we encounter in just trying to establish the history of the best documented movements of modern art, like the Bauhaus, for instance,[1] it is easy to imagine the many problems that must arise in any attempted approach to the different schools that constitute the Russian avant-garde. Not only are the documents for the most part missing, but too often the works are missing as well.

The Russian avant-garde movements that came into being only years before the great socialist revolution underwent an unprecedented historical upheaval, which marked their development significantly. The destruction, disappearance, and dispersal of their works, as well as the detachment, defiance, and tensions among artists, increase the complexity of any objective approach to the problem. Nor can we forget in fact the background against which the adventures of the avant-garde took place; that is, the initiation and early years of the C(b)PR and the emotional debates that were—and still are—elicited by this period.

It is no secret that the movements we call "avant-garde" suffered in their direct confrontation with socialist ideology and Marxist-Leninist science during the 1920s—one need only look to the writings of Lenin, Trotsky, Lunarcharsky, etc. (which we shall be returning to). In effect, though no one was obliged to be a Marxist, it is nonetheless impossible to trace the adventures of the Russian ava-

131

nt-garde without considering the determining relations that it had to engage in with Marxism.

From this point of view, it would appear that no real approach to the Russian avant-garde (painting, literature, film)[2] has yet been attempted. For want of such an approach—which would situate the Russian avant-garde in the multiplicity of relations that tied it to the history of the C(b)PR—the art historian finds himself in a position where he can neither understand nor explain the contradictions raised by the participation of avant-garde artists in the revolution (theater sets and productions by Nathan Altman, Puni, Boguslav-skaya; Lenin's Mausoleum by the constructivist architect Shchusev, etc.). On the other hand, the art historian faces the impossibility of examining the ultimate failure of these various attempts at participation and integration except through futile polemics.

Camilla Gray's book *The Great Experiment: Russian Art 1863 to 1922* is rich in previously unpublished information. The author's intellectual choices in organizing the book are, however, particularly telling; she closes her work just at the moment when the avant-garde had to confront its inscription in the socialist ideology, the moment when "theories" of the avant-garde were confronted with and compelled to respond to Marxist-Leninist theory and "science." We might even say—and this despite its many merits—that Camilla Gray's book is entirely determined by this *limit* that the author has imposed. In refusing to inscribe the avant-garde specifically at the ideological level, Gray constantly waivers between readings of the avant-garde as part of the continuous linear history of Russian art and as symptomatic of the dramatically discontinuous break between the nineteenth and twentieth centuries: "The two visions which so radically divide the 19th century from the 20th; 'modern art' from the art of Western Europe since the Renaissance and the birth of 'easel' painting."[3] As a result, her book both contains and demonstrates all the contradictions and all the ambiguities produced by empirical theories of the avant-garde.

The contradictions inherent in Camilla Gray's book stem essentially from the double premise upon which this work is based: (1) the Russian avant-garde as part of the continuity of "national traditions"; (2) the Russian avant-garde as the "radical division" between the 19th and 20th centuries. Thus we are told that, in the period between 1860 and 1890, the group of "Wanderers" and the

"Marmontov circle" (Antokolsky, Polenov, Repin, Yakunchikova, Vrubel, etc.) provoked a radical break in Russia from the academy similar to the one produced in France by the impressionists, with the exception that the Russian circle claimed at the same time to be reviving national traditions and the ornamental style of Byzantine art. In this alone, it is very different from French impressionism; Vrubel, whom Camilla Gray introduces as "the Russian Cézanne," is hardly capable of answering to the historical transformations determined by Cézanne. When Camilla Gray writes, "More than any other artist, Vrubel was the inspiration to the *avant-garde* in Russia during the next 20 years" (p. 21), she is clearly referring to Larionov and Goncharova rather than to Tatlin and Malevich. And, indeed, it is easy to see how in "her vigorous and independent research in reviving national traditions" (p. 90), Goncharova, for example, could be more seriously influenced by Vrubel and Maurice Denis than Cézanne.

It is interesting to observe how in Camilla Gray's scheme, the most diverse influences can add up and combine to produce an avant-garde effect: "Thus one can distinguish two streams in Goncharova's work: her vigorous and independent research in reviving national traditions, and her more timid and academic interpretations of the current European styles. These two streams continued in her work until about 1910, when the student discipline based on studies of the work of Vrubel, Borissov-Mussatov, Breughel, Cézanne, Van Gogh, Toulouse-Lautrec and Maurice Denis, to mention but a few, became reconciled with her experiments in the Russo-Byzantine styles under the impact of the French Fauves" (p. 90).

We find ourselves here at the very heart of the contradictions produced by the double set of assumptions upon which Gray's work is based—that is, the introduction of the notion of the avant-garde within the perspective of a revalorization of national traditions. Such a conjunction can be meaningful only at the level of the vaguest generalities. In fact, without examining in detail the ideological anachronisms that the question of a return to a "national tradition" cannot fail to raise, one must seriously wonder what comes under the heading "avant-garde," particularly when, as in this case, it is used as the definition of an irreconcilable break between the nineteenth and twentieth centuries. Should we then read

Vrubel's interest in the formal flatness of Byzantine painting as a part of this avant-garde move? "Byzantine painting differs fundamentally from three-dimensional art. Its whole essence lies in the ornamental arrangement of form which emphasizes the flatness of the wall."[4] But that being the case, would we not have to interpret the Pre-Raphaelites, Maurice Denis, and Puvis de Chavannes in the same light?[5] And, set against these decorative models, what then becomes of the specificity of Cézanne's work? What is this event that "radically" dividing the nineteenth from the twentieth centuries can nonetheless contain practices as diverse as the decorative neo-academicism of Vrubel and the violently deconstructive work of Cézanne?

It is certainly difficult to isolate exactly what Malevich might possibly owe (through Larionov and Goncharova) to Vrubel, especially if one sticks to simple observations of a very general, formal nature in one's critical approach to the works of these painters. Not only do we then run into problems sifting out influences—they can *all* be found scattered just about everywhere—but it is absolutely impossible to establish just what distinguishes and what defines a pictorial product that is presented as avant-garde and breaking from all traditions.

We are concerned here less with minimizing the importance of Vrubel or Puvis de Chavannes's work than with questioning as precisely as possible the forces at play in the undeniable transformation that takes place at the end of the nineteenth and beginning of the twentieth century.

It would appear that the transformation was clearly determined by a complex network of contradictory forces that were at play in this precise historical sequence. One cannot deny, however, that these forces, which obviously had (have) their effect on painting, literature, and music, were absolutely foreign to those forces that would give rise during the same period to the Russian Revolution. While we acknowledge the complexity of these forces, we must especially insist upon the absolute necessity of recognizing at every level (ideological, economic, political) the role of specifics. That is, to determine for each discipline that comes to affirm itself at this moment, in this relation of forces, the specificity of its (ideological, economic, political) inscription and to stress within that inscrip-

tion the varying states of transformation that are effectively worked out and produced by that discipline.

In undertaking such a study, we should avoid collapsing together the different (ideological, economic, political) levels specific to each discipline. We must look within the historical sequence for those aspects of each discipline that transform the base that constitutes its economy; we must further identify the relations between these autonomous transformations and the social order that contains them. It was thus no accident that it was a Russian artist, as early as 1921, who put into question "the work as an autonomous entity." This is a point to which we shall return. It is in fact impossible to think this questioning of the autonomy of painting outside of a definition of the specificity of painting in its autonomy. And this is where Camilla Gray's work is particularly significant. Starting from a history of the Russian avant-garde, in which she tries to find the most pertinently Russian characteristics in intimate rapport with certain national traditions, Camilla Gray is nonetheless inevitably drawn to quote in turn each of the artists and each of the great movements that marked the history of modern European painting. And the lineage she establishes between Vrubel, Larionov, Goncharova, and Malevich ultimately dissolves into a series of ambiguous alliances. In failing to recognize the specific ideological inscription of painting, Camilla Gray is forced to reduce the entire production of modern painting to purely formal effects of transformation and to throw together indiscriminately the various forces at play. This she does for the Russians as well as for European artists. In other words, she sets aside questions relating to the possible theoretical criteria for the appreciation of avant-garde movements. This kind of art history, which can only be made in the best of all possible worlds, comes down to little more than a chain of objective accidents that are best left unexamined. The implicit conclusion is that art history is made without history and with the art that—once the ideological level has been censored—no one knows quite how to define.

Russians and Other People

If I have dwelt upon the contradictory aspects and effects of Camilla Gray's work, it is because these contradictions stem from

the hazardous encounter of arbitrarily chosen concepts and an object of study that never fails to reveal the arbitrariness of those concepts. Thus, the historical discourse that Camilla Gray examines appeals to a different conceptual field whose many possible references are signaled repeatedly throughout the book.

If we follow the evolution of the first groups of artists between 1890 and 1910, and in particular the group gathered around the journal the *World of Art,* we can see how—and in terms of which functional forces—the transformations of the Russian avant-garde were brought about. The group was more or less built around the personalities of Diaghilev and Benois, who continued to dominate Russian artistic life for many years. Until around 1904, the *World of Art* oriented the tastes of the Russian school, especially in the field of painting, through its essential predilection for *art nouveau*—Beardsley, Burne Jones, Puvis de Chavannes, and Vrubel, who was the hero of the group. More than the impressionists or even Cézanne, it was Puvis de Chavannes who seems most to have marked the young painters at the time. When in 1906 Goncharova met Diaghilev at a *World of Art* exhibition, she, like Larionov, was still very much under the influence of a disciple of Puvis de Chavannes, Borissov-Mussatov. And while the introduction of European schools of painting into Russia was handled entirely by enlightened art lovers (Diaghilev, Charles Birlé, a diplomatic attaché to the French consulate in St. Petersburg) and rich collectors (Shchukin and Morosov), the logic of its presentation remained far more a fact of eclectic good taste than real interest in painting. Benois reports that the French impressionists remained unknown in Russia "until the *World of Art* exhibitions in the early years of this century and the later issues of their magazine"[6] around 1904. Benois himself was thus more familiar with Klimt and the German impressionists than with the French; similarly Diaghilev was far more struck by Puvis de Chavannes on his first visit to Paris than by the impressionists, whom he seems to have ignored entirely. And when Charles Birlé, a diplomat, introduced French painting to the young Russian artists who would later take charge of the *World of Art,* it was through the work of the postimpressionists, Gauguin, Seurat, and Van Gogh. As a result, the *World of Art* journal first exposed the Russian public to the Nabis, Bonnard, and Valotton before introducing them, in its last issue, to Cézanne.

Nor was the arrival of French painting in Russian collections any less anarchic. Shchukin first went about acquiring works from the Batignolles school of the 1870s (Manet, Fantin-Latour, Pissarro, Sisley, Renoir, Degas, Monet, and others); the first Cézanne made its appearance in his collection around 1904, almost at the at the same time as the first Picassos and Matisses. And, indeed, it was from 1904 to 1910 that the evolution of young Russian painting suddenly took off. The acceleration is particularly evident in the works of Goncharova, Larionov, and Malevich at this time. In less than five years they would effect the passage from the more or less decorative aestheticism of the *World of Art* to a formal revolution destined to question the very foundations of traditional painting that painters until then had consistently looked to for support. The referential field was abruptly displaced; and no doubt the arrival of the Picasso and Matisse paintings (1906, 1908–) helped the painters in reconstituting the chain of forces that had determined the radical transformations effected in painting. It is with this view in mind that the respective evolutions of Larionov, Goncharova, and Malevich should be examined more closely in terms of their determining influences.

One may well wonder about the Goncharova/Malevich relationship, as Camilla Gray presents it: "These works of 1910–12 by Goncharova such as *Dancing Peasants* and *Hay Cutting* were, as we shall see, the direct source of Malevich's inspiration at this period. Not only did he make use of the same color range and similar pictorial devices, but often even the subject and title were the same as pictures by Goncharova."[7] While it is no doubt true that Malevich's and Goncharova's work followed similar paths at this time, and while we make speak in their case of collective inquiry, it seems to me completely mistaken to say that Goncharova during this period was "the direct source of Malevich's inspiration." As early as 1908–9, with the *Chiropodist in the Bathroom,*[8] Malevich began to undertake a series of studies that he would pursue from a theoretical point of view until 1930 ("An Attempt to Determine the Relation between Color and Form in Painting" in *Nova Generatsiya,* nos. 6, 7, 8, 9, 1930)[9] where the explicit reference is clearly Cézanne. And if Malevich then used Goncharova's formal vocabulary as his raw material, it was only to the extent that this vocabulary was already invested, more or less consciously, with the forces that were in

general shaping modern art; a vocabulary that could be easily and deliberately manipulated—rethought in terms of the most productive of these forces. One need only place a 1908–9 painting by Goncharova like the *Flight into Egypt* side by side with Malevich's *Chiropodist in the Bathroom* to be convinced: for Goncharova the forms are an end in themselves while for Malevich they are already no more than a means. *The Bather* (1909–10) works with the most Cézannesque aspects of Matisse, while Goncharova's paintings from the same date seem unquestionably marked—even in the way she uses the new formal vocabulary—by the decorative style that she inherited in her anachronistic "desire to revive national traditions"; Camilla Gray even notes in this respect the "timid" and "academic" way in which Goncharova thought and interpreted European styles at the time.

It was probably with Cézanne's *Card Players* in mind that Malevich discovered and proceeded through the various movements of modern art ("This was a favorite work of Malevich and one of which he always kept a reproduction on the wall, although he had probably never seen the original.").[10] The questions that Cézanne raised for him, seen through the different movements of modern art, allowed Malevich to pass through "cubo-futurism," "synthetic cubism" and even "suprematism" without stopping at any of them. It was undeniably these questions that determined all his theoretical essays, the elaboration of his pedagogical method, and even to some extent his withdrawal from painting around 1920: "The economic question has become for me the principal pinnacle from which I look down and examine all the creations of the material world: this work with pen rather than brush is my chief occupation. It seems that one cannot attain with the brush what can be attained with the pen. It is tousled and cannot get into the inner reaches of the brain—the pen is finest."[11]

In less than five years (Malevich's first suprematist works date from 1913; the *Black Square* was shown for the first time in 1915), the Russian avant-garde achieved what it had been vaguely striving after for almost twenty-five years (if we choose, as Camilla Gray does, to see Vrubel as the origin of the movement): that is, the ability to produce a theoretical synthesis of European movements. Of course, this desire for synthesis and the synthesis itself must be questioned, but when viewed from an avant-garde perspective, it is

perfectly obvious that the arrival in Russia of works by Matisse, Picasso and Braque and the problem of the theoretical appreciation of Cézanne's *œuvre* that is assumed in the work of these painters are infinitely more important than the *World of Art* aesthetic. The creation of the Shchukin collection around 1904 and the special issue of the *Golden Fleece* in 1908[12] are pertinent turning points.

I have insisted upon the possible relations between Goncharova and Malevich to stress the particularly significant differences that emerge from such a comparison. Judged from this angle, however, Larionov's work presents the same formal conventions as Goncharova's. Similarly it could be demonstrated that Tatlin's accelerated production derives essentially from Cézanne and Picasso.

From 1911 (*Bouquet,* oil on canvas, 48 × 93cm., Tretyakov Gallery, Moscow) to 1913–14 (first constructivist montages) following a visit to Paris, Tatlin passed from the strongly marked influence of Cézanne to that of Picasso. Camilla Gray notes quite rightly that for Tatlin as for Malevich, Cézanne is the "common denominator."

Despite all the misunderstandings it has produced and generated, the history of the Russian avant-garde never ceased to expose its own particularly well-defined field of influences. The fact that Goncharova may have introduced Tatlin to icon painting is not sufficient to inscribe Tatlin in a Russian national tradition any more than Picasso's discovery of African masks inscribes him in an African tradition. Tatlin, Malevich, and Picasso's use of a given formal vocabulary must not in any way be confused with the productive force at work in these artists' paintings. And they all recognized that the force with which they identified was determined by the systematic production of Cézanne at the end of the nineteenth century.[13]

The fact that the Russian avant-garde presents unquestionable analogies with other avant-garde movements that continued to develop elsewhere in the world is not a sufficient indication of its own reality. It is not the multiplication of modernist forms or more or less irrational gestures that give reality to the history of modern painting; in the order of specific knowledge, it is rather the productive forces that allow this knowledge to develop alongside the sciences that are contemporary to it. Painting cannot remain untouched by developments in the social and natural sciences—painting, being understood here to be not a metaphysical object but a productive force within the order of a specific realm of knowledge.

It is for this reason in particular that it is important to establish the real forces that at a given moment may actualize transformations (especially when, as is the case here, it is a question of forces conditioned by economic change: nineteenth-century France and Cézanne)—this is why the interface between the Russian avant-garde and the revolution is particularly significant.

The Avant-Garde and the Revolution

Of all the different art movements at the beginning of the twentieth century, the Russian avant-garde is the only one to think seriously of inscribing itself fully, without compromise, in a new society. The 1917 October revolution was for the artists of the avant-garde a sign of fundamental transformation; a transformation that they assimilated almost immediately to the change they were themselves practicing in their respective disciplines. It is worth noting that this phenomenon holds true for the artists of the avant-garde alone; the artists who were conservative in their art would be equally so in their ideas when the revolution broke out.[14] Tatlin, who was constructing his *Monument for the Third International,* wrote at the time: "The events of 1917 in the social field were already brought about in our art in 1914 when 'material, volume and construction' were laid out as its 'basis.' "[15] As for Malevich, he went just as far, writing in 1919: "Cubism and Futurism were revolutionary movements in art, anticipating the revolution in economic and political life of 1917."[16] At the same time, Eisenstein enlisted in the Red Army, where he worked as a decorator and poster designer for the Agit-Prop. To the question, "Can the intelligentsia work with the Bolsheviks?" Blok replied: "It can and it must"; and Mayakovsky observed: "To accept or not to accept? That was a question I didn't even ask. This revolution was mine."

As we can see, the artists of the avant-garde themselves identified from the start with the revolution, but that identification eventually gave rise to problems when by the same token they chose to identify the revolution and their art. What is peculiar to the Russian intelligentsia of 1917–20 is the confusion between the specifically political level and the ideological level, as the texts of Tatlin and Malevich quoted above clearly show. The first years of the revolution and the Soviet republic fostered this confusion. Agit-Prop, for instance, took on proportions that are absolutely unimaginable in

any other context; one need only think of the excitement for artists given the opportunity to stage for the first anniversary of the revolution a reenactment of the storming of the Winter Palace. (According to Camilla Gray, the decor and staging of this reenactment were done by Altman, Puni, and Boguslavskaya.)[17]

The reorganization of the cultural superstructures that was entrusted to Lunacharsky, the Commisar of Education in the Bolshevik government, also promoted all sorts of misguided illusions among the artists. Nor did this reorganization always function effectively on its own: Lenin was called upon to intervene in opposition to Lunacharsky at the first congress of the Proletkult in October 1920.

The illusion that seems to have been most widely held by the Russian artists was clearly a product of the climate of agitation and upheaval in Russia at the time; it can be characterized as a belief on the part of artists that being avant-garde was preparation enough for the construction of "a new world" (Malevich). As it happens, between the ideas of a culturally very advanced avant-garde (that was not always sufficiently equipped at a theoretical level to distinguish between what in its manifestations might stem from objective work and what should come from empirical practice) and the realization of their projects, there was the real (economic and political) situation of a Russia whose population at the time was still 73 percent illiterate.

Lunacharsky thus found himself caught between two extremes and in a position of reconciling the irreconcilable. Contradictions abounded: there is the example of the proposal made to Kandinsky (a notorious antimaterialist and anti-Marxist)[18] to become a member of the Praesidium in charge of reorganizing the various pedagogical and artistic institutions into an academy of the sciences. Yet this contradiction is hardly the most blatant by comparison with the more general context in which Lunacharsky found himself: surrounded by painters, poets, filmmakers, and theater people who were proclaiming a total break with the past and a liquidation of all traditions, he, on the other hand, was Commissar for Education in a country where close to 90 percent of the population had no idea what the past represented and even less an idea of what the traditions could possibly be.

Similarly we find the following declaration by Mayakovsky: "We

do not need a dead mausoleum of art where dead works are worshipped, but a living factory of the human spirit—in the streets, in the tramways, in the factories, workshops and workers' home."[19] Such declarations, like those of Malevich and other futurists, resulted in severe reprimand from political leaders. In a now famous text on futurism, Trotsky writes:

> But Futurism carried the features of its social origin, bourgeois Bohemia, into the new stage of its development. In the advance guard of literature, Futurism is no less a product of the poetic past than any other literary school of the present day. To say that Futurism has freed art of its thousand-year-old bonds of bourgeoisdom is to estimate thousands of years very cheaply. The call of the Futurists to break with the past, to do away with Pushkin, to liquidate tradition, etc., has a meaning insofar as it is addressed to the old literary caste, to the closed-in circle of the Intelligentsia. In other words, it has a meaning only insofar as the Futurists are busy cutting the cord which binds them to the priests of bourgeois literary tradition. But the meaninglessness of this call becomes evident as soon as it is addressed to the proletariat. The working class does not have to, and cannot break with literary tradition, because the working class does not know the old literature, it still has to commune with it, it still has to master Pushkin, to absorb him, and so overcome him.[20]

For his part, Lenin would be just as direct: "The first [obstacle] was the plethora of bourgeois intellectuals, who very often regarded the new type of workers' and peasants' educational institution as the most convenient field for testing their individual theories in philosophy and culture."[21]

What is particular striking in the history that we have traced here is the way in which a discipline may be specifically prepared for radical transformations without these transformations necessarily becoming productive in relation to the different levels of the social order. It could be said that the advance that characterizes modern painting in Russia in the first twenty years of this century—an advance largely stemming from painterly specificity—blinded the order of a practice that was destined no longer to think of itself as an autonomous entity (a point emphasized by Varvara Stepanova). Once again we rediscover all the ambiguities (and their consequences) which gave rise to the Russian school.

Historical confusion, incomplete knowledge of the initial work that was to undergo so many influences, and theoretical anachronisms all produced the hasty acceleration of the avant-garde whose effects remain for all this, in many ways, no less tangled in the texture of contradictions that determined them. Thus, after his large suprematist works, Malevich would devote himself to a particularly elaborate theoretical project in which he found himself forced to question fixed concepts in the history of painting (the artist, the author, the *œuvre*, and form).[22] However—and this, it seems to me, is one of the inevitable consequences of avant-garde haste—the theoretical reassessment of painting would entail a general abandonment of his artistic practice.

Malevich's essays on art deserve much closer attention than we can possibly give them in these few lines. Nonetheless, what should be noted in passing is that however rich Malevich's texts may be in suggestive glimpses of the future, they belong, all the same, to the theoretical empiricism characteristic of all the other texts by art theorists contemporary to him. In his necessary recourse to disciplines outside the field of painting, Malevich seems curiously unconcerned by the implications that the concepts he borrows—in particular, philosophical concepts[23]—may carry for his critique of specifically pictorial questions. From that point on, painting, which was once and for all accepted as a process of knowledge, marked within a critical space that questioned all the phenomenological interpretations that have since been so successful, remained despite all else caught in the theological space of art that had always been its own—and this largely due to the fact that the author never managed to define his own practice within a differential and interdisciplinary relation. Painting, in other words, censors the specific level of its inscription within ideological space by posing as transcendental or by supposing art to be transcendental. The apparent strength of contradictions such as these may indeed have produced a desire to break with the past (*May the Praxiteleses, the Phidiases, the Raphaels, the Rubenses and all their generations perish in monastery cells and in graveyards*),[24] a desire whose naiveté proves Lenin's and Trotsky's criticism right on every account. It may also be responsible for the impossibility of understanding and adapting these forces to the demands of the present. This is a problem that any discipline—called upon at whatever moment to think

through its relation to the dominant ideology—cannot ignore without falling into regression.

It is no accident if, of all the avant-garde artists in Russia, it is those who understood their discipline most clearly in terms of ideology, the filmmakers, who best perceived the contribution that scientific materialism could make to their practice.[25] Consequently it is the filmmakers who best adapted the most avant-garde techniques to the service of a revolution that was theirs at the ideological level and could therefore become theirs as well as its political and eventually (with admitted difficulty) economic levels. But that is another ideological adventure that refers to yet another network of forces and contradictions—that is to say, another text.

October, 1969

POSTSCRIPT: MALEVICH CENSORED

Since this essay was first published, Russian futurism has met with tremendous success both from the commercial and the critical points of view, a success that seemed quite unlikely in 1969. On the other hand, the question of the relations between art and politics that I tried to call attention to—the antinomies of artistic practice and political institutions—has been cautiously put to rest. The Russian avant-garde, Russian futurism, is for me above all the symptom of a malaise that can be quite tragic in the case of the relations between art and political parties and institutions. The plastic productions of the Russian futurists, of which only a very few remain—the rubble of a studio or the work of third- or fourth-rank artists whose mediocrity can only stop the art historian for the purposes of tendentious speculation—none of this (as should be clear) has more than secondary importance in my view. As such, these traces are evidence of how limiting the conjuncture of artistic prac-

tice and political institutions may be and how fatal it may be for the most important expression of man's life and thought—art. Malevich knew something of this in his own time. It is true that afterward he seems to have become, like Mayakovsky, a sort of ventriloquist or *cadavre exquis* for good thoughts of all sorts. And by good thoughts I mean the bad conscience or bad consciousness that turns about and avoids at all costs the question of the ideology of art and of the relation of art to institutions, precisely because this question raises the problem of the subject of art and its incompatibilities with whatever institution. The historian who finds himself in this position tends to draw up the economy of what constitutes history and what works through the constitution of that history. It is my purpose to address not simply the plastic or aesthetic virtualities that determine the position of the subject vis-à-vis institutions but his political place as well. To be exact, it is my intention that this essay introduce into a very precise ideological-political context the question of the repression of the subject which may be read from the perspective of "Matisse's System" as the coming to terms with elements that cannot be dealt with outside the framework of Freudian theory. That the repression of the subject is at the core of all these questions becomes all the clearer when we consider the critical and commercial strategies constructed since; they elaborate a theory of the history of modern painting and its contemporary developments which uses Russian futurism in order to revoke (by revoking surrealism) any trace of Freudian influence in the pure paradise of formal analogy that then becomes the story of painting. Personally, I think that if Malevich stopped painting in the circumstances in which he did, it was not simply as a result of sociological conditions. To refuse to consider the objective realities in which this artist found himself, caught as he was with no possibility of resolving the problematic between his artistic practice and the political institution—to refuse to take all this into consideration is to censor him yet again and to censor any artist from the true freedom of creation, because it is to deny the artist the very possibility of being conscious of his work and of working to find his own limits.

(1976)

Notes

TRANSLATOR'S INTRODUCTION

1. Like most of the members of the editorial board of *Tel Quel* (the major exception being Julia Kristeva), Pleynet maintains no academic affiliation. In fact, his initiation into the academic world as a professional intellectual took place in America when he was invited to teach at Northwestern University in the mid-sixties. Of that experience Pleynet guards what he calls a "semi-hallucinatory memory of that first passage through the University." (*L'Amour: Chroniques du journal ordinaire 1980* (Paris: Hachette, 1982), 55.

2. As of 1983, the editorial board of *Tel Quel* dissolved their affiliation at Seuil and moved to Gallimard, where they have formed a new journal, *L'Infini.*

3. Pleynet has on occasion tried to minimize the identification of his own writing with the editorial purpose of *Tel Quel.* In the second volume of his intimate diary, *Spirito Peregrino* (Paris: Hachette, 1981), he gently reproaches a young Ph.D. candidate from England for assuming the implicit equivalence between the parallel evolutions of his poetry and *Tel Quel.* "It is not only the history of *Tel Quel* that is at issue; my own history figures here. The two do not necessarily overlap" (51). In the case of his critical writings, however, a definite argument can be made for the "overlap."

CHAPTER 1

1. See my essay "Contradiction principale, contradiction spécifique. L'Imitation de la peinture," in *L'Enseignement de la peinture,* coll. Tel Quel, (Paris: Seuil, 1971).

147

2. John Rewald, *The History of Impressionism* (New York: Museum of Modern Art, 1961); *Post-Impressionism* (New York: Museum of Modern Art, 1962).

3. Gaston Diehl, *Henri Matisse* (Paris: Pierre Tisné, 1954).

4. Raymond Escholier, *Matisse, ce vivant* (Paris: Fayard, 1956).

5. Alfred Barr, *Matisse, His Art and His Public* (New York: Museum of Modern Art, 1951).

6. Escholier, 18.

7. Matisse's mother had, we know, artistic aspirations. She helped her young son in making his decision to become a painter (the older son was destined to take over the store). Similarly, it was the idea of seeing Henri Matisse take courses from Bouguereau (who was then at the peak of his career, his fame, and his awards) that determined the father's decision.

8. Henri Matisse, *De la couleur* (Paris: Ed. Verve, 1885).

9. Matisse to Gaston Diehl, May 1943.

10. Catalogue to the Centenary Exhibition, Grand Palais (Paris), April–September, 1970.

11. Jacques Guenne, *Portraits d'artistes* (Paris: Scheur, 1927).

12. Barr, *Mattise.*

13. Escholier, *Matisse,* 23.

14. See the catalogue to the Centenary Exhibition, no. 4.

15. Ibid, no. 5.

16. Courtauld collection, Courtauld Institute Galleries, University of London.

17. Catalogue to the Centenary Exhibition, nos. 7–10–12; these canvases came from the artist's studio.

18. Diehl, *Henri Matisse.*

19. Ibid.

20. E. G. Robinson collection.

21. The composition and subject matter of this painting are identical to Vuillard's painting, *The Vuillard Family at Lunch,* 1896, R. F. Colin collection, New York.

22. Reported by Barr, *Matisse,* 35.

23. The two Cézanne paintings from the Caillebotte collection that were exhibited at the Luxembourg are: *The Gulf of Marseille seen from Estaque,* 1883–85 (Venturi, no. 428), and *Farmyard,* 1879–82 (Venturi, no. 326).

24. Barr, *Matisse,* 38.

25. Quoted by Escholier, *Matisse,* 41.

26. Ibid., 45.

27. Ibid., 41

28. Dr. A. M. Sackler collection, New York; Catalogue to the Centenary Exhibition, no. 26.

29. For this anecdote, see Diehl, *Henri Matisse;* the painting that Matisse bought appears in the Venturi catalogue as no. 381: 1879–82, *Three Bathers,* 50 × 50 cm. This painting is now at the Petit Palais in Paris.

30. Matisse to Raymond Escholier, quoted in Escholier, *Matisse,* 50.

31. Georges Duthuit, *Les Fauves* (Geneva: Ed. des Trois Collines, 1949).

32. "Henri Matisse vous parle," *Traits,* 1950.

33. Diehl, *Henri Matisse.*

34. Henri Matisse, *De la couleur* (Paris: Ed. Verve, 1945), vol. 4, no. 13, p. 10 (my emphasis).

35. Matisse to A. Rouveyre, 28 December 1947.

36. "Henri Matisse vous parle," *Traits,* 1950.

37. Matisse, *De la couleur,* 10.

38. Christian Zervos, *Picasso* (Paris: Hazan, 1949), vol. 2, a.

39. Matisse, *De la Couleur,* 10.

40. Remarks by Matisse, reported by Gaston Diehl.

41. Cf. bibliographical information in Jean Laude, *La Peinture française et l'Art nègre* (Paris: Klincksieck, 1968).

42. See "L'Imitation de la peinture," in my *L'Enseignement de la peinture.*

43. Henri Matisse, "Note d'un peintre sur son dessin," *Le Point,* July 1939.

44. Jacques Derrida, "The Double Session," in *Dissemination,* trans. Barbara Johnson (Chicago: University of Chicago Press, 1981).

45. Ibid, p. 188.

46. Cf. Jacques Derrida, *Of Grammatology,* trans. Gayatri Spivak (Baltimore: Johns Hopkins Press, 1976).

47. Nietzsche, *The Will to Power* (ed. and trans., Walter Kaufman (New York: Vintage, 1968); 548 (1885–86), p. 294.

48. Remarks by Matisse reported by Gaston Diehl.

49. Preface to Duthuit, *Les Fauves.*

50. Henri *Matisse,* text published in *La Grande Revue,* December 1908. Quoted by Barr as "Notes of a Painter," in *Matisse,* 119–23.

51. Duthuit, *Les Fauves.*

52. According to Raymond Escholier, Matisse often recited the following lines from Mallarmé:

Imitate the Chinese, clear and refined
Of heart, whose pure bliss is to paint the end
Upon his cups of snow torn from the moon
Of a weird flower that breathes perfume upon
His lucid life, that in his infancy
Grafted upon his soul's blue filigree . . ."

from "Las de l'amer repos . . ."
(trans. Keith Bosley)

One is tempted to juxtapose these lines of verse to a recollection of Matisse's mother, who painted on porcelain—"painted china." The "Chinese man" in the poem is oddly reminiscent of Matisse.

53. The first of these quotations may be found in Matisse's speech in his home town on the inauguration of the Cateau museum on 8 November 1952, just two years before his death. The second quotation is drawn from "Note d'un peintre sur son dessin."

54. In the *Grande Revue,* December 1908.

55. According to Escholier, *Matisse.*

56. Ibid.

57. Ibid., 35–36.

58. Henri Matisse to Pierre Matisse, 7 January 1942.

59. On this point see Philippe Sollers's work on the notion of "monumental history," in *Logiques,* coll. Tel Quel (Paris: Seuil, 1968).

60. Matisse, *De la conleur,* 20.

61. Escholier, *Matisse.*

62. Henri Matisse, *La Chapelle du Rosaire* (Vence, 1951).

63. Quoted by Guichard Meili, *H. Matisse* (my emphasis).

64. In the *Grande Revue,* December 1908.

65. Henri Matisse, *Portraits* (Monte-Carlo: Sauret, 1954). Aragon, thinking back to these remarks by Matisse, writes: "What I would not give to find that crumpled scrap of paper no doubt thrown on the ground in that post office in Picardy!" (*De la ressemblance,* Fondation Maeght, 1962). The *analytic task* that we set ourselves here is precisely to rediscover that "crumpled scrap of paper" that Aragon's eclectic manner systematically circumvents.

66. Matisse, *De la couleur,* 20.

67. Matisse, "Note d'un peintre sur son dessin."

68. Matisse to A. Rouveyre, n.d.

69. Barr, *Matisse,* 550.

70. Ibid., 13. Pierre Schneider writes: "It was immediately after the gift of this box [of paints] that he painted his first canvas." Catalogue to the Centenary Exhibition.

71. Barr, *Matisse;* cf. note 52.

72. Diehl, *Henri Matisse,* 6.

73. My emphasis.

74. Museum of Fine Arts, Copenhagen.

75. J. Koerfer collection, Bern.

76. Reported by Barr, Matisse.

77. Matisse, "Note d'un peintre sur son dessin."

78. Diehl, *Henri Matisse,* 97.

79. *Grande Revue,* December 1908.

80. Cf. the normative definition of painting that Plato provides in book 10 of the *Republic:* "And is the painter also a craftsman and maker of such a thing?"—"Not at all."—"But what of a couch will you say he is?"—"In my opinion," he said, "he would not sensibly be addressed as an imitator of that of which these others/are craftsmen."—"All right," I said, "do you, then, call the man at the third generation from nature an imitator?" Trans. Allan Bloom (New York: Basic Books, 1968).

81. Melanie Klein, "Our Adult World and its Roots in Infancy," in *Envy and Gratitude* (Delacorte Press, 1975), 248–49.

82. Philippe Sollers, "Dante et la traversée de l'écriture," in *Logiques.*

83. Sigmund Freud, "On the Universal Tendency to Debasement in the Sphere of Love," in *The Complete Works (Standard Edition)* (London: Hogarth Press, vol. 11 (1957), pp. 188–89.

84. Sigmund Freud, *Totem and Taboo,* in ibid., vol. 13 (1955), p. 27.

85. Theophrastus *De sens.* 49–82; in Maurice Solovine, *Démocrite* (Paris: Felix Alcan, 1928), 81.

86. Aëtios 1, 15, 8, in *Démocrite,* 68.

87. Aristotle, *De gen. et corr.,* 1, 2, 316 al, in *Democrite,* 69. The state in which the texts by the ancient materialists have come down to us does not permit us to establish a conceptual system based on the fragments we have; we are therefore limited largely to using these texts as part of a working hypothesis. I would like briefly to signal certain fragments by Democritus on color, taste, and form that may be read alongside the *Hong Fan,* a Chinese treatise of the sixth or fifth centuries B.C. that proposes the same operational structures for analysis. That is to say, a Chinese work that is virtually contemporary with Democritus. According to Sextus Empiricus, *Math.* VII, BS, Democritus writes: "Sweetness is a convention, bitterness a convention, heat a convention, and cold a convention: in reality there are only atoms and the vacuum." As we have noted above, according to Aëtios, 1, 15, 8, Democritus asserts that color "takes on four kinds of appearance: *white, black, red, yellow."* And according to Aristotle, *De gen. et corr.,* "Democritus claims that *black* corresponds to *roughness* and *white* to *smoothness* and he links the tastes to atoms." Theophrastus, *De caus. plant.,* VI, 1, 6 (55AI29) adds: "Democritus coordinates a particular form to each taste and says that *sweetness* is produced by a form that is *round* and of well-proportioned size; *sourness* is produced by a form of large proportions, covered with points, angular and not rounded; *sharpness* (of taste) is produced, as its name suggests, by pointed forms, angular, bent, light but not rounded; *tartness* is produced by a form that is round, light, angular, and curved; *saltiness* is produced by the angular form that is a well-proportioned size, oblique and scalene; *bitterness* is produced by a

rounded form that has a single curve and is small in size; the taste of *fat* is produced by a light form that is small and round" (my emphasis).

According to Democritus's classification of tastes, above, we are thus left with:

white—smooth/black—rough
red—sharp?/yellow—round?

Despite our general uncertainty regarding these fragmented texts and the way they have been transmitted to us, we may yet add to this "system" the correspondence that Empedocles establishes between *white* and *fire,* and *black* and *water.*

The *Hong Fan* which Marcel Granet has analyzed in *La Pensée Chinoise* (Paris: Albin Michel, 1950) dates back, according to one tradition, to 2000 or 3000 B.C.; while some modern critics have dated it 700 B.C., and others 200 B.C., Granet places it somewhere around 500–400 B.C. The *Hong Fan* also establishes a combination of equivalences between *Colors* and *Tastes* (*Flavors*). Granet writes: "The *Hong Fan* and *Yue Ling,* which attend to the Elements, propose numeric correspondences from different but apparently complementary points of view, the *Hong Fan* for the *first* of the numbers in a congruent pair and the *Yue Ling* for the *second.* Both are inspired by a general system of classification *whose many myths* are proof of its antiquity and prestige. This system consists of a combination of equivalences between the *Seasons,* the *Orients . . . Colors, Tastes . . .* and the *Elements* as well as the *Numbers.* The *Yue Ling* links the number 6 and *saltiness* (hien) to *Winter* (= the North), which is placed under the influence (tö = virtue) of *Water;* number 7 and *bitterness* (k'ou) are linked to the *Summer* (= the South) which comes under the influence of *Fire;* number 8 corresponds to *acidity* (siuan) and *Spring* (= the East) which comes under the influence of *Wood;* 9 goes along with *sourness* (sin) and the *Autumn* (= West) which is placed under the influence of *Metal;* number 5 and sweetness (kan) are linked to the *Center* which is identified with the *Earth.* The *Hong Fan,* which designates the cardinal tastes by the same words as the *Yue Ling,* writes: "(That which) moistens (and) tends to the *Bottom* [Water: 1] produces saltiness; (that which) blazes (and) tends to the *Top* [Fire: 2] produces bitterness; (that which) curves (and) stands [Wood: 3] produces acidity; (that which) is malleable (and) multiform [Metal: 4] produces sourness; (that which) is seeded and mown [Earth: 5] produces Sweetness" (pp. 170–71). Elsewhere, as Granet indicates (p. 87), in the scholary system of Chinese thought, *Red* is emblematic of *Summer* and the *South; Green—muscles, the liver, Spring* and the *East; White—the lung, Autumn* and the *West; Black—Winter* and the *North; Yellow—*the *center.* In other words:

BLACK	Winter	North	Water	Saltiness	bottom
GREEN	Spring	East	Wood	Acidity	curved (and) standing
RED	Summer	South	Fire	Bitterness	top
WHITE	Autumn	West	Metal	Sourness	malleable, multiform

(YELLOW-CENTER-EARTH-SWEET-SEEDED [and] MOWN)

As we can see, the Greek materialist theories of Democritus—or what we have of them—are remarkably similar to the logic of the Chinese in their organization of time and space and the elements that determine them.

88. Sigmund Freud, "Instincts and Their Vicissitudes," in *Collected Papers* (London: Hogarth, 1949), vol. 4, p. 66.

89. Ibid., 74–75.

We have become accustomed to call the early phase of the development of the ego, during which its sexual instincts find auto-erotic satisfaction, *narcissism,* without having so far entered into any discussion of the relation between auto-erotism and narcissism. It follows that, in considering the preliminary phase of the *scoptophilic instinct,* [in French, *la pulsion de regarder*] when the subject's own body is the object of the scoptophilia, we must place it under the heading of narcissism; it is a narcissistic formation. From this phase the *active scoptophilic instinct,* which has left narcissism behind, is developed, while the *passive scoptophilic instinct,* on the contrary, holds fast to the narcissistic object. Similarly, the transformation from sadism to masochism betokens a reversion to the narcissistic object, while in both cases *the narcissistic (active) subject is exchanged by identification* for another, extraneous ego. Taking into consideration the preliminary narcissistic stage of sadism constructed by us, we approach the more general view that those vicissitudes which consist in the instinct being turned round upon the subject's own ego and undergoing reversal from activity to passivity are dependent upon the narcissistic organization of the ego and bear the stamp of that phase. Perhaps they represent attempts at defence which at higher stages of the development of the ego are effected by other means.

At this point we may remember that so far we have discussed only two pairs of instincts and their opposites: sadism-masochism and *scoptophilia-exhibitionism.*

Freud's analysis merits formalization within the field of an approach to painting; in the present instance, our reading of Matisse, the narcissistic subject is exchanged by identification with that other, extraneous (yet very close) ego, the mother.

90. Freud, *Three Essays on the Theory of Sexuality,* in *The Complete Works (Standard Edition),* v. 7 (1953).

91. Karl Abraham, "The Influence of Oral Erotism on Character Forma-
tion," in *Selected Papers* (London: Hogarth, 1949), 404.

92. Ibid. 400 (my emphasis).

93. See "L'Imitation de la peinture," in my *L'Enseignement de la
peinture*.

94. Henri Matisse, interviewed by R. Bernier ("Regarding the film *A Vis-
it with Matisse,*" 1946, A Leveille, director) in *Vogue*, February 1940.
Quoted by Barr, *Matisse*, 260.

95. Matisse, *Portraits*.

96. Matisse, *Jazz* (1947).

97. Ibid.

98. Quoted by Escholier, *Matisse*, 188 (my emphasis)

99. Louis Aragon, *Matisse en France* (Ed. Martin Fabiani, 1943) (my
emphasis).

100. Ibid.

101. Ibid.

102. Ibid.

103. Remarks made by Matisse to Tériade, in *Minotaure*, 1934.

104. Matisse, "Note d'un peintre sur son dessin."

105. Matisse, *Jazz*. We should note that when called upon to produce
the text that would separate the plates of *Jazz*, Matisse for some reason
(which he himself does not explain well) found that he must do it in hand-
writing (or hand-drawn writing): "I decided that handwriting was better
suited to this purpose . . . The exceptional dimension of handwriting
seemed necessary to me for the decorative relation with the nature of the
color plates. These pages thus serve to accompany my colors just as asters
give greater importance to the composition of a bunch of flowers." It is
clear that Matisse is more interested here in the graphic quality of his writ-
ing than in the writing as a graphic vehicle for something else. It should be
further pointed out that this text is also one of the most religious and
metaphysical by the artist; in it one finds a long quotation from *The Imita-
tion of Christ* (which serves, perhaps, "to accompany" the artist's colors).
In addition to the definitions of the sign, of color, and of everything that is
in multiple ways *readable* in the text from *Jazz*, one might wish to develop
the notion of "imitation" in Matisse (and in painting in general). Imitation
which is, Matisse says it well, more the imitation of a drawing than that of a
figure—unless, that is, the drawing is of a figure . . .

106. What is developed pictorially in the artist's practice might well be
certified by his name itself—cf. the suggestions at the end of the chapter
"Drawing with Scissors."

107. E. Tériade, "Propos de Matisse," *Minotaure*, nos. 3–4/10 (1933).
Reprinted in *De la couleur*, Ed. Verve, no. 13 (1945).

108. My emphasis. *De la couleur.*

109. Ibid.

110. Ibid.

111. Pierre Schneider, in the catalogue to the Centenary Exhibition, notes that the *Woman Reading at a Yellow Table* (1944) was interrupted when Matisse's daughter returned from being deported, and that he was never able to complete this canvas.

112. Matisse to A. Rouveyre, 6 October 1941, quoted in the catalogue to the Centenary Exhibition, 254.

113. I would further point to this period as an example of the work that resulted from Matisse's new approach to his paintings as initiated by the *Woman with the Hat.*

114. In my tentative approximations of Matisse's system, I have no choice but to schematize the vast texture of contradictions that Matisse's practice enacts; at present, the state of Matisse scholarship—most notably the current state of biographical research—prevents us from advancing any further in this regard.

115. Barr, *Matisse,* 193 (my emphasis).

116. Escholier, *Matisse,* 111. See the Matisse-Camoin correspondence, presented by Danielle Giraudy in *La Revue de l'Art,* no. 12 (1971). Matisse writes to Camoin in the autumn of 1914: "What became of my mother, whom the doctors had given a year or two to live three years ago when she had a heart attack?" This correspondence appeared just as I received the first proof of this book; it has the great merit of fixing with some authority certain events in Matisse's biography (the death of his father in 1910—see the letter to Camoin, 18 October 1910; family difficulties—letter to Camoin, July 1941, etc.). Above all, it helps us to date by Matisse's own account, the chronology of the "two lessons" (Matisse's letter of 1917 allows us to conclude that *The Piano Lesson* preceded *The Music Lesson*).

117. Escholier, *Matisse,* 117.

118. Jacques Lassaignes, *Matisse* (Geneva: Skira, 1959), 89.

119. These three paintings are reproduced in the catalogue to the Centenary Exhibition 39, 41, 215.

120. Johannes Itten (*L'Art de la couleur,* Paris: Dessain et Totra, 1967) would say the following about *The Piano Lesson* (which he calls *The Piano*): "The brightly colored person sitting on a high chair is no doubt the reflection of a young girl listening to the boy who watches her as he plays the piano or imagines her like a vision." The fanciful nature of this description is only surpassed by its blindness. Gaston Diehl is more cautious, but no less attached to a naturalistic interpretation; he writes: "The figure of a woman listens to young Pierre Matisse practice his scales. She is perched upon a studio stool (like *The Woman on a High Stool* in the Shchukin

collection), and, in order to fill up the large gray rectangle that forms her background, Matisse stretched his model in height, like the Romanesque sculptors used to do." *H. Matisse,* 142. Diehl's description is no less surprising than Itten's. Since we know in fact that Matisse often reproduced his earlier paintings in later ones, why should anyone choose to see, in the reproduction of *The Woman on a High Stool,* the figure of a woman listening to young Pierre play his scales and sitting on a high stool *like The Woman on a High Stool?* For that matter, how did Diehl decide that Pierre Matisse was practicing scales?

121. Catalogue to the Centenary Exhibition, 196.

122. We note the dialectical relations that are maintained by the following pairs: music/piano, violin/metronome, a picture/painting.

123. The most amusing information in this regard can be found in remarks by the artist's wife, which Escholier reports in *Matisse,* 119: "The truth about the kind of musical frenzy that the artist would get carried away with at this time was revealed to me by Mme Henri Matisse after the death of the master. While I was speaking to her about the dry curatile illness [*sic;* I have no idea which illness Escholier gave this name to] that threatened Matisse's eyesight during his last years . . . , his widow came out with the most surprising comment: 'This illness must have gone back very far indeed, for as long as I knew him, my husband was tormented by the fear of losing his sight. So much so that when we settled in Nice in 1918, he was obsessed by this thought and started studying the violin very seriously. One day I asked him the reason, and Henri simply answered, 'It's a fact that I am afraid of losing my eyesight and never being able to paint anymore; so I thought of one thing: when you are blind, you have to give up painting, but not music . . . That way I could always go into the squares and play the violin. I could still support us all: you, Margot, and me.'" I think we should avoid interpreting the childishness of this remark—which can of course be read in many ways. For my own part I would simply stress the association (sight-eye-music), an association that in the series that interests us here (lesson-music-violin-piano . . . dance) seems to have been properly therapeutic.

124. This letter and several others are reprinted in the catalogue to the Matisse exhibition that took place in Moscow and Leningrad in 1969 on the occasion of the one hundredth anniversary of the artist's birth.

125. The two versions of the Merion panel in fact reverse the order of the two "lessons."

126. One must insist all the more on the subjective importance of this work as Matisse seems at first to deny it. In February 1934, he writes to Romm: "I, who always let myself be guided by my instinct (insofar as it manages to dominate my reason), had to avoid it [this time] because it took

me outside of my problem." Catalogue to the Matisse exhibition, Moscow. The denial here is repressing what is most forcefully at work.

127. Matisse to A. Rouveyre, June 3, 1947, in the catalogue to the Centenary Exhibition, Paris, 244.

128. Matisse to André Lejard, in *Ami de l'art*, October 1951.

129. Cf. the description of these problems in Barr, *Matisse*, 241–244.

130. Dorothy Dudley, "The Matisse fresco in Merion, Pennsylvania," *Hound & Horn* 7, no. 2 (January–March 1934), pp. 298–303.

131. Escholier, *Matisse*, p. 129.

132. See above, the chapter on "The Painted Woman"—the "body-to-body" contact is mediated here by a "cutting out" that recalls the treatment of Yvonne Landsberg.

133. Barr, *Matisse*, p. 242.

134. Catalogue to the Centenary Exhibition, Paris, 44.

135. My emphasis.

136. Cf. *Mallarmé: The Poems*, trans. Keith Bosley, (London: Penguin, 1977). [I have made some slight changes to Bosley's otherwise sensitive translation to emphasize the literal meaning of specific images that are evoked in the context of the present discussion.—Trans.]

137. One could quite easily divide Matisse's career into fifteen-year periods: 1891—entrance into the Académie Julian; 1905—the *Woman with the Hat*, fauve portrait of Mme Matisse; 1917—*The Piano Lesson*; 1932—the Merion mural; 1947—*Jazz* and the large paper cutouts.

138. The collection of "Poems by Mallarmé" must be read in its entirety to understand the terms of Matisse's drawings and the place they occupy in his system. This Mallarmé volume has a great deal to teach us about Matisse.

139. On this point, see Matisse's relation to food as sketched above ("The Painted Woman," and "Sign/Nature").

140. Matisse describes these illustrations in the following way: "Etchings done in a very regular line, very fine, without hatch-marks, which leaves the printed sheet almost as white as before the printing. The drawing fills a page that has no margin, which makes the sheet even lighter, since the drawing is not massed together in the center, as is usual, but spreads out over the entire page. The rectos with the inset plate face the versos, which have the text in italics, printed in 'Garamond corps 20.' The problem was thus how to balance the two pages—one white, with an etching, and one black, relatively, the one with the type. I achieved this result by modifying my arabesque in such a way that the spectator's attention would be drawn as much to the white page as to the promise of reading a text. I compare my two sheets to two objects chosen by a juggler. We can imagine, in this regard, a white ball and a black ball and, on the other hand,

my two pages, the light one and the dark one, so different, yet face to face. Despite differences between the two objects, the juggler's act manages to produce a harmonious combination in the eyes of the spectator." Extracts from *Comment j'ai fait mes livres* (Geneva: Skira, 1946), 74–76. Reprinted in "Matisse, l'œuvre gravée," in the catalogue to the Exhibition at the Bibliothèque Nationale, Paris, 1970.

141. Matisse, *Jazz.*

Chapter 2

1. Apollinaire, "Through the Salon des Indépendants," in *Apollinaire on Art: Essays and Reviews,* ed. Leroy C. Breunig, trans. Susan Suleiman (New York: Viking Press, 1972), 289.

2. "You know that the intention of Cubism—in any case in the beginning—was to express volume. The three dimensional space (natural) remained thus established. (It shows that Cubism *au fond* remained natural and was only *an abstraction* but not *abstract.*) This was opposed to my conception of abstraction which is that this space *just has to be destroyed.* In consequence I came to destroy volume by using the plane—then the problem was to destory the plane also." Quoted by James Johnson Sweeney, "Mondrian, the Dutch and de Stijl," in *Art News,* Summer 1951, pp. 25, 62.

3. *Cercle et Carré,* no. 2 (April 1930).

4. Cf. Paul Renner, *Color, Order and Harmony* (New York: Reinhold, 1964).

5. *Goethe's Color Theory,* ed. Rupprecht Matthaei, trans. Herb Aach (New York: Van Nostrand Reinhold, 1971), 168, 174.

6. Mondrian, "Natural Reality and Abstract Reality," in Michel Seuphor, *Piet Mondrian, Life and Work,* (New York: Abrams, 1956), 306

7. *Cercle et Carré,* no. 2 (April 1930).

8. Mondrian to J. J. Sweeney, *Art News,* Summer 1951.

9. "The system of oppositions within which something like form, or the formality of form, can be thought, is a finite system. It is not enough for us to say that 'form' has a *meaning* for us, a center of *evidence,* or that its *essence* is given to us as such: in truth, this concept cannot be, and never could be, dissociated from the concepts of appearance, meaning, evidence, or essence." Jacques Derrida, "La Forme et le vouloir-dire," *Revue internationale de philosophie,* no. 81 (1967).

10. "The metaphysical domination of the concept of form necessarily prescribes some subordination to the gaze of the viewer. This subordination will always be a subordination of *meaning* (or sense) to the gaze, of sense to the sense of sight, since sense in general is the concept proper to

every phenomelogical field. One could develop the implications of such a *confrontation with the gaze* . . . to show, for example, how that confrontation with the gaze and the concept of form allow descriptions of time and intersubjectivity and a latent theory of the work of art to circulate between the project of a formal ontology." Jacques Derrida, ibid.

11. "Natural Reality and Abstract Reality," p. 348.

12. "Home—Street—City," *Transformations* (New York: Wittenborn and Schultz), vol. 1, no. 1 (1950), p. 46.

13. See Julia Kristeva, "Distance et anti-représentation," *Tel Quel,* no. 32 (Winter 1968).

14. "Home—Street—City," 47.

15. Renner *Color, Order and Harmony,* 46–47.

16. *Goethe's Color Theory,* 174.

17. "The plastic means must be the rectangular plane or prism in primary colors (red, blue and yellow) and in non-color (white, black and gray). In architecture, unfilled space can be counted as non-color, materials as color."

18. Kristeva, "Distance at anti-representation"; see also "Matisse's System," chap. 1 above.

19. For the concept of the "trace," see Jacques Derrida, *Of Gramatology* (Baltimore: Johns Hopkins Press, 1976).

20. "No longer subordinated to the gaze" simply means in this case that "the object of knowledge, painting" is no more subordinated to the gaze (the sense of sight) than is the reading of a text (this one, for instance), a text which, if read in braille by a blind person, would not become any more tactile in its essence. [Throughout this essay the word "gaze" is used to translate the noun *le regard,* which in French connotes something between the "look" and active "looking."—Trans.]

CHAPTER 3

1. Cf. "Origine et histoire du Bauhaus," by Hans Maria Wingler, director of the Bauhaus-Archiv in Darmstadt, *Cahiers Renaud-Barrault,* no. 53 (February 1960).

2. Catalogue to the traveling exhibition organized by the Württembergischer Kunstverein, *50 Years Bauhaus* (London: Royal Academy of Arts, 1968).

3. "Gropius rejected the academic title of professor and gave the teaching faculty instead the title of *master,* a title which students in turn could aspire to at the end of their course of study." Wingler, "Origine et histoire."

4. Gropius, "My conception of the Bauhaus idea," in *The Scope of Total*

Architecture (New York: Harper, 1955), 16. (Reprinted in *50 Years Bauhaus,* 14–17.)

5. Cf. Claude Klein, *Weimar,* in the series Questions d'histoire (Paris: Flammarion 1968). On the origins of the SPD, see Gilbert Badia, *Histoire de l'Allemagne contemporaine* (Paris: Ed. Sociales) vol. 1 (1962).

6. Wingler, "Origine et histoire."

7. Ibid.

8. *50 Years Bauhaus,* 24–25.

9. Ludwig Grote, "Walter Gropius and the Bauhaus," ibid., 9–11.

10. Kandinsky, *On the Spiritual in Art* (New York: Solomon Guggenheim Foundation, 1946), 97.

11. Paul Klee, "Approche de l'art moderne," in *Théorie de l'art moderne* (Paris: Médiation, 1964). Reprinted from *Die Alpen,* no. 12 (1912).

12. Ibid.

13. Klee, *Journal* (French edition) (Paris: Grasset, 1959), p. 234.

14. Klee, "Approche de l'art moderne."

15. Kandinsky, *On the Spiritual in Art,* 50, note 1; the emphasized phrase in the French translation of Kandinsky's text reads "élément purement pictural."

16. Klee, "Exakter Versuch im Bereich der Kunst," Bauhaus, *Zeitschrift fur Gestaltung* (Dessau, 1928).

17. Klee, lecture given in Jena, 1924, in *Théorie de l'art moderne.*

18. Otto Stelzer, "The Preliminary Course in Weimar and Dessau," *50 Years Bauhaus,* 35–36.

19. Regarding this problem (autonomous specificity/differential specificity), see also "Mondrian Twenty-five Years Later," chapter 2 above, and my "Peinture et réalité," in *L'Enseignement de la peinture.*

20. "I am constantly drawn to quote from Klee and Kandinsky to the extent that their texts are the most ambitious and the best elaborated of all those left to us by the Bauhaus. In any case, everyone agrees that they represent the teaching of the Bauhaus particularly well." Cf. Grote, "Walter Gropius and the Bauhaus."

21. Klee, "Approaches to the Study of Nature," in *Wege des naturstudiums* (Staatliches Bauhaus in Weimar, Weimar-Munich: Bauhausverlag, 1923).

22. Gropius, "My Conception of the Bauhaus Idea."

23. Gropius, *The New Architecture and the Bauhaus* (Cambridge: MIT Press, 1955), 108. One notes the apparent contradictions between this text and the construction of the Pan Am Building in 1958.

24. Kandinsky, *On the Spiritual in Art,* 21–22. This statement has been isolated and discussed by Jean-Paul Bouillon in "La matière disparaît: note sur l'idéalisme de Kandinsky," in *Cahiers de l'art contemporain,* docu-

ments II, May 1974, Centre de documentation et d'études d'histoire de l'art contemporain, Saint-Etienne. I do not, however, entirely agree with Bouillon when he tries to explain Kandinsky's ideological positions in terms of the failure of the Russian experiment. The contradictions that enter into play here cannot be limited to the domain of philosophy alone. In my opinion there are investments of a very different order at stake: investments that program "talents," pictorial activity, and productivity, that is to say, sexual investments. My essay on the Bauhaus dealt with (deals with) the sociological angle of an artistic phenomenon. That is one of its limits. If one were to pause to examine more closely any one particular artist, one would have to consider the demonstrative essay that initiates *L'Enseignement de la Peinture* and outlines the program of that book, "Matisse's system" (cf. above, chapter 1). Regarding the work that remains to be done on Kandinsky, one would have to link the artistic production of the artist in an analytic way to the corpus of biographical information at our disposal; this would include the Russian period and the ideological commitments of the Bauhaus period. And in studying that period it would be essential to introduce the question if Kandinsky's anti-Semitism as expressed in the correspondence between Kandinsky and Schoenberg in April and May 1923. Schoenberg writes: "I have heard that even a Kandinsky cannot see anything but *bad* in the actions of a Jew, and anything but *Jewish* in bad actions; that is where I give up hope of ever understanding him. It was a dream. We are two different types of human beings. Definitely!" This in reply to the offer that Kandinsky had made to him to come teach at the Bauhaus. Cf. Schoenberg's correspondence, and also J. M. Straub's film *Einleitung zu Arnold Schoenbergs Begleitmusik zu einer Lichtpielsgene.* (The filmscript along with excerpts from the letters have been reprinted in the journal *Ça*).

25. Gropius, "The Bauhaus Manifesto," in *Bauhaus,* ed. Herbert Bayer (New York: Museum of Modern Art, 1938), 16. (Reprinted in the *50 Years Bauhaus,* 13.)

26. *50 Years Bauhaus,* 22–23, and *Pädogogisches Skizzenbuch* (Munich: Langen, 1925).

27. Kandinsky, *On the Spiritual in Art,* 58–59.

28. Immanuel Kant, *The Critique of Judgement,* trans. James Creed Meredith (Oxford: Oxford University Press, 1978), 168.

29. Kandinsky, *Point and Line to Plane,* (trans. Howard Dearstyne and Hilla Rebay (New York: Dover, 1979), 39.

30. A referential order could also be established from the influence of Rudolph Steiner's theosophy on Kandinsky. Cf. For example Steiner's *Goethe's Conception of the World* (*Goethes Weltanschauung*) (London: Anthroposophical Society, 1928).

31. Klee's anecdotal reference to Feuerbach in "Schöpferiche Konfession," *Tribune der Kunst und Zeit* (Berlin, 1920), reveals an absolute misinterpretation.

32. One may well imagine the effect that Johannes Meyer's arrival must have produced in such a climate. Ludwig Grote tells us that Meyer's "scientific Marxism limited his perspective." Quoted by Wingler, "Origine et histoire."

33. The phrase comes from Charles Etienne, *Du Spirituel dans l'art,* Afterword.

34. Kandinsky, *Point and Line to Plane,* Foreword.

35. Gropius, "The Bauhaus Manifesto."

36. Klee, "Exacter Versuch im Bereich der Kunst."

37. In February 1919, just one month before the creation of the Bauhaus, Ebert, who had just been elected president of the Reich, exhorted his constituants in a grand speech to promote the movement of Germany "from imperialism to idealism, from power to spiritual grandeur." Cf. Badia, *Histoire de l'Allemagne contemporaine.*

38. The same problem, considered from the perspective of Kandinsky and Klee, could be addressed to the "case" of Gropius, who shared the fundamental ideology of the painters but whose more complex practice continued to restructure the course of study and teaching at the Bauhaus. One would want to examine in particular Gropius's invitation to Johannes Meyer to teach at the Bauhaus and later his entrusting of the directorship to him. Similarly, the teaching of Meyer should be studied in depth.

CHAPTER 4

1. See "The Bauhaus and Its Teaching," chapter 3 above.

2. See *"Le Front 'gauche' de l'art,* Eisenstein et les vieux 'jeunes-hégéliens'," *Cinéthique* (Paris), no. 5 (September–October, 1969).

3. Camilla Gray, *The Great Experiment: Russian Art 1863 to 1922* (London: Thames and Hudson, 1962), 21.

4. Vrubel, "Letter to His Sister," May 1890, quoted in Gray, *The Great Experiment.*

5. The relation between Vrubel, Puvis de Chavannes, and the Pre-Raphaelites crystallizes in the *World of Art* movement; on the subject of art nouveau and Vrubel, see Gray, The *Great Experiment,* chapter 2.

6. Ibid., 38; and Benois, *Reminiscences of the Russian Ballet* (London, 1941).

7. Gray, *The Great Experiment,* 90.

8. Stedelijk Museum of Amsterdam (gouache on paper, 132 × 72 cm.).

9. See Malevich, *Essays on Art* (Copenhagen: Borgen, 1968), vol. 2.

10. Gray, *The Great Experiment,* 130.

11. "Suprematism: 34 Drawings," in Malevich, *Essays on Art,* vol. 1, p. 127.

12. Special issue devoted to the French School, with reproductions of the one of the *Portraits of the Artist's Wife* and one *Still Life* by Cézanne. Gray, *The Great Experiment,* 72.

13. From the perspective of the inscription of Cézanne's work within the Russian avant-garde, we note in addition the "Knave of Diamonds" exhibition in 1909, organized by a group of young artists first known as "the Cézannists." Ibid., 104.

14. Cf. "Aux sources de la littérature soviétique," *Œuvres et opinions* (Moscow 1969), reprinted in *Tel Quel,* no. 37.

15. Quoted Gray, *The Great Experiment,* 215.

16. "On the New System in Art," in Malevich, *Essays on Art,* vol. 1, p. 94.

17. Gray takes her information from the constructivist architect Bertold Lubetkin. *The Great Experiment.,* 217; 309, note 7.

18. See Kandinsky, *On the Spiritual in Art* (New York: Solomon Guggenheim Foundation, 1946); and "The Bauhaus and Its Teaching," chapter 3 above.

19. Quoted by Gray, *The Great Experiment,* p. 216.

20. Trotsky, "Futurism," in *Literature and Revolution,* (New York: Russell and Russell, 1957), 130.

21. Lenin, "First All-Russia Congress on Adult Education, 6–19 May 1919," in *Collected Works* (Moscow: Progress, 1965), vol. 29, p. 336.

22. "That which we consider to be form has disappeared completely." Malevich, *Essays on Art,* vol. 2, p. 135. (Cf. Mondrian's reflections in "Mondrian Twenty-five Years Later," chapter 2 above.)

23. "I am only free when my will can, on a basis of criticism and philosophy, draw out of the existing, new phenomena." Malevich, quoted by Gray, *The Great Experiment,* 284.

24. "To the New Image," Malevich, *Essays on Art,* vol. 1, p. 51.

25. *"Le Front 'gauche' de l'art."*

Index